PHOTOGRAPHING
WILDLIFE

AMPHOTO
AN IMPRINT OF WATSON-GUPTILL PUBLICATIONS/NEW YORK

PATRICIA
CAULFIELD

Patricia Caulfield was born in Chicago and raised in Iowa. Her education sent her east, and she was graduated from the University of Rochester in 1953. She held a variety of editorial positions at *Modern Photography* magazine and meanwhile wrote two books, the *Guide to Kodachrome Films* and the *Beginner's Guide to Better Pictures*, both published by Amphoto.

In 1967 Ms. Caulfield resigned as executive editor at *Modern Photography* to devote her full time to nature photography and conservation. She has been a contributor to many magazines, including *Audubon*, *Natural History*, *National Geographic*, and *National Wildlife*. Her book *Everglades* was published by the Sierra Club in 1970. *Capturing the Landscape* (Amphoto, 1987), her most recent book, is a companion volume to *Photographing Wildlife*.

Many thanks to the following people and companies for their contributions of time or equipment in helping me prepare this book:
Gitzo Tripods, Ann Guilfoyle of AG Editions and the Guilfoyle Report, Mark Iocolano of October Press, Herbert Keppler, Minolta Corporation, Spiratone, Inc., and Marjorie Thompson.

Edited by Robin Simmen
Graphic production by Hector Campbell

First published 1988 in New York by AMPHOTO,
an imprint of Watson-Guptill Publications,
a division of Billboard Publications, Inc.,
1515 Broadway, New York, NY 10036

Library of Congress Cataloging in Publication Data

Caulfield, Patricia.
 Photographing wildlife : techniques for portraying animals in natural habitats / by Patricia Caulfield.
 p. cm.
 Includes index.
 ISBN 0-8174-5442-X ISBN 0-8174-5443-8 (pbk.)
 1. Photography of animals. 2. Nature photography. I. Title.
TR727.C38 1988
778.9'32—dc19 87-31929
 CIP

Manufactured in Japan

4 5 6 7 8 9 / 94

*For my nieces, Elizabeth Marie
and Mary-Patricia Hall.*

CONTENTS

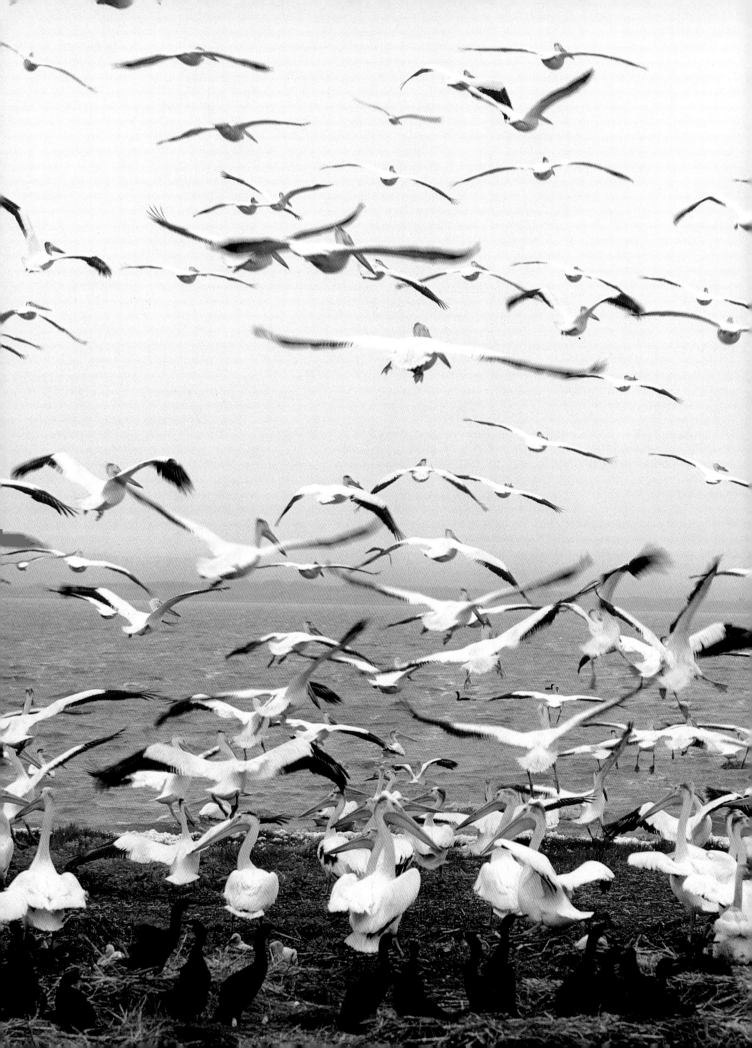

INTRODUCTION

Nature photography is a big field filled with people who have different aims, attitudes, approaches, and techniques. At one end of the spectrum are scenic-landscape specialists and at another are photographers stalking animals in action. The range of photographic techniques involved is so great that I've treated animate and inanimate nature subjects separately by writing a book on each area. *Photographing Wildlife* has a sister volume, called *Capturing the Landscape with Your Camera*, that covers such topics as composition, film choice, and lighting in much greater detail than I do here. You may want to refer to that earlier book if you've never done any previous photography. If you have, *Photographing Wildlife* covers all the photographic basics you'll need. More important, this book is filled with hands-on information about various animal species and how to approach them. I want to impart to you all the animal lore and respect for nature that I've developed during my years of field experience as a wildlife photographer.

How I Got Started

I was in my senior year at the University of Rochester and majoring in history when I found a job working for Beaumont Newhall, who was the curator of photography at the George Eastman House. I was completely ignorant about photography—I'd never even owned a camera. That's why they hired me. My job was to be a student who would be taught the fundamentals of photography on a local television program.

During the course of the thirteen-week program, I spent a lot of time off-camera talking to Beaumont and Nancy Newhall about photography in preparation for the actual television filming. One night, several weeks after the job had started, I was sitting alone in the Newhalls' living room. Right in front of me was a large print of Ansel Adams' "Moonrise, Hernandez, NM." Suddenly, I *saw* the picture, the first picture I had ever really *seen* in my life. I got to my feet and walked up to it; I backed off again and continued looking. "Moonrise" had opened my eyes and captured my heart. It seemed the most amazing, marvelous, and beautiful thing I'd ever looked at. I was smitten—taking pictures was what I wanted to do with my life.

I began looking at photographs in earnest: the other ones hanging in the Newhalls' home, the photographs at Eastman House, and those published in picture books. I started to develop film and to contact-print my own pictures, using the closet in my dormitory room as a darkroom.

I cannot say my initial efforts were successful. I didn't like my pictures. The trouble with them went beyond my initial technical difficulties, such as failure to focus sharply or to hold the camera steady. The real problem was that I was unable to see photographically, or to find and compose significant images in the viewfinder. This was a very serious hurdle to overcome; to even begin taking pictures that satisfied me required several years of work. Actually, I don't know how I persevered through that unrewarding period.

I visited this white pelican rookery in North Dakota with bird banders, but I couldn't wait for the weather to change before I began shooting. I didn't mind the light's quality—the soft, shadowless illumination of a heavily overcast sky was fine. It was the quantity of light that bothered me. I shot this picture for 1/60 sec. at f/5.6 with a 300mm lens. I would have preferred to use a higher shutter speed and a smaller aperture.

When I first encountered photography, I was completing a B.A. in history; I had no clear career goal and no automatic employment possibilities. Discovering photography clarified my goals for me. On the other hand, my career path wasn't clear at all. There didn't seem to be any definite solution to my problem, except to put one foot ahead of the other and to continue taking pictures no matter what else I did.

The summer after my graduation, I went on a trip to San Francisco with a college friend. Both of us loved the city. I decided to stay and visited several employment agencies, hoping to find a job. Job hunting in San Francisco was a painful process; the city was flooded with recent college graduates looking for work. I couldn't summon enthusiasm for any of the entry-level jobs that were available. The only thing I wanted to do was to learn more about photography, and none of the job possibilities I encountered was remotely connected with my desire.

I began patronizing a camera store regularly to buy film and send it out for processing. It was a small store, and I became friendly with the owner and the chief salesman. I found myself reporting to them about my job-hunting progress and my disappointment in the positions I'd found. Fortunately for me, the owner of the camera store offered me a job. I accepted the offer immediately.

I worked at the camera store for nearly a year, and it was an important year in terms of my photographic education. I learned a lot about photographic equipment and about photographs from Jack Cannon, the chief salesman. Jack was an expert photographer who was very active in camera-club salon competitions, and he admired the same photographers I'd learned to venerate as a result of my acquaintance with the Newhalls.

Even so, I still couldn't stand the pictures I was taking. I decided the problem was my general lack of visual knowledge. I'd always been more involved with words than with images, and everything I knew about art had been gleaned in one college semester's quick survey course on modern art. Through a chance acquaintance I heard of the Patri School of Art Fundamentals, a small institution, based on Bauhaus concepts, that was designed for people lacking any other art training. I enrolled early that autumn and went to the Patri School four nights a week for nearly a year. Mondays we sketched, Tuesdays we sculpted, Wednesdays we drew, Thursdays we worked with color, and we frequently used the same models and poses or the same still lifes throughout the entire week. I believe the Patri School solved my visual problems. I began to take a few pictures I liked, and with this initial success came the confidence that I would continue to take better pictures if I persevered.

On to New York

The following year I moved to New York City where most of my college friends had settled after graduation. I wanted to be a photographic assistant, and I called on numerous commercial photographers and studios, using the Yellow Pages as a guide. My quest was fruitless, and when my money ran out, I decided to look for another camera-store job. I landed one almost immediately. Still, those were dark days for me. I was intimidated by New York and hated living in a rooming house and working at a subsistence-level job where I wasn't learning anything. However, help was on the way. A photographer I knew told me about a job opening that I filled as a receptionist at Modernage, a big custom black-and-white lab that catered to professionals. It was an excellent job for me. I met many photographers, and I was able to look at their photographs day after day. I learned a lot about how different people take pictures, and my feelings about my own work improved when I realized that not every shot—regardless of how famous the photographer—came up to the standards set by the pictures in the George Eastman House collection or on the walls of the Museum of Modern Art.

Then came a call from an employment agency. *Modern Photography* magazine was looking for an editorial assistant. I took the job and stayed at the magazine for the next eleven years. Meanwhile, I continued making pictures after work, on weekends, and on vacations.

Becoming a Nature Photographer

Chance has played a big role in my life. I owe much of my growth as a photographer to some marvelous opportunities that have come my way. My job at *Modern Photography* brought me into contact with Eliot Porter, the photographer whose influence led me to become a full-time photographer and to choose nature as my subject matter. I was assigned to do a story on him in 1964, and while I was becoming familiar with him and his work, I found my own interests and aims shifting until I finally became convinced that nature photography was my calling, too. The choice seemed fitting since, as a child, I'd been fascinated with nature and animals. While still an editor at *Modern Photography*, I worked on several nature stories over my vacations, but eventually I quit my job as executive editor and devoted myself to photography full-time.

Although I had some assignments from the start, I didn't enjoy instant success. I wouldn't advise anyone who is attempting to break into this difficult field today to follow my unplanned footsteps.

The nature photography field is more difficult now than it was twenty years ago when I first became interested in it. More and better animal pictures are

being made every year. Many of the photographs you see in nature magazines and books are made by part-time professionals who earn their livings from some branch of science or teaching.

My advice to young photographers is to study for a doctorate or at least a master's degree in biology and to try combining photography with some kind of scientific work. I certainly wish I had such an area of expertise—it would be instrumental in bringing me more assignments. I also suggest you undertake as many photographic projects as possible, meanwhile striving for better pictorial command and steeping yourself in animal-behavior studies, entomology, and botany. Try to photograph all the significant aspects of accessible animal life that can be pictured. Creating a portfolio of excellent samples to show to editors is mandatory for becoming a full- or part-time professional. This can only be done by devoting considerable time and effort to your photography.

Work on a project that attracts you. Your choice of subject matter will significantly affect your develop-ment as a nature photographer. One photographer may choose to depict the metamorphosis and behavior of an insect. Another may focus on the social behavior in a herd of wild horses. A third may depict the life cycles of amphibians. Whatever your choice, I suggest that when you show your work to editors, you show them sets of pictures, arranged as small essays or stories, instead of single shots.

As you begin photographing wildlife, remember that most of us who make a living taking nature pictures didn't become successful overnight. Also, most wildlife photographers work in this area part-time and support themselves by other means. It takes many years of studying photography and nature to successfully launch a full-time nature-photography career. If you have the time and money, by all means consider going to photography school as well as studying biology. As far as I'm concerned, photographic training is a shortcut to learning—the more technical know-how you command, the sooner you'll be able to take pictures that satisfy you and the public.

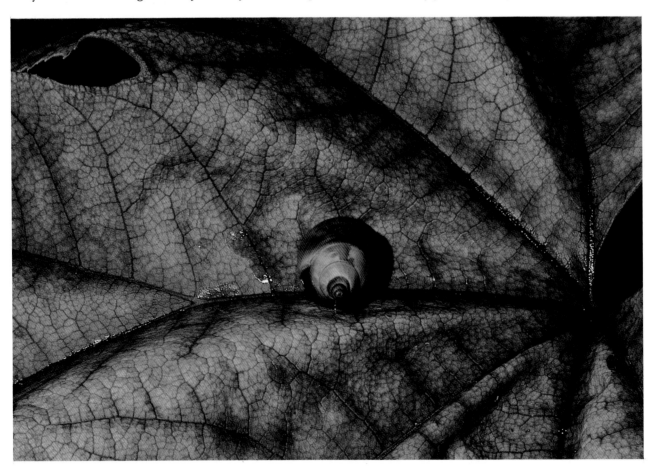

Electronic flash was the light source for the unique red tree snail and leaf. Exposure was f/32 and 1/60 sec. with a 55mm macro lens. The flash was held off camera at the right distance to require the small, f/32 aperture.

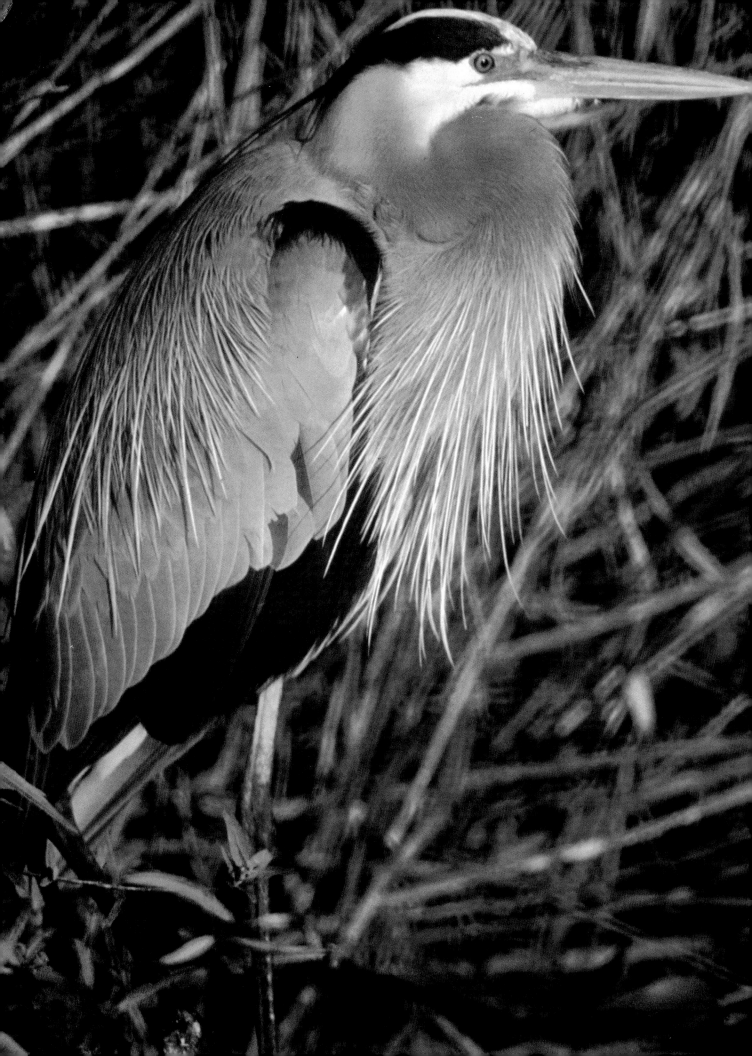

Chapter One

EQUIPMENT AND MATERIALS

Of all the camera formats available today, my favorite is the 35mm single-lens reflex (SLR), not because its results are superior technically or because it makes composing good pictures easier, but because I like its viewing mechanism better. I prefer to look straight out at what I am shooting instead of down into a 2¼"-square groundglass or at an upside-down 4 × 5 image. I also like to work fast and spontaneously, which runs contrary to the more studied work mode dictated by the view camera.

Although landscape photography makes a range of camera formats feasible because of the inanimate subject matter, a SLR camera is the only logical choice for animal work. I don't know any animal photographers who use anything but 2¼"-square or 35mm SLRs. Many landscape photographers work with 4 × 5 and 8 × 10 view cameras because their adjustments—swings, tilts, rises, and falls—are without peer for composing landscapes. However, photographing wildlife poses substantively different problems, foremost of which is speed—and for capturing an animal's fleeting presence on film, the SLR's speed of operation is essential.

I currently use Minolta cameras, both the older XD-11s and the newer X-700s. Because I prefer manual focusing for most of my work, (which, in addition to animals, includes landscapes and closeups) I haven't opted for the new autofocus feature now available. There are many wonderful camera systems on the market, and professional photographers use them all, including autofocus cameras. If you need to buy a camera, first check the technical analyses published in the photography magazines. Then go to your local camera store and examine the specific camera brands and models that interest you and suit your budget. Decide which camera best fits your hand, and which has the most easy-to-locate touch controls. Of course, you won't immediately operate a new camera with the same easy familiarity that you've developed with an old one; however, by shopping around, you can glean an idea of how easy different cameras are to operate without actually shooting off any film.

Carefully consider your photographic needs. Do you want or need to take pictures of wildlife in low light? If the answer is yes and you are willing to carry some extra weight into the field, you may want to pick a system that has fast, extra-low-dispersion, internal-focusing (EDIF) telephoto lenses. Be thorough in checking your options, and take time to decide exactly what equipment you want. One thing you don't want is to have to switch your camera system—buying a different one because you aren't happy with the one you

My 300mm lens wasn't giving me a frame-filling image of this great blue heron, and I didn't think I could get closer to the bird without frightening it; so I switched to my 500mm mirror lens. Note the odd look of the out-of-focus background.

have is an expensive proposition. On the other hand, I assure you that any of the name-brand cameras is capable of producing amazingly good pictures.

Something I frequently encounter in students for whom price is no object is a tendency to buy several different camera models. This strikes me as undesirable, because you need to be able to operate whatever camera you're using without thinking about it. You can't do this correctly if you have to stop to remember what model you have in your hand at any given time. If you aren't happy with your photographs, don't immediately blame your camera. The problems you're having are probably due to your composition, exposure, camera movement, or some other technical or aesthetic consideration within your control instead of being problems caused by your camera.

Choosing the Right Lens

A big difference between landscape and wildlife photography is that having a full range of focal lengths is not nearly as important to the latter. I occasionally use wide-angle lenses in animal photography but take most of my animal pictures with lenses that are 200mm or longer. How close I can get to the animal determines which lens I choose. I am often more concerned about the size of the animal's image in my picture frame than I am by perspective, the interplay between background and foreground, or other aspects of composing the picture.

There are some animal photography situations that permit shorter focal lengths. For example, when I photograph insects, I sometimes use my standard lens, a 55mm macro lens that lets me focus to 1:2 (one-half life-size) without added accessories. Even so, only the most phlegmatic insects let me get really close to them. And I occasionally use wide-angle lenses for subjects that are not camera shy and permit a very close approach. A wide-angle lens allows me to frame a large-sized animal and still get the landscape surrounding it.

Lenses in the 85mm–135mm range are generally too short to be of much use with truly wild animals. However, if you do use lenses in this range, you'll discover that they are long enough to require some serious forethought to avoid making blurred images. This problem with image sharpness results from camera movement when hand-holding long lenses. Using faster shutter speeds is one solution; a tripod is another. The lenses I find most useful are telephotos with focal lengths of 200–400mm; ninety percent of my animal and bird pictures are made with them. Interestingly, these long lenses are capable of creating compositions that at first glance you'd assume were made with a greater variety of focal lengths.

Many nature photographers swear by their long telephotos. Fast 600mm EDIF extra-high-cost optics that deliver sharp images at maximum apertures are particularly popular. I get more use from my 300mm than from my 600mm lens, but there is no doubt that the 600mm opens up a whole new world to portray. With these really long lenses, the classic telephoto shooting problems—shallow depth of field and blur from the least camera movement—become acute. To steady such lenses you need a heavy-duty tripod, and frequently you must rest the lens on another support or weigh the tripod legs down with sandbags. The depth of field provided by a long telephoto is shallow even with the lens stopped down. If you buy a very long lens for a particular trip or project, practice with it beforehand to perfect your shooting technique.

Mirror Lenses

Many telephoto lenses that are longer than 300mm are *catadioptric*, or mirror lenses. Shorter mirror lenses are also available. Mirror lenses are physically much shorter than conventional lenses of the same focal length, and they are also more lightweight. Inside these lenses are mirrors that bounce the subject's image back and forth, which enlarges it. I use long mirror lenses for the same reason I use other long telephotos: to obtain a bigger image of my subject than would otherwise be possible. Some mirror lenses are actually manufactured for telescopes but are adaptable for cameras. Both Questar and Celestron make special photography models.

A mirror lens has a single, fixed aperture: 250mm mirror lenses are f/5.6; 500mm lenses are f/8; 1000mm lenses are f/11. Usually, the amount of light delivered to the film is less than the f-stop indicates. Because of the mirror lens' fixed aperture, all exposure control comes from changing the shutter speed.

Out-of-focus backgrounds and foregrounds have an odd, fluttery look when made with mirror lenses. This is because they produce doughnut-shaped circles of confusion, as opposed to the usual disk-shaped ones. However, when all of a subject is on a single plane, so that everything in the frame is in focus, a picture made with a mirror lens is indistinguishable from one made with conventional optics.

Zoom Lenses

The longer multi-focal-length, or zoom, lenses are great for photographing wildlife. I regularly use a 70–210mm zoom. At its longer setting it has replaced a fixed 200mm lens in my standard gear. Lens designers have had to make some compromises in optical quality to deliver zoom lenses at a reasonable weight and cost. However, the resulting distortion isn't as big a

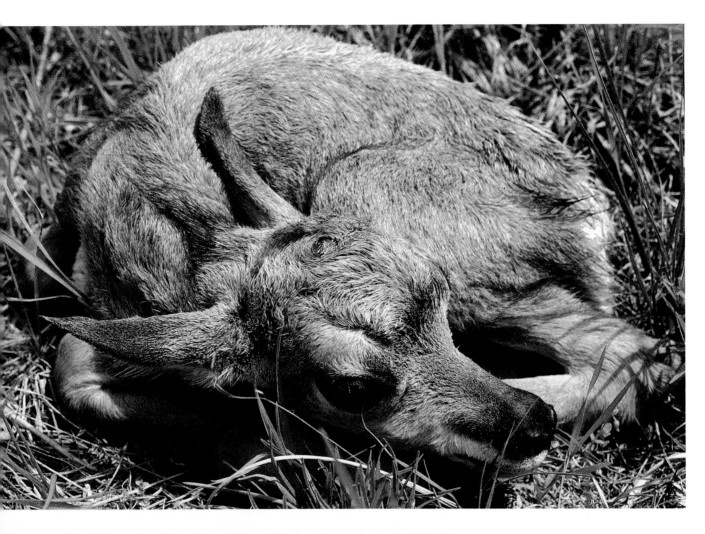

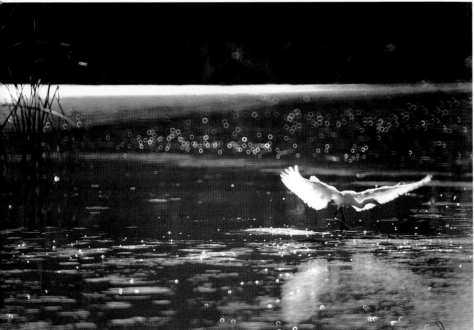

I occasionally use 15–24mm extremely wide-angle lenses to photograph subjects that are not camera shy and permit a very close working distance. For example, this infant pronghorn was settled down next to its mother in a meadow when I came into view. She immediately departed but the fawn remained, which is typical deer behavior—fawns remain motionless no matter how close you come to them.

I couldn't have been any farther from the infant and still have made this picture; otherwise, grass would have blocked my view, even if I had been using a standard focal-length lens. The exposure was 1/125 sec. at f/11 on Kodachrome 64 film using a 20mm lens.

I used a 500mm mirror lens to make this shot of an American egret taking flight. The light was very low because the day was overcast.

problem in nature work as it is in architectural photography, where depicting truly straight lines is essential. A zoom lens may perform far better at one extreme of its focal lengths than at the other. Your best guide to the specific aspects of a zoom lens' capabilities is the exhaustive equipment tests performed and printed in the photography magazines.

Most current zoom lenses are called *macro zooms*. These lenses incorporate a macro mode that usually makes images up to one-quarter life-size or at maximum magnifications of 1:4. The macro mode functions across various ranges on different zooms—some can take one-quarter life-size photographs only at their shortest focal length, others only at their longest. At the longer focal lengths the macro mode is excellent for shooting insects; you may want to make this feature a criterion for selecting a lens.

Macro Lenses
One of the main reasons for buying a so-called macro lens that focuses from infinity down to one-half life-size (or, in a few cases, even down to 1:1) is the ease of making closeups. In wildlife work insects are the most typical subjects photographed with macro lenses, and many insects are very shy of approach. You must be able to stay as far away from them as possible to make good pictures. For this reason I don't recommend using standard focal-length macro lenses. You'll find a 90mm, a 105mm, or even a 200mm macro lens much more useful.

Macro lenses tend to be slower than regular lenses of the same focal lengths. Macros are optically designed to produce their finest depictions at close range; often they are not as good at greater distances as regular lenses. But if you are interested in general nature photography, including landscapes as well as animals, I suggest you buy a standard macro lens rather than the standard lens marketed with your camera. I would also buy a short telephoto macro lens instead of the regular short telephoto. Bear in mind that the cost of these macro optics will be considerably greater than the cost of regular lenses of the same focal lengths.

If you don't own any macro lenses, you can still do closeup photography of insects and flowers and other small subjects, either by inserting extension tubes or bellows between the camera body and the lens or by adding closeup lenses or teleconverters to your regular lenses. These methods yield excellent results. Macro lenses are more convenient because they allow continuous focusing without having to add accessories, but using macros is not the only way to make good closeup pictures (see "Closeup Photography" in the appendix).

The bird pictures I find most interesting are often taken when the subjects display atypical attitudes. Such was the case with this green-backed heron stretching its neck. On an overcast day I used a 70–210mm zoom to make this exposure of 1/125 sec. at ƒ/5.6 on Kodachrome 64.

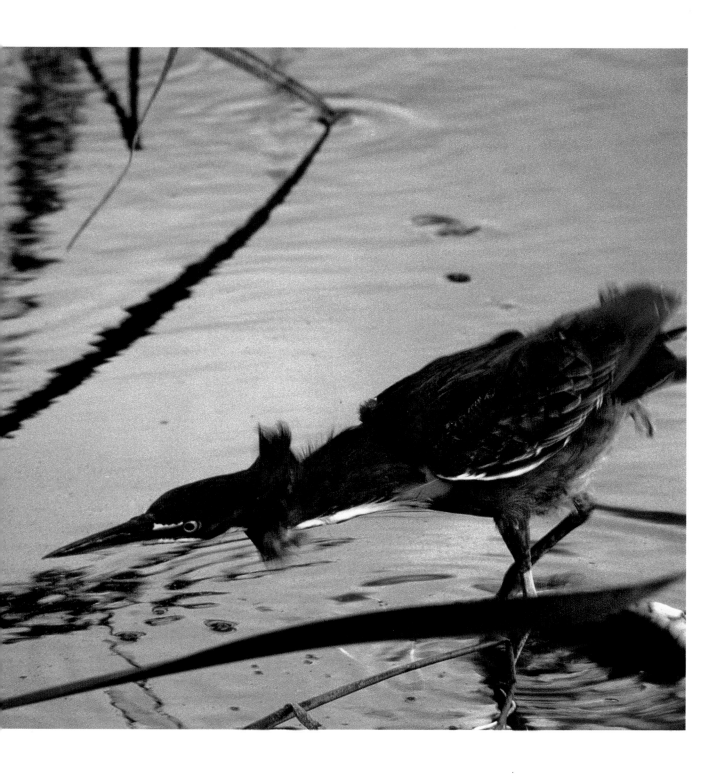

True Macro Lenses

Real macro lenses are actually short-mount lenses constructed without focusing helicoids, and they are intended for use with bellows. These lenses produce optimum optical results at magnifications greater than 1:1. Lacking automatic diaphragms, real macro lenses must be stopped down manually after focusing and before shooting. Many of these lenses are available in very short focal lengths, so that great magnifications can be achieved without an enormous amount of bellows extension. If you are interested in photographing inanimate as well as animate subjects at very high magnifications, invest in one of these lenses.

Teleconverters

Teleconverters, or extenders, range in their magnification capabilities from $1.4\times$ to about $3\times$, $2\times$ being the most common magnification. When attached between the lens and the camera, this optical device increases the focal length by its magnification factor. For example, a $2\times$ extender makes a 105mm lens into a 210mm lens, a 70–200mm zoom into a 140–400mm zoom, and so on. In addition to increasing focal length in normal-range shooting, teleconverters also increase magnification in closeup work.

Teleconverters do degrade image quality, but the better ones are manufactured for use with specific lenses and groups of lenses, and these produce acceptably sharp pictures. Always buy the best teleconverter you can find and afford for your lens. There is no point in buying top-notch primary optics and then adding a cheap accessory that is guaranteed to degrade the image.

Closeup Lenses

Closeup lenses are simply magnifying lenses that screw into the filter threads of the lens attached to the camera. Inexpensive closeup lenses are made by most camera manufacturers and by independent lens makers. They are usually marketed in sets of three: $+1$, $+2$, and $+3$ diopter power (these demarcations are not magnifications). Closeup lenses usually consist of a single element; however, several camera manufacturers are now marketing two-element closeup lenses that are of excellent quality. I can recommend these two-element lenses without qualification.

Choosing a Film

Most wildlife photographers like to shoot in color, so you are probably a color shooter, too. Whether you use a positive-transparency or a negative-print film depends largely on how you plan to view your results. If you plan to project your pictures in slide shows, you will naturally shoot slide film. If you want prints, you will probably use negative film.

Professional photographers who publish their work in magazines and books shoot color transparencies, even though they may want to make some prints from them. You can get excellent prints from slides. Book and magazine publishers usually prefer to make color separations for reproduction from color transparencies instead of working from color prints.

Transparency films demand accurate exposure techniques. Color-negative films have much more latitude. For example, with Kodacolor negative-print film you can still obtain a usable picture of a low-contrast subject even when you underexpose two stops or overexpose three stops more than indicated by an exposure meter. On the other hand, with Kodachrome transparency film an exposure difference as small as ½ stop is visible in the resulting slide images.

Color films have many attributes. In terms of wildlife photography, the most important is film speed, or sensitivity to light. A film's speed is indicated by its ISO number: the higher the number, the greater the film's sensitivity. Because your subjects are active animals, it may seem logical to use a fast color film. This is not necessarily or even probably so. Most nature photographers use slow ISO 25 or ISO 64 speed film for virtually all of their shooting because they are concerned with such film characteristics as contrast, grain, color saturation, and sharpness, which are all linked to film speed. Slow color films usually have finer grain, greater sharpness, and better color saturation than faster films.

I take most of my pictures on Kodachrome 64 transparency film. In bright sun I can use the highest shutter speed my camera incorporates—1/1000 sec.—with an aperture of f/4 for average-toned subjects. Occasionally, I use faster films: Ektachrome 200 for dark days, even Agfachrome 1000 for pictures after sunset or before dawn. Whatever film you choose to work with, be prepared to test it thoroughly.

The big-lubber grasshopper that abounds in the Everglades is known for its evident lethargy. If you move in on one slowly, you can get within inches without spooking it. This big lubber perched on a spikerush, a ubiquitous plant in the 'Glades, while I recorded its elegant upperside.

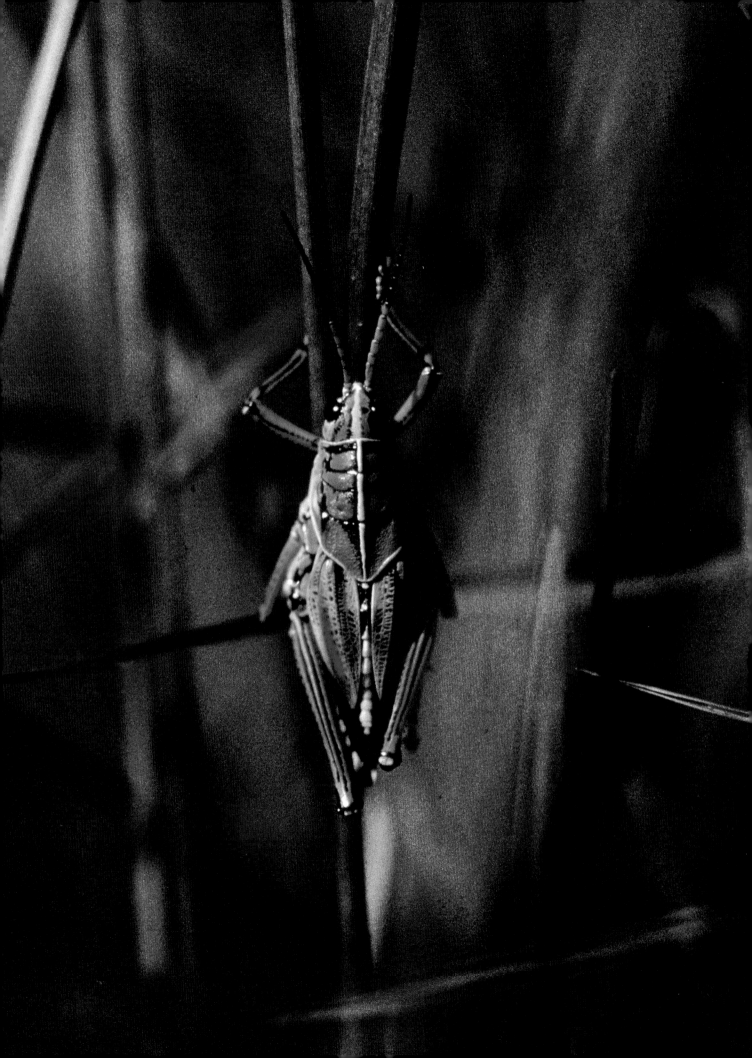

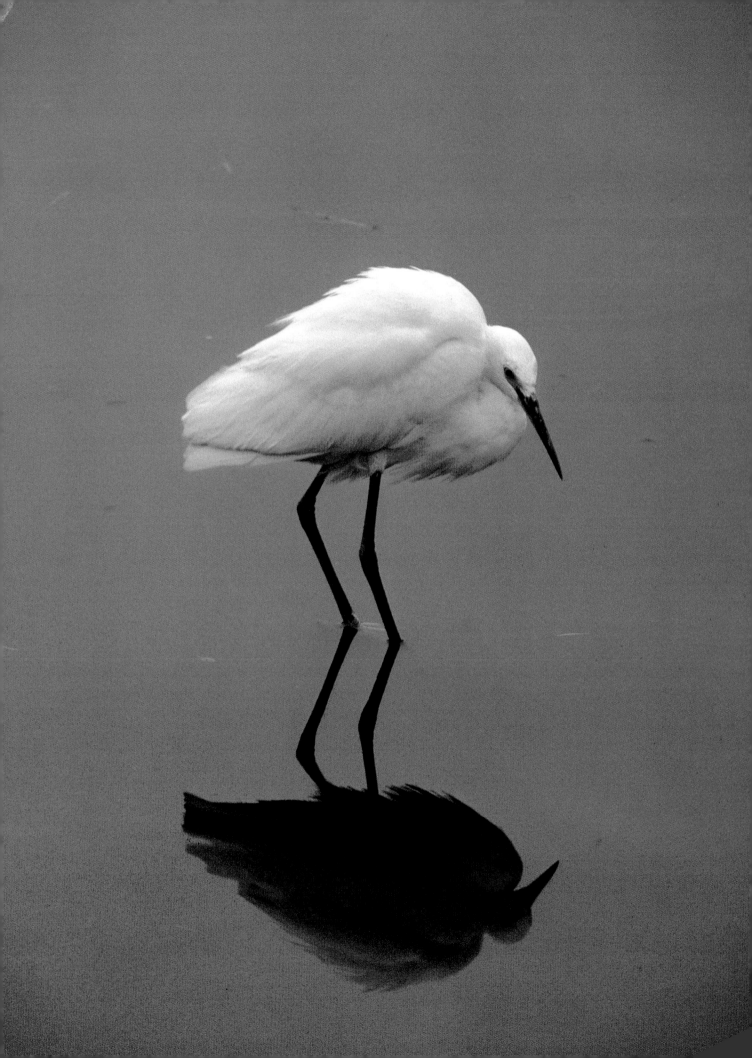

Chapter Two

LIGHT AND EXPOSURE

The nature and quality of the light illuminating your wildlife subjects fundamentally affects your photographic results. Different kinds of lighting require different exposure techniques. When shooting in the field, it is essential to be as aware of your lighting conditions as you are of the wildlife. The exposure meters built into your cameras don't always provide the correct or best exposure, regardless of the type of illumination.

It is important to be aware of two different aspects of light. The light falling on your subject is called *incident light* and the light reflected from your subject is called *reflected light*. The latter is what your built-in, through-the-lens (TTL) exposure meter reads, and it is also the light read by separate or built-in spot meters.

Depending on the subject's *tonality*, or its darkness or lightness, a reflected-light meter's readings should or should not be followed. That's right. Exposure meter readings aren't inviolate rules for exposure; they are only light readings. It is always up to you to decide on exposure, and your meter's light reading is only one factor. Another important one is what you can see with your own eyes about the subject's tonality and the light's direction and quality. In general, dark subjects should be given less exposure than a reflected-light reading would indicate. The reverse is true for light subjects; they need more exposure than a meter would

indicate. This rule applies if—and this is a big if—the subject fills the frame and is not just a small object surrounded by a large area of different tonalities.

Interestingly, the brightness or dimness of the illumination doesn't determine whether a picture gives the impression of being light or dark; instead, the overall tonal balance of the subject does. Subjects that consist primarily of light tones, regardless of how they are illuminated, are best rendered in *high key*. This means that the exposure is calculated to make the picture look light and bright. When basing a high-key exposure on a reflected-light reading, add ½–1½ stops to the meter's reading. Subjects that consist primarily of dark tones are best rendered in *low key* regardless of the illumination's brightness. To create a quiet, subtle feeling for a dark subject, subtract ½–1½ stops from your reflected-light reading.

Calibrate Your Camera's Exposure Meter

The first thing you should do when you take a new camera home is check the accuracy of its TTL exposure meter, and if you haven't already done so, you should also check the meters on any other cameras you already own. All you need to test and calibrate a TTL meter is a system that reads out in *f*-stops or shutter speeds. Take the camera and any lens outdoors on a bright sunny day. If you have an aperture– or

Storm clouds covered the sky above this scene, which produced the flat light illuminating the snowy egret. I gave the picture one-half stop less exposure than my meter indicated for Kodachrome 64. My exposure was 1/60 sec. at *f*/5.6, using a 70–210mm zoom lens.

shutter-speed–priority camera, set it to one of these modes instead of a "programmed" automatic exposure mode. Now prop up a gray card (available at camera stores) so that it faces the sun. View the card through the camera with the lens focused at infinity. Move close to the card until it completely fills the picture frame. (If you don't have a gray card, green grass and blue sky are good substitutes.) Set the film speed on the camera according to the ISO speed of the film you intend to use. Now look on the inside of the film box to find the correct exposure settings for different kinds of light, or use the sunny *f*/16 settings described later in this chapter.

To demonstrate how you can use the film manufacturer's information to check your meter's accuracy, I will use the settings recommended for Kodachrome 64 (ISO 64) as an example and presume an aperture-preferred system. In bright sun this film should be exposed at 1/125 sec. at *f*/11 (or 1/60 sec. at *f*/16) for such a middle-toned subject as a gray card, green grass, or blue sky. Set the aperture on the camera at *f*/11. What shutter speed is recommended by your camera? If it is 1/125 sec., your meter is tuned perfectly. But if it is 1/60 sec., your meter is indicating a one-stop difference, which means your pictures will consistently be overexposed by one stop if you follow the meter's readings. To compensate, raise the film speed on the camera by one full stop; for example, with ISO 64 film, set the speed at 125; with ISO 100 film, set the speed at 200; and with ISO 25 film, set the speed at 50.

If you have more than one camera, tape a note onto each one indicating how it deviates from the correct exposure reading. A note such as " +1" would mean the ISO index should be doubled, or set one full stop more than normal, and writing " − ½" would mean the ISO index should be reduced by ½ stop. These increments, +1, −½, or whatever, will be consistent for all film speeds. If, for example, you have checked your system for ISO 64 film and discovered that the film speed should be doubled, the film speed should be also doubled for ISO 25, 400, or any other speed film you may use. By keeping track of the meter's deviance in this way, you can change to different-speed films without having to recheck the camera's meter.

Converting a Reflected- to an Incident-Light Meter

Until you become sophisticated in interpreting reflected-light readings, you may want to check your reflected-light readings against incident-light readings to analyze why they are identical or differ from one another. Several manufacturers sell detached incident-light exposure meters that are excellent, but they cost a minimum of one hundred dollars and are another item to carry around and keep track of in the field. You can convert your camera's reflected-light TTL meter to an incident-light meter easily and cheaply by using an accessory available from camera stores for less than thirty dollars. This device looks like a translucent lens cap. You just snap it in, stand in the subject's position (or in an identical lighting condition), turn your camera toward what will be the camera position, and presto!—you have an incident-light reading.

I gave one-half stop more exposure to this picture of a coot in the fog than was indicated by my reflected-light reading. I wanted the picture to look high-key with light-toned fog in the background instead of the middle-gray gloom that would have resulted from the meter's recommendation.

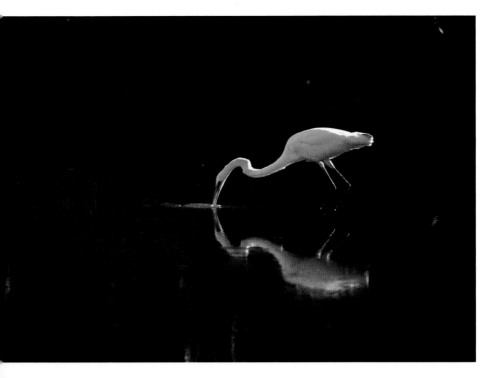

This egret shown drinking water from a dark pond against a dark background is an excellent example of a low-key picture. I based my exposure on a corollary of the sunny f/16 rule instead of on a reading from my TTL meter. A reflected-light reading would have indicated too much exposure, thereby rendering the background a middle-toned gray or brown and the bird a burned-out white. My exposure was f/8 at 1/125 sec. on Kodachrome 64, using a 70–210mm zoom lens.

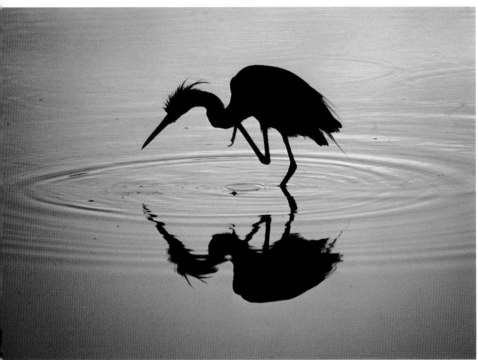

This bird silhouette was exposed for a middle-toned background. When I want to make a background look middle-toned, I expose a scene as recommended by a reflected-light reading.

The Styrofoam Cup Method. There is an even cheaper way to convert a reflected-light TTL system to read incident light: a Styrofoam cup placed over the camera lens. To test the accuracy of your plastic-cup method, take your camera, lens, and cup out into bright sun. You know what your exposure should be in bright sun—it is written down on the inside of every film box—and you have already calibrated your exposure meter for accuracy. For ISO 64 film the correct exposure is 1/125 sec. at *f*/11. With aperture-preferred systems, set the aperture at *f*/11 and point the camera, with the Styrofoam cup over the lens, toward the sun. Keep the camera horizontally true, with the lens axis parallel to the ground. If your shutter speed reading is 1/125 sec., your system is completely in sync for both reflected-light and incident-light readings.

If the shutter-speed reading is different from 1/125 sec., you can still consistently extrapolate from whatever readings you obtain. For example, if the shutter speed reads 1/60 sec., you know that your incident-light reading using the cup is one stop lower than it should be; thus, you should always compensate by one stop for incident-light readings. In other words, you should stop down one full *f*-stop or decrease the shutter speed one full increment if you are using an incident-light reading to determine exposure. If the shutter speed reads 1/250 sec., you know that your incident-light reading will always be one stop higher than it should be. In this case, you should open up by one full *f*-number, or double the shutter speed.

Test all your lenses with the Styrofoam cup just to be sure that you are getting consistent incident-light readings with each different optic. If you aren't, tape a small note reading "+1," "+1½," "−1," or whatever correction is relevant to the appropriate lenses so you won't have to rely on memory when you're out shooting.

The Sunny *f*/16 Rule

In bright sun you don't really need a meter at all. A very handy rule of thumb called the *sunny f/16* rule can determine your exposures for you. Sunny *f*/16 means that for average-toned subjects, the correct exposure in bright sun is the reciprocal of the film speed at an aperture of *f*/16. Thus, the exposure for ISO 25 film in bright sun is 1/30 sec. (1/25 rounded to the nearest standard shutter speed) at *f*/16. The exposure for ISO

64 film is 1/60 sec. at *f*/16. The exposure for ISO 100 film is 1/125 sec. at *f*/16.

For very light subjects such as white birds, polar bears, or arctic hares, the sunny *f*/16 rule becomes the bright *f*/22 rule: The exposure for such white, bright, subjects in bright sun is 1/30 sec. at *f*/22 for ISO 25 film, 1/60 sec. at *f*/22 for ISO 64 film, and 1/125 sec. at *f*/22 for ISO 100 film. The sunny *f*/16 rule has another important corollary: the dark *f*/12.5 or even *f*/11 rule. For dark subjects such as black bears, otters, and some alligators, the exposure in bright sun is 1/30 sec. at *f*/11 for ISO 25 film, 1/60 sec. at *f*/11 for ISO 64 film, and 1/125 sec. at *f*/11 for ISO 100 film.

Naturally, these rules of thumb shouldn't always be used at these exact shutter speeds and *f*-stops but can also be employed at their equivalents, which you should learn. For your convenience, here's a chart with the equivalent readings at the different *f*-stop/shutter-speed combinations pertaining to ISO 64 film.

TYPICAL OUTDOOR EXPOSURES WITH ISO 64 FILM

Shutter speed (seconds)	Bright f/22 (bright subject)	Sunny f/16 (middle-toned subject)	Dark f/11 (dark subject)
1/4000	*f*/2.8	*f*/2	*f*/1.4
1/2000	*f*/4	*f*/2.8	*f*/2
1/1000	*f*/5.6	*f*/4	*f*/2.8
1/500	*f*/8	*f*/5.6	*f*/4
1/250	*f*/11	*f*/8	*f*/5.6
1/125	*f*/16	*f*/11	*f*/8
1/60	*f*/22	*f*/16	*f*/11
1/30	*f*/32	*f*/22	*f*/16
1/15	*f*/45	*f*/32	*f*/22
1/8		*f*/45	*f*/32
1/4			*f*/45

Metering Your Palm for a Middle Tone

Although you can operate effectively with the sunny *f*/16 rule and its corollaries in bright sun, in other lighting conditions you need an exposure meter. At dawn, at dusk, and for achieving exactly the right exposure in different degrees of overcast, you can't rely on even the most sophisticated and experienced eye

I photographed this baby blue winged teal in a Nebraska pond with a 70–210 zoom lens. I used the sunny *f*/16 rule to determine my exposure: 1/125 sec. at *f*/11 on Koda-chrome 64.

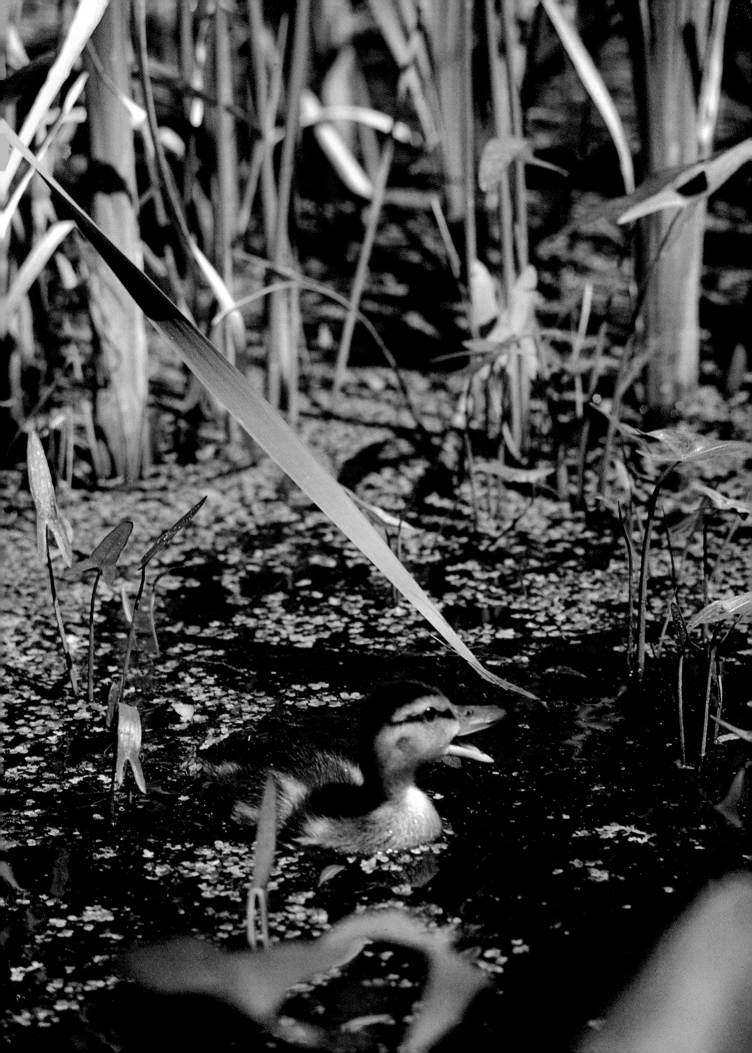

to estimate light levels. For proper exposure in other than bright sunlight, you need to take a reading from a middle-toned part of your subject, or you need to take an incident-light reading.

If you are caught afield without an incident-light meter or a Styrofoam cup, and you are shooting a subject with nary a middle tone in it, you are still in luck. You may not be aware of it, but a middle tone is something you always carry with you: the palm of your hand, which is about one stop brighter than middle tone. Check your exposure meter's readings by metering your palm in exactly the same light as that illuminating your subject. Take a reading of your palm with your lens focused the same way it will be for the picture—don't focus close-up on your palm—and be careful not to let the exposure meter or camera shadow your hand while you are taking a reading. Then give your subject one stop more exposure than your meter indicates. Expose light-colored subjects according to the meter reading, and for very dark subjects, add two stops more exposure.

Standard Exposures for Different Weather

Although finding the correct exposure without an exposure meter can be difficult in different kinds of weather and in low light levels, there are some standard ground rules packaged with your film that are useful. In hazy light, sunny $f/16$ becomes $f/11$; on cloudy days, sunny $f/16$ becomes cloudy $f/8$; in heavy overcast, sunny $f/16$ transforms to dreary $f/5.6$; and for backlit subjects, sunny $f/16$ becomes backlit $f/8$. Here is a chart of these permutations of the sunny $f/16$ rule and its interpolations for various f-stop/shutter-speed combinations.

EXPOSING FOR VARIOUS LIGHTING
CONDITIONS WITH ISO 64 FILM

Seconds	Brilliant	Sunny	Hazy	Cloudy	Dreary
2					$f/64$
1				$f/64$	$f/45$
1/2			$f/64$	$f/45$	$f/32$
1/4		$f/64$	$f/45$	$f/32$	$f/22$
1/8	$f/64$	$f/45$	$f/32$	$f/22$	$f/16$
1/15	$f/45$	$f/32$	$f/22$	$f/16$	$f/11$
1/30	$f/32$	$f/22$	$f/16$	$f/11$	$f/8$
1/60	$f/22$	$f/16$	$f/11$	$f/8$	$f/5.6$
1/125	$f/16$	$f/11$	$f/8$	$f/5.6$	$f/4$
1/250	$f/11$	$f/8$	$f/5.6$	$f/4$	$f/2.8$
1/500	$f/8$	$f/5.6$	$f/4$	$f/2.8$	$f/2$
1/1000	$f/5.6$	$f/4$	$f/2.8$	$f/2$	$f/1.4$
1/2000	$f/4$	$f/2.8$	$f/2$	$f/1.4$	$f/1$
1/4000	$f/2.8$	$f/2$	$f/1.4$	$f/1$	$f/.7$

Using Electronic Flash

When I work with electronic flash, I generally use the standard guide-number method to calculate the flash exposure, or I use the flash dial on the flash unit. (Doing closeup work with flash requires a different approach to calculating exposure; see "Closeup Photography" in the appendix.) The guide-number method works quite well. First, you measure or estimate the camera-to-subject distance in feet, and you divide this number into the guide number on your flash unit to get the right aperture. When you are using flash in daylight to fill in shaded subject areas, close down your aperture one stop. Then, using this aperture, decide what shutter speed you need for the right exposure.

Be sure to check the resulting aperture/shutter-speed combination against the fastest shutter speed synchronized for electronic flash on your camera. You can't use a shutter speed faster than that for which your camera is flash-synced (usually 1/60 or 1/125 sec. for 35mm SLRs). If the shutter speed you come up with using the guide-number method is too high for your system's sync, you'll have to cut down on the flash

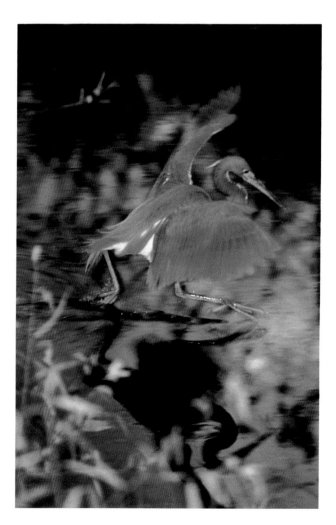

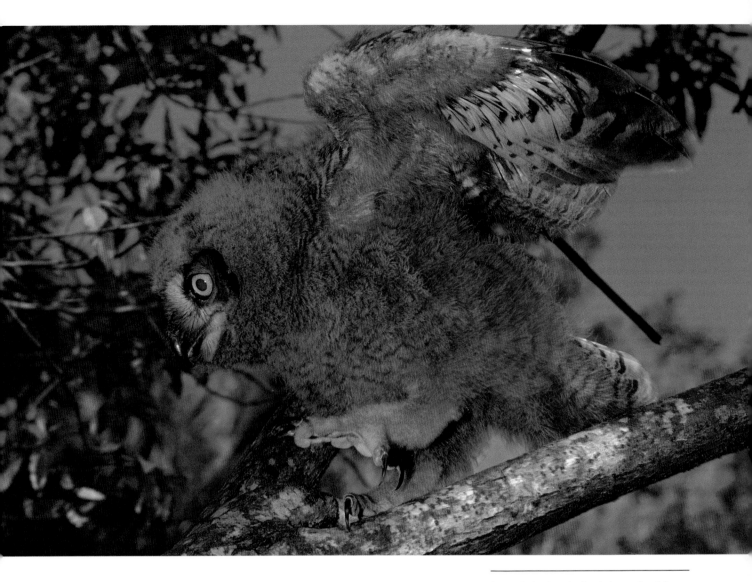

I used electronic flash to make this picture of a young horned owl at a nature center in south Florida. I determined my exposure according to the guide number on the on-camera Heiland flash unit. The exposure was 1/60 sec. at ƒ/8 on Kodachrome 64.

I set my Vivitar 283 electronic flash unit on manual to make this shot of a speeding tricolored heron in the Everglades. First I determined the correct exposure for the ambient light and arrived at an exposure of 1/60 sec. at ƒ/8 for the background. This aperture allowed just enough light from the flash to stop the bird's action (of course, the bird was at rest when I decided on the exposure and made the camera settings). I couldn't have directed better action—the bird took to its heels, and with a slight assist from its flapping wings, it sped across the water.

output, either by reducing the power if your unit has such a control, putting gauze or tissue over the flash head to cut down on the light, or moving the flash back from the camera's position if you're using a flash unit off-camera.

The Color of Light

Light is usually red, orange, or yellow at sunrise and sunset because it passes through much more of the earth's atmosphere than when the sun is overhead. Haze and air pollution also increase its warm color. Photographs made with this kind of light add a dramatic dimension to their subjects. For example, silhouetting birds against a sunset sky is one of the most common compositions in nature photography. How you calculate this type of exposure depends in part on what focal-length lens you use, and this in turn determines the size of the sun in the picture. If you are including a large image of the sun in your photograph, you should usually take a reading of the sky excluding the sun in order to determine the exposure. When the sun image is very large, including it in your exposure reading will produce a middle-toned sun and a very underexposed sky.

You can get wonderful warm-toned pictures of animals and the landscape at sunrise and sunset without picturing the sun itself. At that time of day, shadows look bluer because of the color contrast between the skylight illuminating them and the warm, direct light from the sun. The best way to learn what kind of light is most appropriate for your subject is to observe how the color of light changes from early to late in the day. Make notes of what you see and key your lighting conditions to the exact times you take photographs.

The low light at dawn and dusk makes the wide apertures of many long EDIF lenses invaluable. EDIF lenses provide an extra 1–1½ stops that allow you to use a slower, sharper film and still get the picture. Unlike the contrasty lighting at sunrise and sunset, the light at dawn and dusk is very flat because the whole sky is acting as the light source. I sometimes combine flash with ambient light at these times in order to achieve special effects. I set my exposure for the ambient light and use an aperture that would be one-half the correct exposure if my flash were the only light source.

Haze, Fog, and Overcast. Color film is very sensitive to blue light and to ultraviolet light. Because water droplets in the atmosphere reflect blue, your pictures will have a bluer-than-normal cast when it is foggy or hazy. (An exception occurs when the haze results from particulate matter other than water droplets, such as air pollution. Then the light's color will be yellower than normal.) Foggy conditions call for an increase in exposure beyond what the reflected-light meter indicates. I suggest that you bracket your shots, giving ½–1 stop extra exposure; after processing your film, you can decide which exposure you prefer.

The light on heavily overcast days is considerably bluer than the light on bright sunny days. The contrast between tonalities is also weaker because the main light source is the entire overcast sky, not the small disk of the sun. If your subject is middle-toned, you can expose according to your reflected-light meter's reading. If your subject is light in tone, for a high-key rendition you'll want to give it more exposure than indicated by the meter. If your subject is dark in tone, giving it less exposure than indicated by a reflected-light reading will result in a low-key interpretation.

The sun had set and night was almost upon us when I made this picture of egrets in an Everglades pond. I chose my aperture based on the right exposure using an electronic flash. My guide number was 90 feet and I was using Kodachrome 64. Because the birds were white, I wanted to give the scene one stop less exposure than normal. I set the camera on aperture preferred to achieve background tone. The exposure was longer than one second.

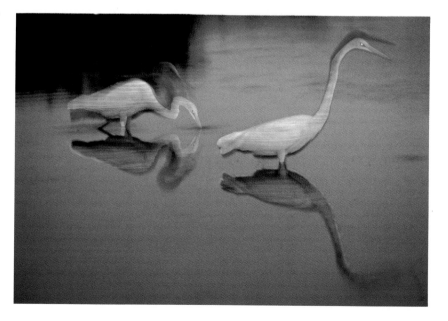

The sun is fairly small in this 200mm-lens picture of a sunset and a flock of ibis, and I exposed the scene as indicated by a reflected-light reading: 1/250 sec. at ƒ/11 on Kodachrome 64.

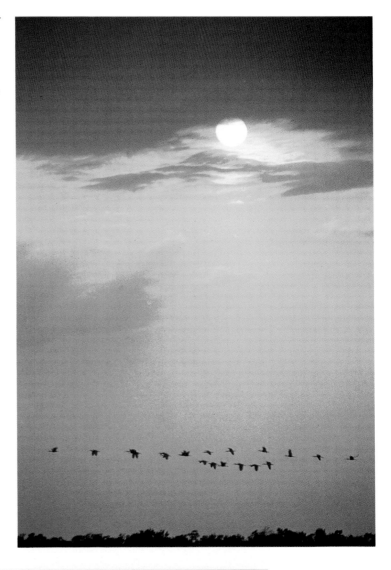

I made this shot of an egret at dusk in much less light than most people think is necessary for photography. The picture's deep blue color comes from the last light of a blue sky. My exposure was 1/30 sec. at ƒ/11.

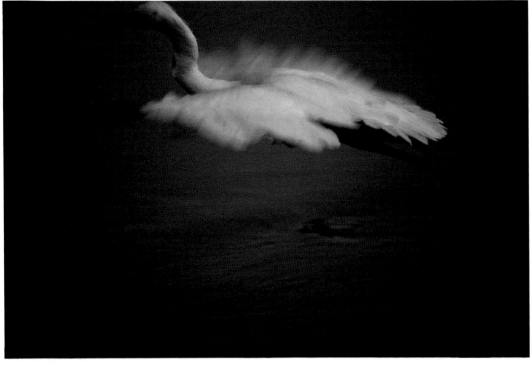

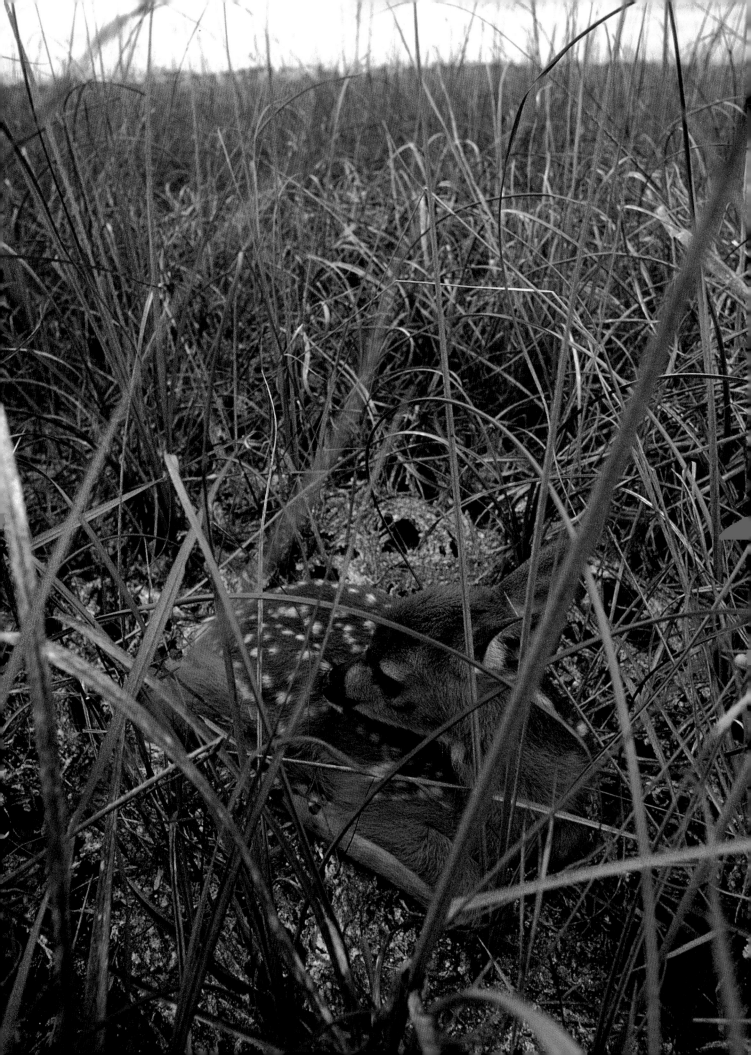

Chapter Three

COMPOSITION

Every photographer using a manual 35mm SLR has essentially the same camera controls for manipulating exposure, and many of the same potential compositions are accessible to everyone. The basic elements of photographing wildlife are universal: You choose a shutter speed to stop or blur motion. You select an aperture, which is an important part of controlling the depth or field, or area of sharp detail, in the photograph. You either hold the camera rock steady during the exposure, or you pan it along with the action, thereby keeping the subject sharp and blurring the background. You pick the focal length of your lens, the camera angle, the camera-to-subject working distance, the time of day, and how you place the subject elements in the frame. The compound of all these choices adds up to your personal style, something that distinguishes your pictures from those of all the other photographers in the world.

Showing Motion

One of the most important decisions to make about photographing a moving subject is what shutter speed to use. A fast shutter speed, such as 1/500 sec., arrests motion; a slow speed, such as 1/30 sec., renders it blurred. How fast a speed is needed to stop an action depends on several factors: the speed of the action, its distance and angle in relation to the camera, and the focal-length lens you use. Under the following circumstances, you should usually employ the fastest shutter speed possible to freeze an animal's action on film: your subject is moving fast and close to the camera, the direction of its motion is practically parallel to the film plane, or you're using a long focal-length lens. Obviously, deciding on the ideal shutter speed isn't always easy. And a shutter speed can't be considered in isolation because it must be combined with one particular aperture to deliver the right exposure.

Putting the horizon high in the frame forces the eye to move down across the earth. This picture also makes the eye to do a little detective work before focusing on the fawn hidden in tall grass.

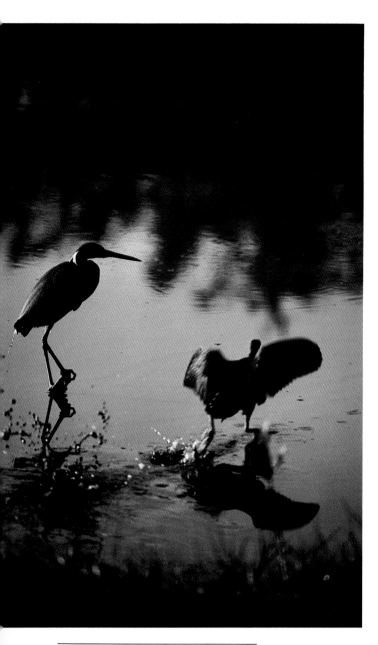

Accumulated experience will ultimately be your best guide. Meanwhile, you are welcome to use the following table showing the shutter speeds necessary for stopping a subject's motion as it crosses your view parallel to the film plane. This table is for 200mm lenses. For longer lenses use the next-fastest shutter speed each time you double the focal length of the lens. For shorter lenses use the next-slowest shutter speed each time you halve the focal length.

SHUTTER SPEEDS TO STOP ACTION
THAT IS PARALLEL TO THE CAMERA

Miles per Hour	Camera to Subject Distance in Feet			
	10	25	50	100
	Shutter Speeds in Seconds			
2	1/1000	1/500	1/250	1/125
4	1/2000	1/1000	1/500	1/250
8	1/4000	1/2000	1/1000	1/500
15		1/4000	1/2000	1/1000
30			1/4000	1/2000
60				1/4000

At first glance, the high speeds indicated on this table may seem discouraging, but when you consider that 1/500 sec. was the highest shutter speed I used for any of the birds in motion that you see in this chapter (and many of them were shot at 1/250 sec.), you should take heart.

I was focused on the bird perched on the stick when this moorhen dashed past. I was using a 300mm F4.5 IF lens, and the exposure was preset for 1/250 sec. at *f*/8 in bright morning sunlight.

The very blurred appearance of this tricolored heron in flight comes from using a slow shutter speed of 1/15 sec. while panning the camera along with the motion. I was shooting with a 300mm F/4.5 IF lens set at *f*/22, and my film was Kodachrome 64.

Panning Your Subject for Sharp Focus

Panning a moving subject, such as a running antelope or a flying bird, means moving the camera to follow the subject while you make your exposure. The background and foreground of your picture will be blurred by the panning action and thus create a dramatic feeling of movement, but your subject will ideally be in focus. It is easiest to pan along with a subject when its path is predictable or repetitive—for example, when a bird approaches its nest from a particular direction. However, it is very difficult to follow a subject and stay in focus, even when you have gear specifically designed for the purpose.

When your subject moves in a predictable pattern, prefocus an anticipated shot for a specific distance or place in the landscape. Then pan your subject as it moves toward this spot—the subject will be out of focus during the approach—and shoot when the subject reaches it and is in focus. You can use a slower shutter speed when you're panning than when you want to stop your subject's action with the camera fixed in place. It is sometimes possible to pan with the camera on a tripod if you are using a ball head and the head is not locked.

Designing a Wildlife Photograph

Good composition is based on the same basic principles regardless of whether you're working with animals or with inanimate subjects. However, the way a wildlife photograph is designed is often not nearly as compelling as the action or the degree of animation in the subject. A picture of a snarling cougar can enthrall a viewer no matter how the picture was composed.

I panned the camera to follow this cormorant as it flew past the red mangroves where a breeding colony was located. The exposure was 1/30 sec. at f/16 on Kodachrome 64.

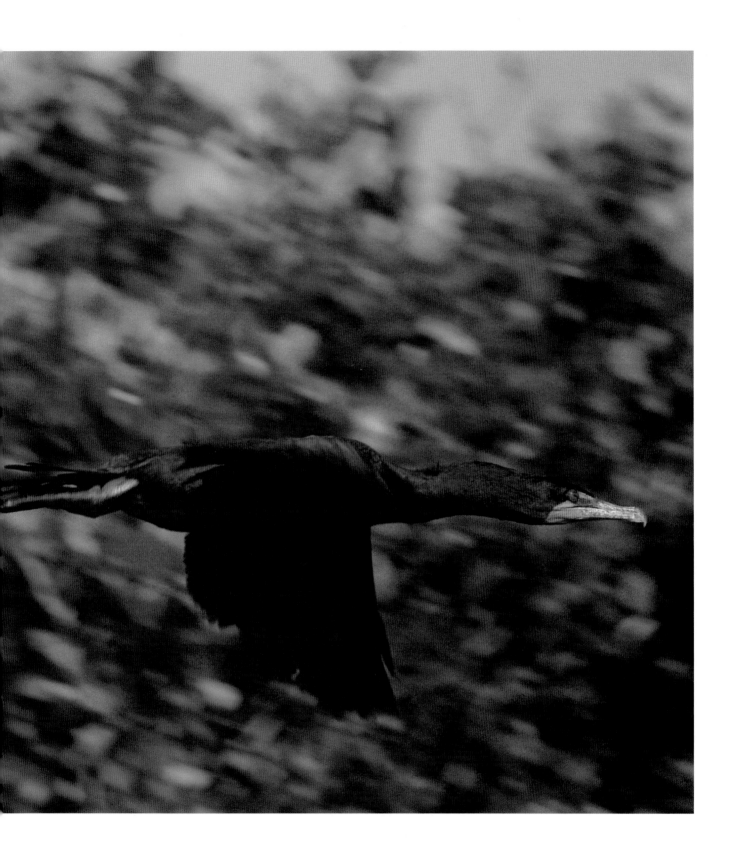

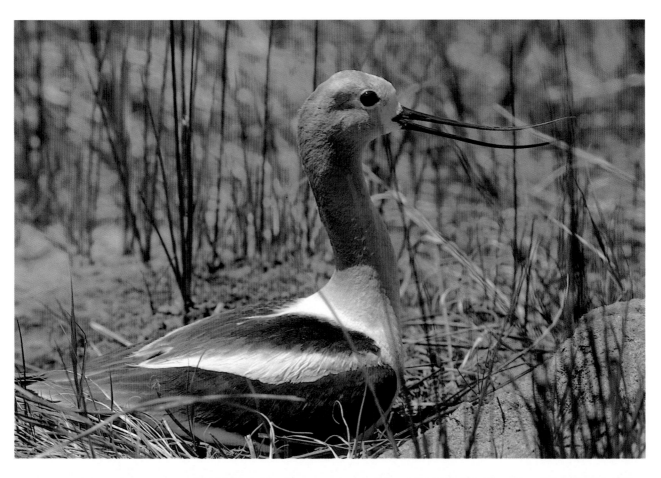

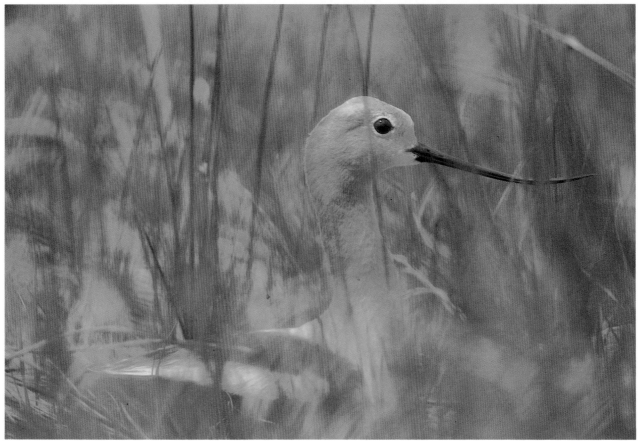

This lack of discrimination on the viewer's part is fortunate as far as the wildlife photographer is concerned. The conditions surrounding wildlife photography often make aesthetics take a back seat compared to the difficulty of simply capturing the animals on film. Nonetheless, the wildlife photographer must still make some critical choices about composition.

Depth of Field. Chief among these is your decision about depth of field, or how much of the picture will be in sharp focus. Once you have selected your lens and working distance, the aperture controls your depth of field. To achieve maximum depth of field, use a small aperture. This will bring distant as well as nearby objects into sharp focus. For a more selective range of focus, open the lens up, which means use a wide aperture. Sharp detail will only appear around your point of focus within the range specified by your choice of aperture.

Camera Angles. Exploring different camera angles is also very important and is one of the easiest ways to start taking better pictures. Finding a new camera angle is often the solution to what may seem like a deadend problem in composing a photograph. Unfortunately, many beginning photographers overlook this simple step. When you're working around water, don't ignore the possible reflections of your subjects; try to angle your camera to include some of these fantastic shapes if they are present.

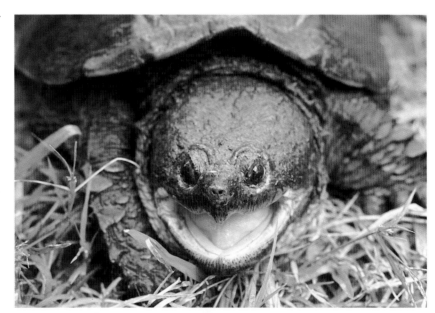

The pictures on the left of an avocet on its nest were taken with the smallest and largest apertures possible on my 300mm lens. I shot the top picture for ⅛ sec. at ƒ/32 on Kodachrome 64 to create the greatest depth of field possible. In the bottom picture, exposed for 1/250 sec. at ƒ/5.6, everything but the bird is out of focus. I didn't shoot with the lens totally wide open because that usually degrades image sharpness.

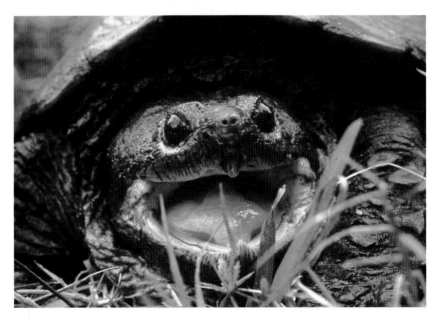

Beginners don't usually explore the many possibilities offered by different camera angles, instead opting to shoot from eye level when standing. These pictures of a snapping turtle demonstrate the common error of that strategy. The top picture is an example of how not to photograph animals by aiming down at them from an above position. The other picture shows a better camera angle, achieved by bringing the camera to the subject's own height and shooting straight at it. To do this I lay prone on the ground. Using a right-angle viewfinder made it easier to focus the camera while at ground level. An assistant behind the turtle kept her from turning and walking off. It was springtime, and the turtle was on dry land scouting for a good location to lay her eggs.

Most people know the approximate size of the animals we photograph; however, serpents, reptiles, and insects are exceptions. The grand-canyon king snake, shown here slithering across the sand, looks like a huge, formidable serpent. But when you see it juxtaposed with someone's arm and camera in the other picture, you realize its actual size, which comes as a surprise.

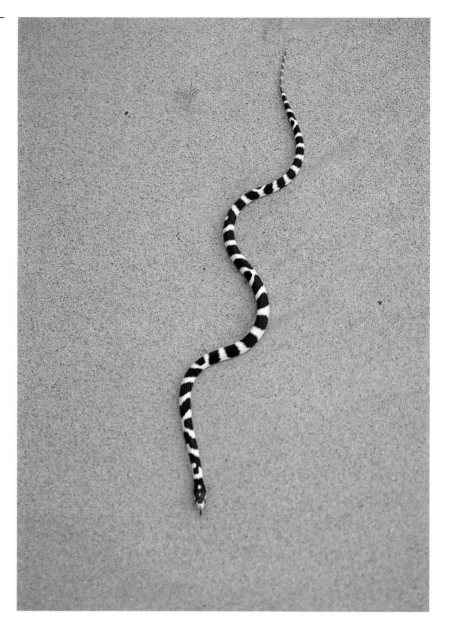

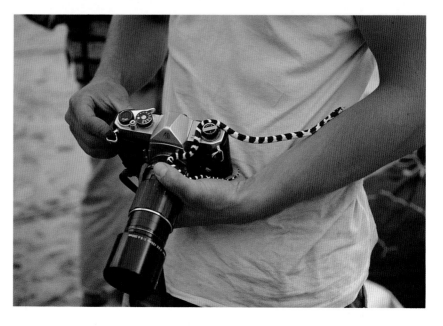

Scale. You can introduce scale into a picture by including an object of known size inside the picture frame. This is especially helpful in scientific photography where the viewer needs to have an immediate grasp of the subject's true dimensions; however, in most creative nature work scale is a secondary consideration, unless for some reason you want to show how small or large your subject is.

The Rule of Thirds. Line, shape, texture, pattern, and color are the building blocks of photographic design. The way you organize these elements determines how you compose a picture, and this process is probably the most important aspect of your personal style.

The most helpful compositional guideline is the rule of thirds, which states that the picture should be divided into thirds vertically and horizontally. According to this rule, you should place the picture's center of interest at one of the intersections of the vertical and horizontal lines.

Another important decision concerns where to place the horizon. Placing it high or low in the frame generates a pleasant tension by drawing the eye to the larger area. This is generally less confusing to the eye than a horizon located in the middle of the picture. For more dramatic results you can put the horizon even higher or lower than the rule of thirds indicates.

Balancing the strong elements in the picture is a further consideration. Empty space can balance the weight of a solid form, a vivid color can offset a dull, monochromatic color scheme, and a deeply textured surface can lend contrast to a smooth glossy one. The rule of thirds can help you in deciding where to put these elements in relation to one another, but remember—this rule, like any other idea about design, is only effective as long as it doesn't hinder your creative process or keep you from recording an animal on film. Sometimes breaking a rule can lead you to a breakthrough in your photographic vision—and that's what a powerfully composed picture is all about.

I put the horizon line almost at the top of this picture to show that the world is indeed flat, at least according to this soft-shelled turtle. Where you put the horizon always influences a picture's scope and, therefore, its mood.

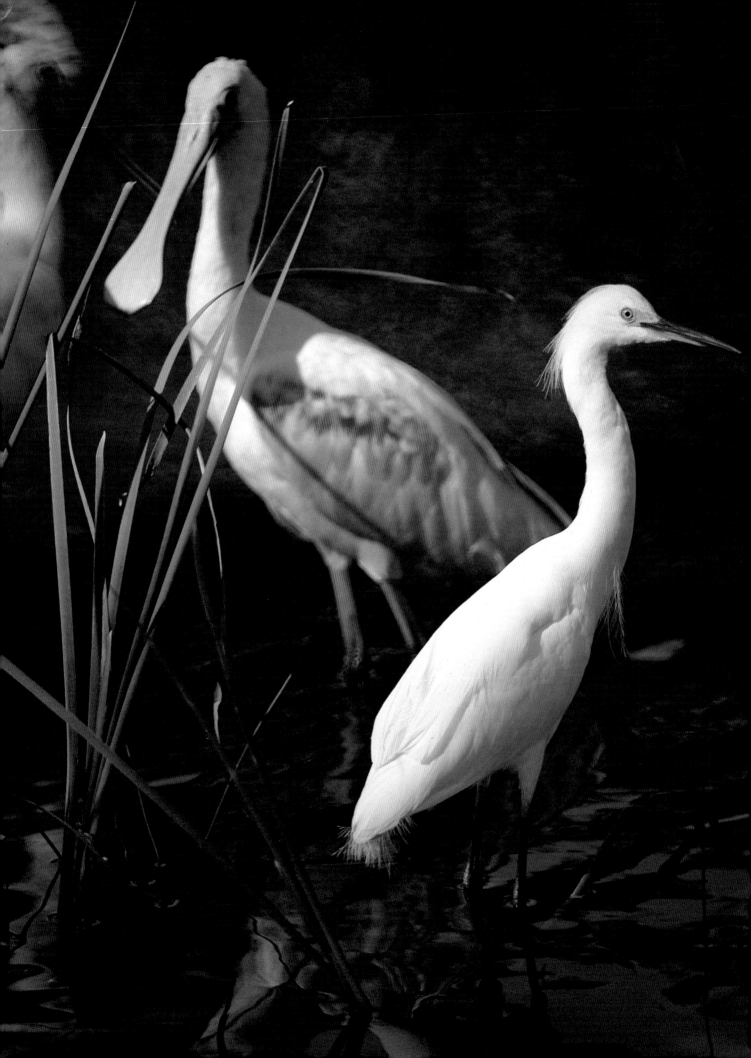

Chapter Four

BIRDS

The behavior of wild birds varies as much as their appearance. Their behavioral differences don't follow any generalizations we might draw from the birds' taxonomic status, their sizes, habits, or looks. For example, red-winged blackbirds and yellow-headed blackbirds are closely related. They look somewhat alike and neither is hunted or intentionally harassed by people. Yet, in my experience, the red-winged blackbird is much easier to approach and photograph than the yellow-headed species. Big behavioral differences also exist between individual birds of the same species. Individual birds are comfortable with different working distances and react differently from day to day, depending on varying weather conditions and the season.

Protecting Birds from Your Approach

You can often come close enough on foot to take good pictures of birds that are ardent nest defenders. But the number of species you can approach in such a direct way is limited. Most birds will flee out of camera range when you come near their nests. Some birds are known to desert their nests if they see a person walking within a quarter mile. You are assuming a big responsibility when you photograph wildlife. Ethics demand that you read all you can find about a bird species, especially regarding its tolerance for people, before tackling it with photography.

If you think that your proximity is causing any bird to leave its nest, immediately withdraw. Retreat to a safe distance: perhaps a hundred yards away with some birds, or a hundred feet with others. Using binoculars, watch the area of the nest to be sure that the bird returns. You should always forgo a photography project rather than sacrifice a subject. No creature should have to pay with its life for our interest in it. A bird's eggs and unfeathered young are very vulnerable. In direct sun, the eggs may quickly overheat, killing the embryos. Cold can kill them, too, so be careful not to spook their parents into leaving their nests on chilly, overcast days.

Bird Sanctuaries in the Everglades. The easiest places to photograph birds are areas that are well trafficked by humans but allow no human interference with the wild residents. Outstanding examples of such locations exist in southern Florida in the Everglades National Park.

Anhinga Trail, Mrazek Pond, and Eco Pond in the Everglades are immensely popular with bird watchers and bird photographers because of the unusual number of birds in evidence. Birds flock to these sanctuaries because they offer good supplies of food during critical times of the year when food is scarce and because the birds are never hunted or harassed. An important feature of Anhinga Trail is its boardwalk

The tannin dissolved in southern swamp waters makes them the color of strong tea, a good dark background color for such wading subjects as spoonbills and snowy egrets. I was in a blind when I exposed these two birds for 1/250 sec. at f/11, according to the brilliant f/22 corollary to the sunny f/16 rule.

across Taylor Slough. People must stay on the boardwalk, so the birds become accustomed to and comfortable with this limited human contact.

Traveling to Florida to photograph at Anhinga Trail won't automatically produce remarkable pictures. Even there you must move slowly, softly, and be prepared to dedicate hours and days to your photography. Luck also plays a part.

I've spent many full days from predawn to dark photographing at Anhinga Trail. In late winter and early spring many anhinga, the birds for which the trail is named, frequent the waters and trees along the winding trail. At least three or four pairs of anhinga nest there within reach of a long lens. Anhinga swim underwater to fish. Afterward, they always climb up onto a bank or low tree limb to dry their saturated feathers before taking flight. Such protected areas are heavenly for birds and photographers alike.

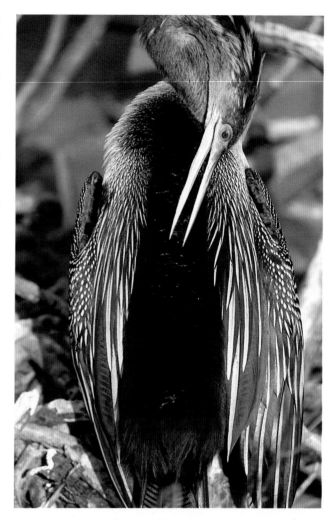

I was about forty feet away when the anhinga in these photographs climbed out of the water onto a bank near the boardwalk. At its closest point, the trail I was on passed within seven or eight feet of the bird. By walking on the part of the trail farthest from the bird, I was able to stay out of its sight until I was right behind it.

At that point I walked a few paces closer, just close enough to see the entire bird, and I began to take pictures. The anhinga spread its wings, preened, and struck various attitudes while staring in different directions. When it wasn't looking in my direction, I inched forward. Finally, I was within eight or ten feet of it and still taking pictures. Incredibly, the bird showed no signs of nervousness and no inclination to move. I worked mostly with 300mm and 500mm lenses and also took a few pictures with my standard 55mm and my 105mm lenses.

I already had my 500mm lens on one camera mounted on a tripod. Then I decided to use my 300mm lens, so I mounted it on another camera body and steadied it as best as I could atop the tripod-mounted camera. I was able to take pictures of this bird for at least ten minutes, an amazingly long time considering that I was by then in plain sight.

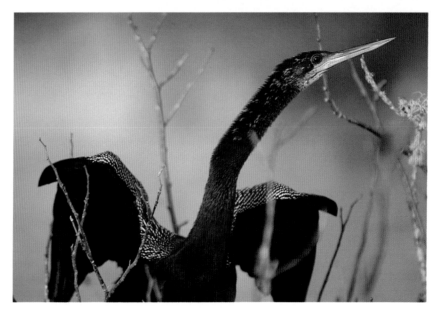

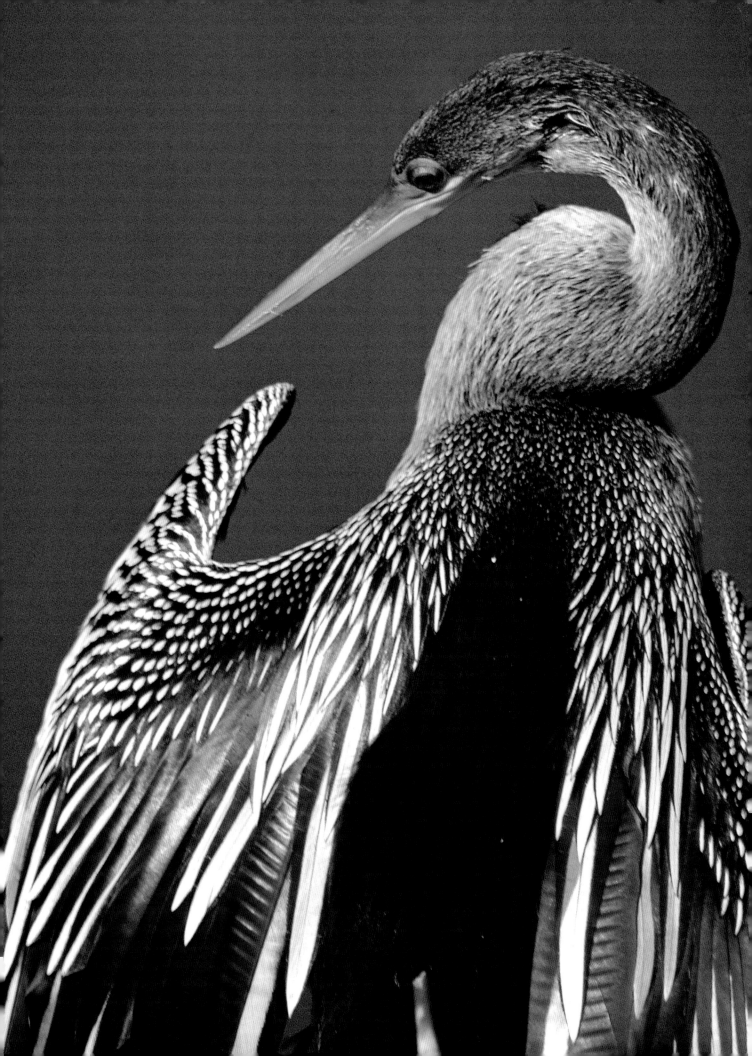

Using a Blind for Camouflage

Avian eyesight is remarkable. Birds can see in color, and they see far more sharply than we do. Think for a moment about the feeding behavior of such birds as hawks and buzzards. Both species cruise high in the sky, riding air currents thousands of feet above the ground as they scan the scene below them for food. From this height they can spot carrion or potential prey that are camouflaged in color and pattern. Now *that* is good eyesight.

Compared to most mammals, birds have an inferior sense of smell, and their hearing, while acute, is quite different. Birds seemed tuned in to the calls of other birds, and yet, unlike mammals, they frequently ignore man-made noises.

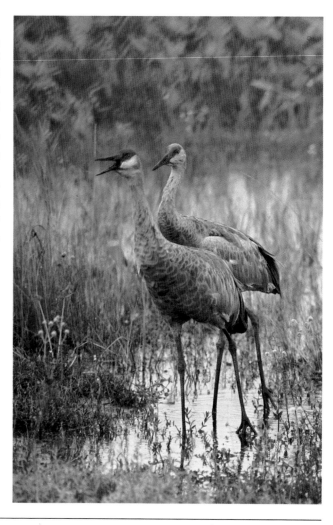

I had wanted to take pictures of sandhill cranes for a long time before I took these. They are very wary birds, especially when mating, nesting, and caring for their single offspring. A young sandhill crane stays with its permanently mated parents for much of its first year. I had read everything written about sandhill cranes, and I had talked to several ornithologists about them. The essence of what I learned is that they are extremely difficult to approach, they nest alone in remote areas, and that trying to photograph a nest would probably cause the birds to desert it.

Naturally, I decided not to try locating or photographing any crane nests; in fact, I dismissed the possibility of photographing any cranes at all. Then one day my friend Bill Piper, who is a Florida cattle rancher and wild-animal expert, mentioned that a pair of cranes and their off-spring returned every autumn to one of his pastures. For the last ten years, these cranes had appeared for three or four months a year around 8:00 AM when he put corn out to feed them. It was the same pair every year, he said, and they always had a new offspring. He wondered if I would like to photograph them.

I quickly accepted his offer of help, popped into his pickup, and proceeded with him to the pasture. As I surveyed the scene, we were immediately surrounded by a herd of horned and humpbacked cattle. We left the pickup and climbed over a fence into another pasture. About fifty feet away was a high-fenced corral. We climbed into and then out of it. On the other side was another barbed wire fence. Fifty feet beyond it in a boggy area was where Bill scattered the corn every morning for the big birds.

I had a portable blind with me, but Bill thought it would be better to make a blind using palmetto fans for camouflage. Palmettos were commonplace to the birds, and Bill thought the fans would cause less suspicion than an unfamiliar object. He nailed some boards together and tacked some palmetto fronds on them to hide me. The blind was fairly small and not very high. Seated inside it on the ground, I had only an inch or two of blind above me. Still, there was room to set up an unextended tripod and a camera mounted with my 640mm Novoflex Follow-Focus lens. The front of the lens didn't extend beyond the palmetto fans, which was my main requirement.

I asked Bill if he knew what time the birds arrived at the pasture each morning. Were they waiting when he got there? Did they fly in after he put out the corn? If so, how much later?

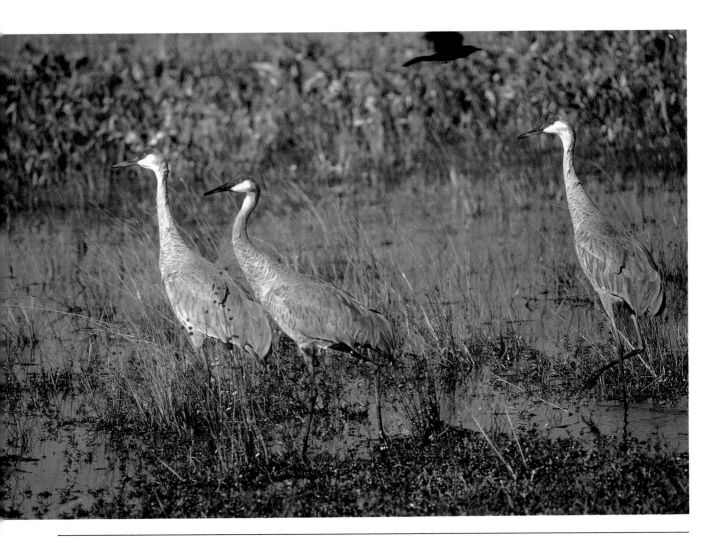

Bill thought the birds timed their arrival to coincide with his at 8:00 AM on the dot. I calculated that If I were there by 7:30 AM, I would have plenty of time to enter the blind before they arrived. My lack of room in the blind didn't seem to be a problem because I didn't plan to spend more than an hour on it.

The next morning, I unlocked the first gate about 7:15 AM. I drove down the lane to the second gate. Inside, I left my car where Bill had parked his, glared at the cattle, then walked to the first fence toting all my equipment. I climbed that fence, crossed the corral, and walked on to my blind.

As I was climbing the second fence on the far side of the corral, I heard the unmistakable call of the cranes. Alternately and synchronously, the adults cried out. I looked off to my right—there they were, the three of them, eyeing me

suspiciously. I entered my blind anyway. When Bill arrived a half hour later, he cast out the corn and left. I stayed in the blind for about an hour and a half, but the birds wouldn't approach. Obviously, I needed to be there earlier if I were going to fool those birds.

Every day I tried coming earlier and earlier, but somehow they always managed to be there first. One chilly morning I found myself crawling into the blind at 3:00 AM, long before the first light of day. By now I had added a flashlight, a blanket, and a sandwich to my gear. Also, I had begun dressing as much as possible like Bill, and I was practicing trying to walk like him. I was sleepy that morning, but I was also smug because I was certain I had finally beaten the birds to the feeding site. I was about ten feet from my blind when I heard them calling at the top

of their lungs from a position several hundred feet out in the pasture. And at that point I gave up.

I crawled into the blind anyway, and took a nap. When Bill arrived, I went out to greet him and walked with him while he strewed the corn. When he finished, he walked me back to my blind, and I got back into it. That morning, the birds finally fed on the corn while I was in the blind, and this picture is one of the many I took of them. I don't kid myself that we fooled the birds by Bill walking me to the blind and then leaving—cranes are wary and smart. I believe they were perfectly aware of me in the blind but had become sufficiently familiar with me to eat the corn anyway. They frequently looked toward the blind and called out a lot, much more than they would have if I hadn't been there. Ultimately, though, my patience had paid off in pictures.

Out of Sight is Out of Mind. Because birds see so extraordinarily well, they have evolved relying on their eyesight to protect them from danger. What they can't see doesn't bother them, which is most fortunate for those of us interested in studying and photographing them. Serious wildlife photographers use *blinds* (or *hides*, as the English call them) to camouflage themselves from their subjects when doing bird photography. Broadly defined as any lightly built structure that hides a photographer or hunter, blinds are the bird photographer's best friend.

The first nineteenth-century nature photographers who trod the woods, shores, and fields believed they had to make their blinds look like a natural formation or even like an animal. They spent a lot of time carefully building blinds that looked like trees, rocks, and occasionally cows. Today it is clear that such efforts aren't necessary. Most birds will accept almost any structure or device that completely hides the photographer as long as the blind doesn't flap or bend in the wind and as long as the birds don't know that anyone is inside.

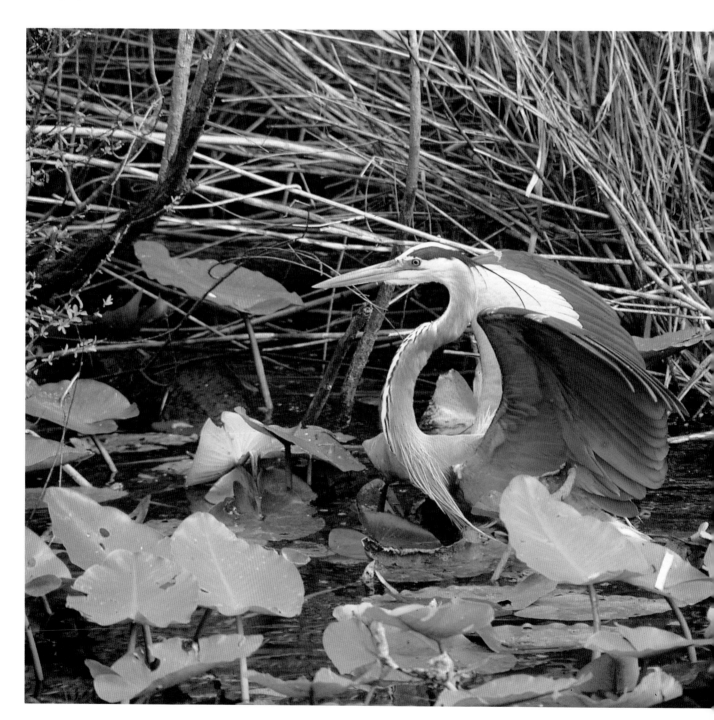

Sometimes photographers don't need to use blinds in the formal sense; instead, you can use such natural cover as dense bushes or tree branches. You can also make a casual blind by lying beneath a length of camouflage cloth or by placing the cloth over a bush or a natural formation. Another option is to build a blind on the spot, using natural materials with or without additional camouflage material. And sometimes a portable blind or a tent is most useful especially in wide-open spaces or other places where no natural cover already exists.

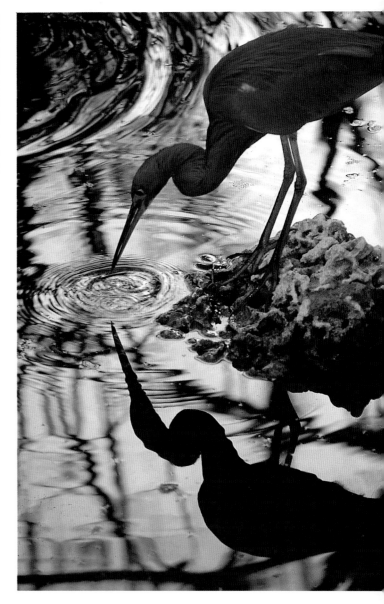

An electronic flash mounted on-camera threw just enough light onto this tricolored heron drinking to bring out some detail in its features but not in its deep black shadow. My exposure was 1/60 sec. at ƒ/5.6 on Kodachrome 64, using a 300mm F4.5 lens.

I tracked this great blue heron as it slowly stalked forward through a marsh. I kept my camera trained on it for at least half an hour and was able to shoot during the fraction of a second when it raised its wings to this unusual position. My exposure was 1/60 sec. at ƒ/5.6 on Kodachrome 64.

Portable Blinds. There are several factors to consider when building or buying a blind or a tent to use as a blind. First, regardless of the lighting conditions, from the outside you should never be able to see anything moving inside the blind. This makes canvas material preferable to burlap, even if the burlap for the blind is several layers thick. Another factor to be conscious of is your own comfort. You should have enough room inside the blind to stretch and even to stand upright if possible. A third consideration is the blind's stability in the wind. Birds are frightened by motion, so make sure all of your equipment is stationary. Nothing on the outside of the blind should ever flap. In windy country I stabilize my blind or tent with guy wires.

I've owned several different portable blinds over the years. The first blind I used extensively was a special pop tent, manufactured by Thermos, that had many strategically placed zippered openings for camera lenses or observation. Thermos no longer makes these tents, but pop tents are still available. A pop tent has a vertical frame of nylon ribs that pop up when depressed, giving the tent a rigid form. If you want to customize a pop tent for picture taking, you can cut slits in the tent and sew in heavy-duty zipper flaps with Velcro fasteners. Before you begin altering the tent, decide what constitutes eye level when you are seated in the blind. Put your camera on a tripod, set it up the way you intend to use it in the blind, and mark the blind material where the lens would intersect it. You'll want to have eye-level openings on opposite sides of the blind or possibly on three or four sides.

You'll also want to use different camera heights. In addition to the eye-level openings for ground seating, you may want to make openings at ground level or at the level of a camera mounted on a tabletop tripod. In practice, vegetation may preclude using the lowest vantage points even with ground-nesting birds. If your blind is tall enough, you might opt to cut some lens portholes at eye level when you're standing.

There are several blinds manufactured especially for photography. Lepp & Associates, P.O. Box 6240, Los Osos, California 93402, makes a blind that is well thought-out for wildlife purposes. Their blind is superior to any tent I've ever used as a blind.

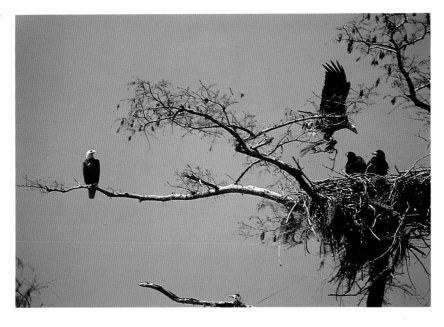

I waited for four days to frame this entire eagle family in one shot. I used a 500mm mirror lens for its reach, and my exposure was 1/250 sec. at *f*/8 on Kodachrome 64.

The extensive depth of field you see in this picture required a small aperture and a fairly long shutter speed that blurred the flying birds' wings. I used a 70–210mm zoom, and my exposure was 1/8 sec. at *f*/22 on Kodachrome 64. Although such aggregations of birds are commonly seen in the Everglades in the spring, being able to approach and photograph them is unusual. They rarely congregate by roads, and their appearance at any one place is unpredictable.

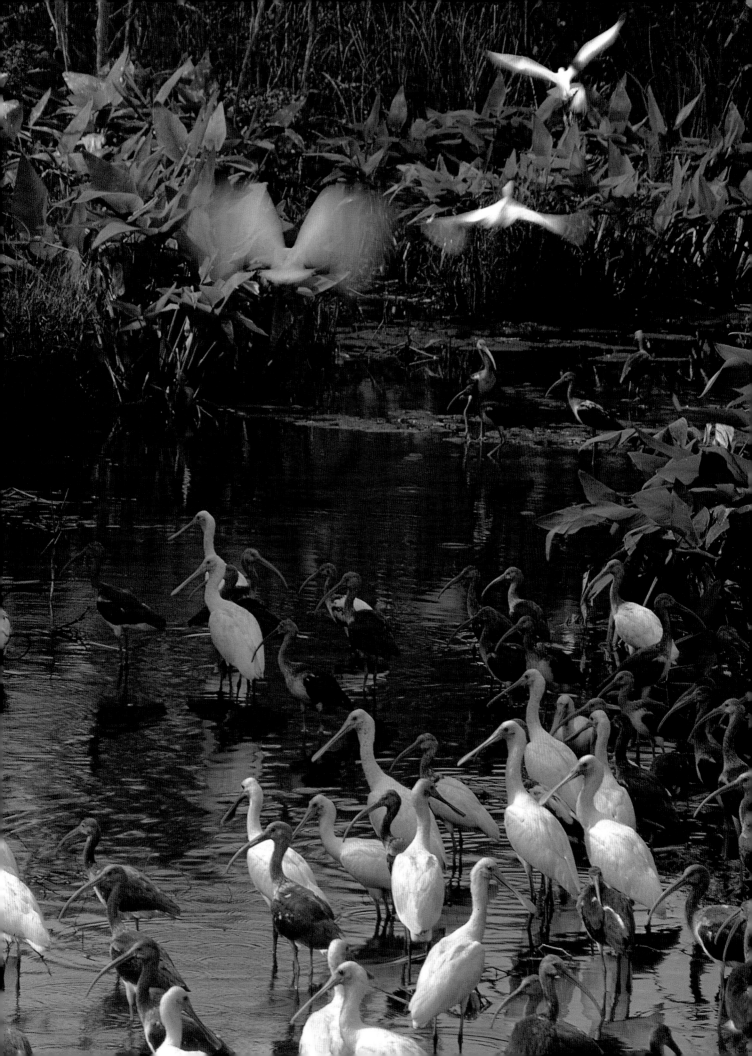

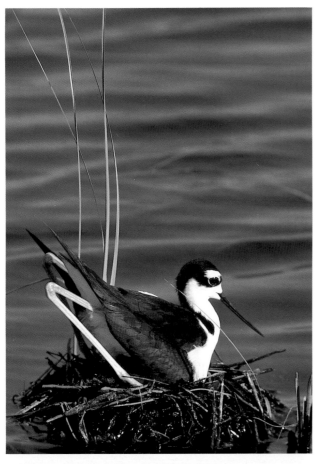
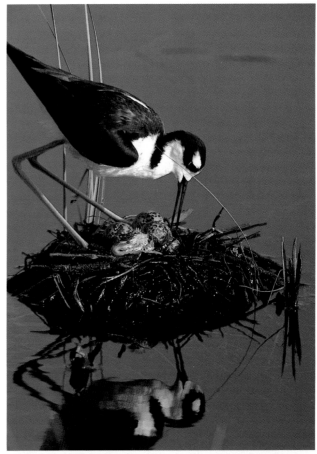
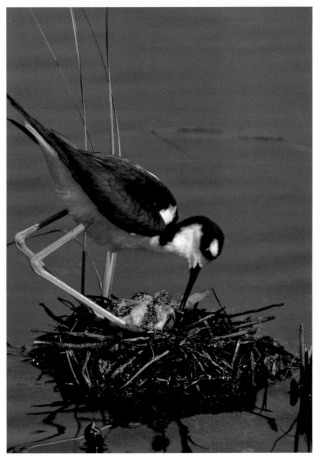
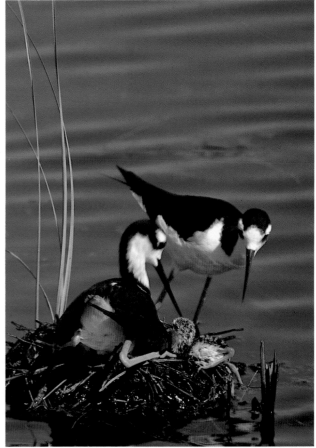

When You Need a Platform. Sometimes you may need to construct a platform to support your blind, for instance, when the birds you want to photograph nest in high treetops. The tree you choose for your platform must be near the nest tree and be able to accommodate it at a level slightly higher than the nest to give you a clear view of it. Without such a tree some photographers build towers of metal tubing for their blinds.

Putting a platform and a blind in place is a tricky business because it must be done when the birds are absent, preferably before the nesting season. Some bird species return to the same nests year after year. Constructing a platform near their nests is relatively simple since it can be erected any time other than during the nesting. For other birds it should usually be done after the eggs hatch, a time when the platform is unlikely to cause the parent birds to desert their young.

Such elaborate preparations shouldn't be undertaken unless you can consistently spare enough time to photograph the birds. It also shouldn't be undertaken if there is any possibility that the birds' safety is compromised. Be absolutely certain that the nesting birds you want to photograph aren't endangered or threatened. Nest photography constitutes harassment and shouldn't be undertaken with rare or endangered creatures.

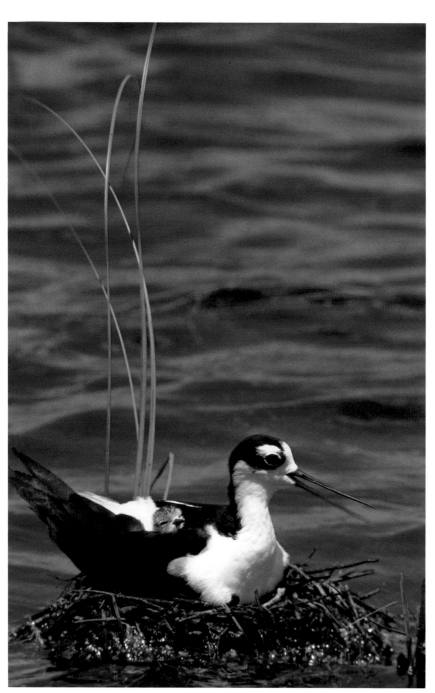

Building a platform for my blind was an essential first step in my photography of these black-necked stilts nesting deep in the Everglades. They build their nests right in the swamp water by constructing a foundation of vegetation that supports their eggs above water level.

The water during their mating season was about eighteen inches deep. I expected to work from my blind for several weeks and knew that setting it up and then sitting in the water would be a disaster—every time I moved, I would have risked dunking my cameras and other equipment. So a friend of mine built a platform for me from 2 × 4's and boards. The platform was about 3½ feet from the ground and had an area of 4 × 4 feet.

I was transported to the blind twice a week for several weeks until it became evident that the eggs were ready to hatch; then I went out every morning for a few days. Stilts are *precocial*, which means that as soon as they are hatched, they are active, down-covered, and able to swim. A stilt nest is empty the day after the eggs hatch, so perfect timing is imperative for capturing the newly hatched offspring on film.

Floating Blinds. Some photographers have made floating blinds from truck-tire inner tubes. These hardy souls wear chest waders to ambulate about in lakes, ponds, and bays, and they have had success coming within a few feet or so of birds feeding or nesting in aquatic vegetation along the shore. I very much want to try this technique the next time I am in a suitable location, say a breeding lake in the prairie states of Nebraska or the Dakotas.

I'd like somehow to incorporate the metal ammunition cases I use for carrying and storing my camera equipment into my floating blind, a practice I've never heard mentioned. When closed, these storage boxes are absolutely air and water tight. (They are available at army surplus stores, and L.L. Bean sells them mail order.) I have visions of getting caught in a stiff breeze and blowing out to the center of the lake, and I would just as soon have my cameras safe and dry in case I have to ditch the blind unexpectedly and then come back for it later by boat.

Using Cars and Trucks as Blinds. You can get much closer to birds if you are in a vehicle than if you are on foot. I've worked alone using this technique, but I believe it would be easier to use a driver as an assistant. The most useful lenses for this technique are 300mm or longer.

When I'm photographing birds from a car, I drive very slowly and try to roll to a stop, rather than braking quickly when I spot a subject. Sometimes I work with the motor running because turning it off might spook the bird; then I don't let my camera touch the car door or window. This helps prevent camera movement caused by the motor's vibration. If I decide to risk turning off the motor, I frequently use the window or door to brace and steady my telephoto lenses.

Cruising country roads slowly is a productive way to look for pictures. I photographed these cattle egrets, gathered around their cow, from my car window by bracing my camera and 300mm lens on the window glass that was partly raised. This exposure —1/250 sec. at ƒ/5.6 on Kodachrome 64—was made on a partly overcast day.

Entering and Leaving a Stationary Blind

When birds are present, you should enter a stationary blind an hour or so before dawn and leave it after dark or else have another person accompany you into the blind and then leave. Most birds will then think that you have also departed. If the birds don't relax and act naturally after your colleague's departure, you may have to add assistants until you reach the highest number to which the birds can count.

Birds Can Count. Different species can keep track of various numbers of people. To fool the more arithmetically able avians, you may have to get help from as many as seven people. Fortunately, very few species can count that high. I've never needed more than one person to help me enter or leave a blind.

Please note that, unless you remain in the blind until well after dark, you must also have help leaving it. If you break this rule, you risk all subsequent photography because the birds may become suspicious of the blind and incapable of relaxing while it is in place.

Colonial Nesting Birds

The birds I've discussed so far are all solitary nesters. Some, such as the blackbirds, are territorial; they chase birds of the same species out of range and proclaim with loud song their intent to defend their territory. Other solitary nesters space themselves widely apart.

Many bird species nest in groups, or colonies. Some colonies are composed of one bird species. Other colonies include birds of several species. Colonial nesting sites can be found high in the treetops, in low bushes, and on the ground. There are bird colonies on the mainland and on islands in freshwater lakes as well as in the sea.

Colonial rookeries vary depending on the personalities and experiences of the birds that compose them and on the physical location of the nests. What follows are accounts of two of my encounters with colonial rookeries, which should help you establish some good ground rules for working with nesting colonies. I will also summarize some other approaches you may want to adopt.

Using Boats as Blinds off a Mangrove Island. You can photograph some colonial rookeries from a boat without ever going ashore. The mangrove rookeries located off Florida and other tropical coasts make photography from a boat essential.

The trees at the edge of the mangrove island I photographed were happily not too tall, so I didn't need any extra elevation to take good pictures; I was able to work well from my seat in a small, motorized flat-bottomed skiff. This rookery had a mixed population of brown pelicans and cormorants. Both were in residence when I photographed the rookery. Red mangrove trees are one of the few higher plant species that thrives in salt water, and at this island the bases of the trees are awash at high tide.

I made several trips to this rookery with the warden in charge of it. He checked it at least weekly, counting the nesting pairs and their offspring through binoculars at a distance of about fifty to a hundred feet from the shore. I accompanied him on these trips for several weeks. We went either early in the morning or at midday. We would anchor and stay in one place at a time for a half hour or more.

The water was choppy on my first trips, and there was some wind; however, it is perfectly possible to take sharp pictures from a rocking boat. I timed my exposures to coincide with the waves' peaks and troughs. There is an instant at the top and at the bottom of a wave's pitch when the boat is virtually motionless. Although the wind's effect on the water was not a problem for me, its effect on the bird's behavior was. They were nervous and flew up when we came closer than a hundred feet away, and this was farther than I wanted to be to make frame-filling pictures with 300mm or 400mm lenses.

I had given up on the idea of getting any pictures I liked of this rookery, but late one afternoon I went on out with the warden for one last try. It was a bright, calm, windless day, and our boat trip to the island was uneventful. The rookery looked splendid when we arrived. Its residents were preening and sunning, and flying back and forth. The warden circumnavigated the mangrove island, counting birds as he went. Then he motored back to the western side where the birds were in full sun. Slowly he approached the island, and the birds stayed put. He edged closer and closer, until finally we were about forty and then thirty feet from shore. We anchored there and worked quietly for half an hour.

We were in an open boat in full view of the birds. As always, in the presence of wildlife I moved as slowly and evenly as possible, and I stayed seated rather than standing. Nearly all my floating bird photography has been done from open boats, but I am sure that boats with cockpits to hide in or craft especially camouflaged for photography would be far better. Transforming a boat into a floating blind wouldn't be particularly difficult. The camouflage details would naturally depend on the specifics of the craft.

Accompanying Bird Banders in the Dry Tortuga Islands. Most colonial rookeries located on public lands are out of bounds to visitors and photographers who don't have special permission. To gain access to such restricted colonies I sometimes arrange to accompany the officials charged with counting and banding the

adult birds and their young. I made a particularly noteworthy trip to the sooty-tern colony in the Dry Tortugas, a group of islands off the southern tip of Florida. The Dry Tortugas are the only place these *pelagic*, or ocean-living, terns nest in the United States. There are other nesting islands in the tropics around the globe.

Sooty terns are believed to come on land only for nesting. They spend the rest of the year fishing far from shore and literally sleeping on the wing. Like other terns, they are not shy. They don't desert their colony under any circumstances, even when a dozen people are walking all over it.

The birds' island in the Dry Tortugas is off limits to visitors during the nesting season except for one official annual visit lasting several days. Otherwise, boats aren't even permitted to approach the island closely. By going with the official banders I avoided unnecessarily irritating the birds since they were already disrupted by the banding efforts.

The trip was carefully planned to coincide with the presence of feathered offspring that were still too young to fly. Feathers are insulators. Once young birds are feathered, they are less vulnerable to exposures of heat and cold when their parents leave their nests. Obviously, the colony was less likely to be adversely affected by our visit at this time of year than earlier in the season.

The time of day we visited the colony was important, too. The banders and I worked for several hours just after dawn and for several hours before sunset. It was cooler early and late in the day, and working at these times was less stressful for the birds than midday contact with us would have been.

Keep these tactics in mind whenever you attempt to work with birds, whether they are solitary nesters or nest in colonies. The least dangerous time for your subjects is after the young are feathered and before they can fly. The best time of day is just after dawn and shortly before dark, not at midday in the hot sun.

I didn't try to photograph the sooty terns from a blind for two reasons. First, the banders walking around the nesting grounds had already disturbed the birds. Second, I didn't know enough to know where I should place a blind. Tern nests are very minimal, a small declivity in the ground at most, and are therefore difficult to recognize. When there are eggs and very young birds in a tern nest, it is possible to pinpoint where the nest is. But when we visited this colony, there wasn't a single nest in evidence. For all I knew every available piece of ground within the colony represented the territory of a young bird and its parents. If I had put up a blind, I might very well have usurped territory already in use by the birds, and without it, some birds might not have survived.

Also, I wasn't engaged in documenting a life history of the terns. Had I been, I would have arrived at the island long before the terns returned to nest and I would have built one or two permanent blinds in order to begin working before the terns' courtship and nesting took place.

Although I didn't use them, there are two types of blinds for terns and other colonial birds that nest on flat, rocky, or sandy areas lacking much vegetation. One type of blind is a permanent or semipermanent structure that stays in place throughout the nesting season and is assembled before it starts. Blinds dug out of the natural landscape and covered with canvas are obviously preferable to blinds that are entirely above ground because dugout blinds fit in better with the landscape and are more likely to be accepted by the birds. Also, you can construct a dugout so that when you are seated, your eye level is just slightly above the level of an adult tern that is standing. This close-to-the-ground camera angle produces better pictures than the higher angle you get from an above-ground blind.

Another good setup for working with ground colonies is a low pup tent in which you can lie prone from head to toe. Such a tent allows you to arrange yourself more comfortably than if you were to use a regular photographic blind. The latter isn't usually long enough for an adult to stretch out completely.

A good short-term approach to photographing a colony of ground nesters is to crawl toward it completely covered with a ground cloth attached to your arms and the bill of your cap. Also make use of any natural cover nearby. A drainage ditch can be a godsend in these situations.

Always work at the edges rather than from the center of a colony unless you have a permanent, centrally located blind. This strategy holds true for photographing all colonial birds. Terns and other colonial ground-nesters nest practically on top of one another. Their nests, eggs, and chicks are so wonderfully camouflaged that you may destroy your subject by stepping on it, a tragedy to be avoided no matter what the payoff in pictures might have been.

Attracting Birds with Lures and Decoys

In all the situations I've discussed so far, I've sought out birds that were nesting or feeding in their natural habitats. However, you don't necessarily need to go hunting for birds to photograph. There are many techniques you can use to bring birds to a preplanned spot that has a good background chosen for your photography. These techniques work best when you are out of sight in a blind or are completely camouflaged. Such ploys are used regularly by hunters but are often overlooked by nature photographers.

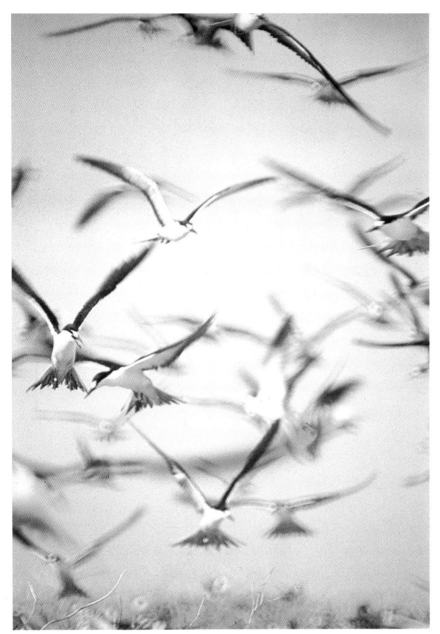

I spent several days at the tern colony, so I had time to observe the birds' behavior and photograph what I considered important, instead of just shooting fast and settling for whatever the results were. One characteristic I noticed was that the adult birds tended to hover in the air above their grounded young. The adults wouldn't hover within eight to ten feet of a human being, but beyond the perimeter many birds hovered at different altitudes. In addition to taking pictures with standard and short telephoto lenses, I decided to capture the airborne flock with long telephoto lenses.

The action was very fast. The birds didn't stay in exactly any one place, so my compositions changed in split seconds. I worked with both 300mm and 500mm lenses on a tripod, but I didn't lock the tripod head in place. I left if free so I could swiftly change the area framed. I generally find this a useful technique for rapidly moving subjects, and when using long lenses, I prefer this technique to handholding the camera.

I had to focus quickly because the birds continually changed their proximity to me as they labored to stay in the air above their young. Many of the pictures I made with long lenses were not successful. None of the images were acceptably sharp, and the problem was more one of focus than of camera or subject movement. This is one of my successful efforts made with a shorter lens.

If you are fortunate enough to accompany a bird-banding expedition, it's often useful to photograph the bird banders as well as the birds. Here Dr. Glen Wolfenden and his children are tagging sooty terns in the Dry Tortuga Islands.

Auditory Lures. You can attract songbirds to a very close working distance by playing a tape recording of songs sung by the same species. Bird songs may be music to your ears, but they are actually challenges between male birds. Songbirds stake out their territories with song, and their songs preserve the distances between their nests.

Records and tapes of different bird songs are available, or you can record your own bird songs in the field. If you play back a male bird's own song to him, he will come to the playback speaker to defend his territory no less enthusiastically than if you play the song of another bird of the same species.

Another technique for attracting songbirds is to play a recording of an owl or a hawk. Owls and hawks prey on songbirds and songbird nests. If small songbirds hear an owl or hawk during the day, they will come to the call and gang up on the offender, or mob it. Using the call with an owl or hawk decoy guarantees some fast action for your camera. I've seen and photographed this attack behavior. Once a red-winged blackbird attacked an Everglade kite within thirty feet of me. Another time a group of songbirds attacked a golden eagle perched in a distant treetop.

Recordings or simulations of bird calls and songs will also attract birds of the same species. There are many recordings available of waterfowl, hawks, owls, and turkeys, such as:

Screech Owl Call: This calls screech owls at night and songbirds during the day.

Baby Bird: The distress cries of a baby bird call all songbirds and predators.

Other available calls include: Death Cry of a Crow, Death Cry of a Crow with Hawk Cries, Crow and Owl Fight, Mallards Feeding on Water, Canadian Goose Calls, Snow Goose Calls, Springtime Turkey Calls, and Fall Turkey Calls.

You must exercise judgment if you bait male songbirds with recorded bird song in the spring. Don't overdo playing the recorded bird song. The stress upon the birds you attract may cause their demise by predators or make it impossible for them to gather adequate food for young nestlings. By the way, using bird song to attract subjects for photography is against the law at most parks and refuges. Be sure to check with park or refuge managers and with the state game department to see if playing bird songs is legal where you'll be working.

Decoys. Using decoys, or models of birds which are shaped and painted like real ones, is another hunters' technique for attracting birds. Most commercially available decoys are largely models of game birds, but you can also buy models of such sensitive and wary birds as the great blue heron. Many bird species are

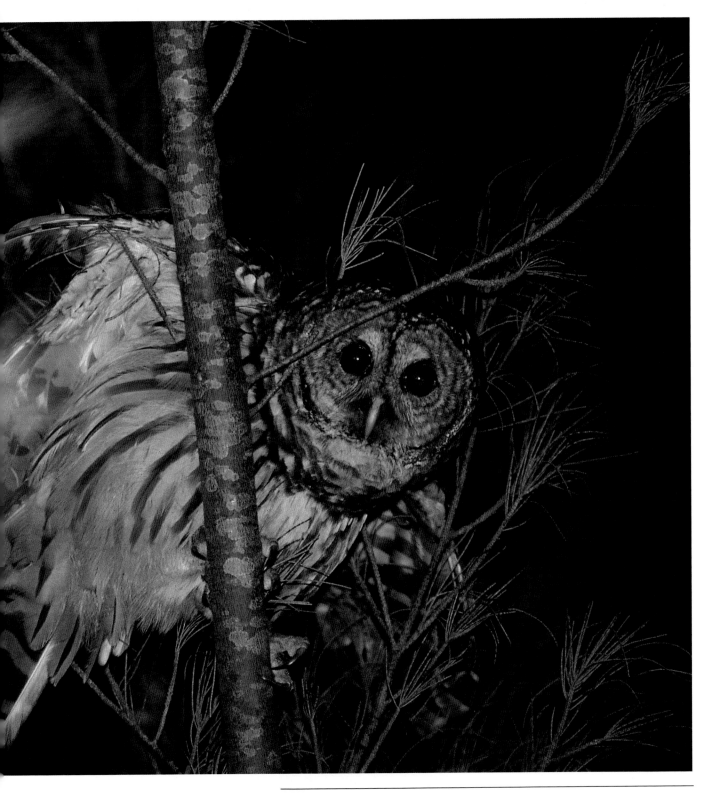

It was midnight when this barred owl flew into view in response to a recorded bird call that I was broadcasting in the Everglades. My recording was of another pair of barred owls, and this owl thought his territory was being invaded by rivals. I made my flash exposure according to the guide-number method; it was 1/60 sec.—the highest shutter speed for which my camera is synced—at ƒ/5.6 on Kodachrome 64. I used a 300mm IF lens to capture the owl's *eye shine*. Eye shine occurs when light is directly reflected off a special layer in an owl's retina. To record eye shine, keep your flash unit as close to the lens as possible, so that the light emitted will closely parallel the lens axis.

reassured by a heron's presence, believing it would flee at any sign of danger. Such decoys are called *confidence decoys*.

You can also make your own decoys. They don't have to be perfectly shaped to be effective; in fact, they don't even have to be three dimensional. Two dimensional owl-shaped, hawk-shaped, and duck-shaped representations will attract other birds to a location. Decoy colors, however, should be accurate. If you have any talent for carving, you can make three-dimensional decoys of Styrofoam, balsa wood, or any other suitable material. Whatever your decoys look like or are made of, be sure to paint them in accurate colors in matte, rather than glossy, paint.

Photographing Bird Nests

Don't start your adventures in bird photography by searching for a rare or elusive species. Instead, begin with the common birds that nest in accessible places near your home. With a bird feeder and bird bath you can also make your own yard into a bird haven if you live in the suburbs or in the country.

When you see birds flying to and from low bushes and trees in the spring, they are probably building their nests or are already nesting. I suggest using binoculars to note exactly where they enter and exit the foliage on their nesting tree. Then walk up to the tree or bush and start searching. Do some research on nesting habits in a bird guide and look for local species that nest in bushes or low in trees. Stay away from doing picture studies on high-treetop or deep-swamp nesters until you have more bird photography experience.

One of the prime advantages in doing local bird photography is being able to get to the nest often, daily if possible, to check its progress. With *altricial* species, or birds that are helpless at hatching and require parental care, don't start to photograph until the young

birds have hatched. As I have mentioned, adult birds are not likely to desert a nest after the hatch.

Working with a Blind. There are several possibilities. The best way, in terms of getting good pictures and enriching your understanding of your subjects, is from a blind that has a clear view of the nest. For small birds you'll need to be from four to eight feet away, and you'll need a 200mm or longer lens, or a zoom lens that includes approximately this focal length. You can also position a remote-control camera, mounted with a normal or wide-angle lens, within a few feet of the nest, operating the remote control from a blind at a greater distance, say fifteen to thirty feet or even farther if you have binoculars to watch nest action. (See "Camera Traps" in the appendix for more information on remote-control photography).

I have nothing against using remote-control cameras for nest photography, but you will learn more about your subjects if you can work close in from a blind. Remote setups are sometimes the only convenient way to photograph nests and other subjects, but they can't contribute as much to your store of wildlife knowledge as looking continuously at your subject through your camera for the many hours it takes to make an excellent set of nest photographs.

During your first early-morning session, try positioning the blind exactly where you'll want it for your pictures. Withdraw fifty feet away from the blind, leaving it in place, and watch to see whether the adult birds come and go as frequently as they did before the blind was introduced or whether they attack the blind. If the presence of the blind interferes with the birds' activities, remove it to a greater distance, perhaps fifteen or twenty feet, and again check the birds' behavior. Probably all will be well. If not, move the blind farther away. Gradually, day by day, move the blind closer,

I was able to make pictures with several different focal-length lenses by setting up a blind to photograph a long-billed curlew nest. The soft, last light of the setting sun cast warm, diffuse highlights across these eggs layed in Nebraska's sand hills. I discovered the baby long-billed curlew, pictured top right, nestled in the flora. The chick's speckled camouflage is reminiscent of the egg from which it hatched. Look how much the bill of the adult curlew, shown bottom right, has grown during maturation. I used a 500mm mirror lens for this picture, taken at midday in 102°F heat. The bird was panting to evaporate the perspiration from its tongue.

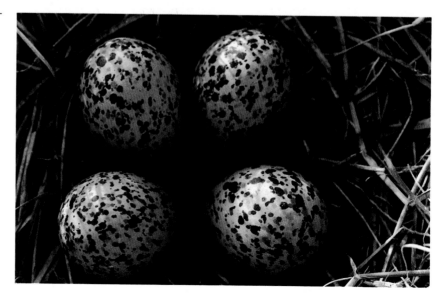

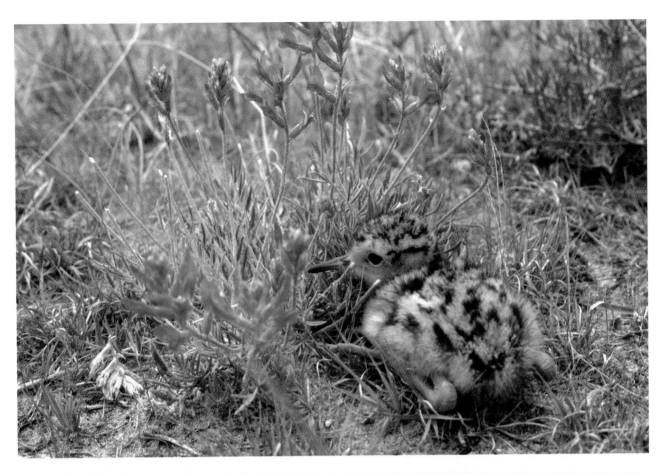

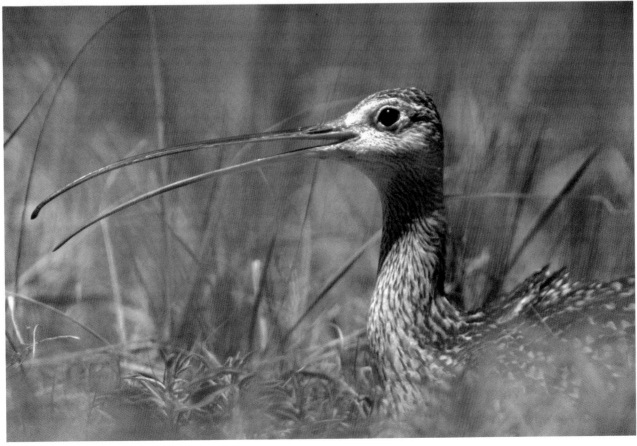

advancing it perhaps four or five feet per day. Within a few days you should be back at your preferred shooting position, ready for the next step.

Be prepared to spend hours in your blind and to put in all-day sessions if possible. Be sure to employ all the strategies I've outlined in this chapter, including having someone accompany you to and from your blind. If your subjects exhibit extreme nervousness even though you always enter and exit the blind escorted, you may have hit on a species more arithmetically able than average. Proceed by organizing two escorts, or three, or more.

Using Electronic Flash. You should confine your nest photography to periods when the nest is shaded by foliage from direct sun. Using electronic flash to illuminate your subjects will produce better results than working by available light. I suggest using two flash units: one flash unit on or near the camera, and a second flash with a slave trigger positioned about half

your distance from the nest at a 45-degree angle from the first flash unit.

You can use your flash-unit's guide numbers to establish approximately correct flash-to-subject distances, but unless you've tested the arrangement with a similar subject, bracket your exposures extensively during your first shooting session. If you are using the recommended guide number as a starting point, bracket in the direction of more exposure. Process your first batch of film as soon as possible to check the lighting and exposure.

Taking Pictures at the Bird Feeder

Almost everyone who has a yard has a bird feeder in it. Over the years, I've checked out hundreds of bird feeders with the idea of taking pictures, but none has ever been photogenically placed where I wanted it. There are number of factors to consider before positioning a bird feeder for photographic purposes, assuming you're using your house as a blind. When

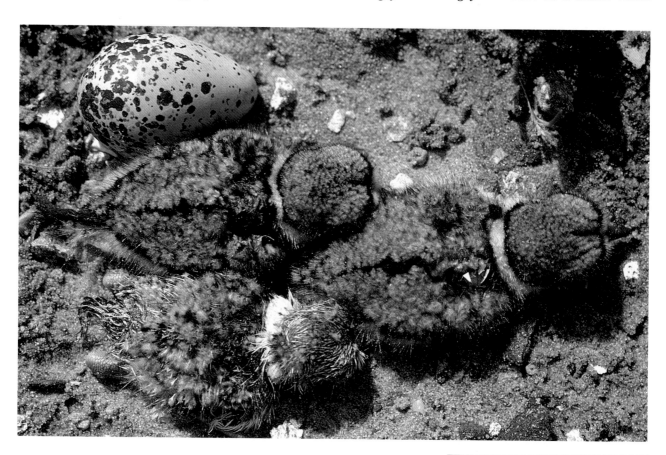

Believe it or not, this is a kildeer nest in which three of the four eggs have hatched. Kildeer are one of many bird species that simply nest in light depressions in sand or soil. I stood directly over these three chicks and the egg to make this shot with a 55mm lens on Kodachrome 64 film. My exposure was 1/250 sec. at f/8.

choosing a window to be your work station, look at what will appear as background behind the feeder. Obviously, seeing vegetation in your pictures is preferable to seeing your neighbor's house.

If you can't find a window opening onto a good background, or if the only window providing one is in the busiest room in the house, you can set up artificial backgrounds behind the feeder. Pine boughs are wonderful. So are branches from deciduous trees in the summer; however, the leaves on deciduous branches will wilt, forcing you to change them more often than pine boughs. Keeping their stems in water will help. Also, attach some branches or twigs above and behind the feeder, or to one side and above it. Pictures of the birds perched on this foliage will be better than those of birds at the feeder itself.

Different Types of Bird Feeders. The bird feeders commercially available are constructed for use by different types of birds. Good feeders discourage the undesirable birds and such animals as squirrels from raiding the food supply. These feeders serve their purposes, but they are not ideal for photography or at least for pictures in which the feeders themselves appear.

For photographic purposes the feeding station should appear to be part of the natural landscape. A simple, effective solution is to place bird seed or other food on top of a stump or log. The top of the stump should be just slightly beneath the vantage point of your window or blind. Another technique is to make a shallow container out of plastic screening and thin strips of wood. Tack a branch to the side of the feeder that faces the camera so that all the camera sees is a natural-looking facade.

Wild-Bird Food. The mixed grains sold as wild-bird food are not necessarily considered popular delicacies by the birds you want to attract. The best sure-fire bird food for all small bird species is sunflower seeds. In winter, suet and fat are also attractive. You can mix the suet or fat with sunflower seeds if you like.

Peanut butter is a popular bird food. Smearing peanut butter or fat on the top and rear side of a branch creates a setup that produces natural-looking photographs of the birds as long as the food is out of the camera's view. I've also had good luck suspending suet from trees in the mesh bags that package onions. I photograph the birds while they are perched on tree branches prior to their landing on the bags to feed.

Wintertime is the most successful season for attracting birds with food. If you start feeding birds in the autumn and winter, you must continue providing food for them well into the spring. Birds become dependent on artificial food sources and will starve if you stop putting food out.

Electronic Flash for Bird Feeders. The best kind of illumination for your bird feeder pictures depends on the natural light at the feeder. If the feeder receives front light from the sun, you will probably prefer to shoot with the available light. If the feeder is in the shade, you should use electronic flash. You may also want to use electronic flash if the feeder is backlit by the sun.

Exactly how you should rig your flash setup depends on several factors. One is how far the feeder is located from the camera position. Another is the strength of your flash units. Their power determines the flash-to-subject distances and the apertures that you can use.

If the feeder is fairly close to the camera, say about five feet from it, you may want to use one flash head on your camera as a fill light and trigger the main light with a slave unit. Put your main flash head about three feet from the feeder at a 45-degree angle to the side. You also have the option of using both flash heads off your camera, with one wired to it for synchronization and the other set up as a slave unit.

Use a dummy bird to check your flash exposure. A small, bird-sized stuffed animal or a nonshiny object works well as a stand-in. Bracket your exposures in half stops, beginning with two stops more exposure than calculated. Keep note of the apertures you use, and examine the slides when they are returned from the processor to decide which exposures you prefer.

When you run these exposure tests, try various lighting angles. Take pictures with the two flash heads each at 45 degrees and equidistant from the camera, or with one flash head at 90 degrees to the side while the other remains at 45 degrees. Shoot a few pictures with both at 90 degrees on either side of the camera and, if possible, with an extra flash head placed high behind the subject for backlight.

The Window Blind. Whenever possible, I prefer shooting pictures while I look through the camera's viewfinder, instead of using remote control or a camera trap. If you live in the suburbs or the country and you can find a good location for a bird feeder five or ten feet from a window, I suggest you plan to shoot from there. That way, you can work in comfort rather than out in the cold.

When you work from a window, the feeder should be slightly lower than your eye level, assuming you are seated in front of the window with your camera on a tripod. You can use a window shade or cardboard to cover the upper part of the window. Cover the lower part where you'll be shooting with a piece of plywood or heavy cardboard that has a hole cut out for the camera lens.

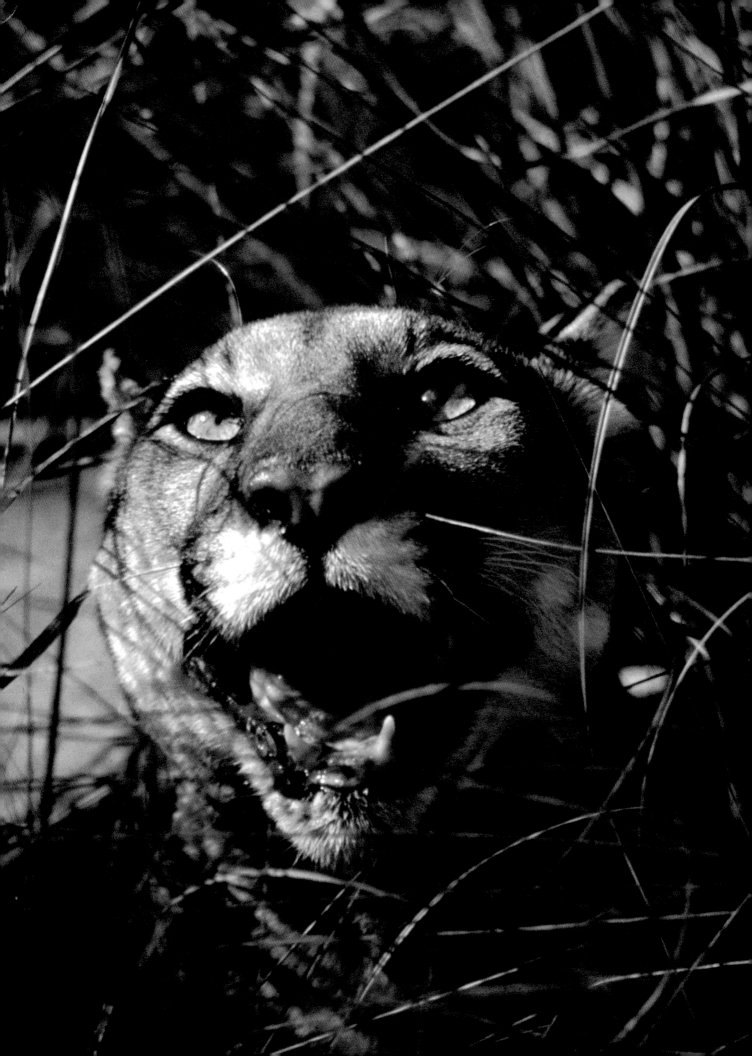

Chapter Five

MAMMALS

How do you think the wonderful animal pictures you see on special television programs and in such magazines as *National Geographic* and *National Audubon* were made? Do you believe, for example, that photographers just walk up to tiger families and film their life stories in no more time than it takes you to view their films or glance at a periodical's pages? Of course, it takes a photographer much longer to do wildlife photography, but does this mean that the published photographer has some special talent that you lack because you haven't yet made a good picture of birds at a feeder after doing three two-hour Saturday-morning stints? Do you feel like a complete flop as an animal photographer because you tried leaving your car to photograph a deer feeding in a field, but the deer fled the moment you opened the door?

Take heart. Television specials don't show a photographer's unedited footage that is typically ten to a hundred times the length of the segment used. Magazines don't print a photographer's thousands of discarded slides. Even if you did see the outtake, it couldn't bear witness to the time a photographer may spend in the field without taking any pictures at all.

Some professional wildlife photographers work, frequently against hope, trying to locate, approach, and photograph subjects that are rarely glimpsed even through powerful binoculars. Perhaps the most impor-

tant aspect of animal photography, which is not evident from the results and not widely discussed in print, is how much of it is in some way set up, organized, or arranged by the photographer.

Making a Set
Sometimes wildlife photographers wait for temporarily caged animals to be released in the wilderness and then immediately photograph them in their natural habitat. A more standard practice is to build a set from which the animal can't escape and camouflage the set to look natural. This practice is particularly favored by cinematographers using tame subjects.

To be present in the field for a significant happening in an animal's life is usually more difficult than finding a needle in a haystack. Observing and photographing a wild animal's natural behavior—for example, the details of its caring for its young, or even its daily routine of eating and drinking—is very difficult. About the only exceptions are the behaviors of some species of African plains animals, such as lions, in African national parks. These animals can be approached, followed, and photographed quite readily from moving vehicles. Even so, the most significant pictures of African wildlife are made during such lengthy ethology studies as Jane Goodall's work with chimpanzees or George Schaller's work on predators.

Florida panthers are rare creatures seldom seen anymore in the wild. For the full story of how I managed to photograph this one, turn to page 64.

This Florida panther and her sister were raised in a cage at Everglades Wonder Garden in Bonita Springs, Florida, a roadside attraction owned by Lester Piper and his brother Bill. The Pipers are old south Florida swamp hands. They were on the scene long before the Tamiami Trail across the Everglades was completed in 1928, so they knew the land when it was virgin territory. They foresaw its destruction, and as woodsmen and animal lovers, they began collecting wild creatures.

Big saltwater crocodiles, once abundant in the seas and estuaries, found harbor with the Pipers as did a few shy Florida panthers (the local name for cougar), that originally ranged across both American continents. Neither creature is abundant

now, although the crocodiles are evidently making a comeback from near extinction in the wild.

I was present when two of the Piper's panthers were released in Everglades National Park. Ordinarily in a magazine that is all you'd be told about these pictures, except perhaps that they were shot at 1/250 sec. at $f/8$ on medium-speed color film. However, several weeks of organizational effort on my part preceded the panthers' release. First, I heard from the park superintendent that the cats might be donated to the park. He didn't know when, and suggested I consult with the Pipers, whom I had yet to meet.

I drove 125 miles to Bonita Springs, all the while remembering that I'd heard the Pipers were rather hard to

get to know. It took several days in Bonita Springs to locate Bill, who said he intended to donate the cats to the park, even though he feared they might wander out of the park's boundaries and be shot to grace a "sportsman's" walls. Bill said the park could pick up the cats whenever it was most convenient.

I called the park superintendent, who put me in touch with biologists John Ogden and Dick Klukas, the two men who would be fetching the panthers and releasing them. The biologists were tied up with research, and we planned on a release date several weeks later. I kept checking with them and with the Pipers, and finally the appointed day arrived. I met the biologists in Bonita Springs, they loaded the crated cats in the back of

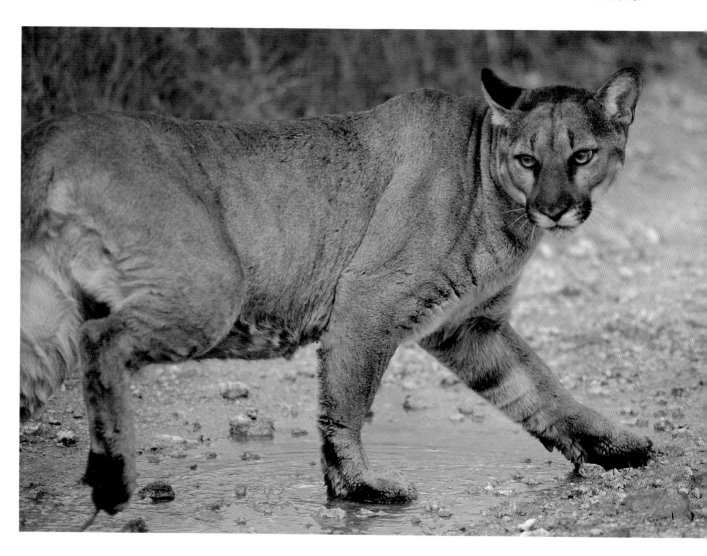

their pickup, and I followed them back into the park.

The release site was deep within the park. Park employees lifted the crates to the ground. All was quiet, including the animals. I was about six feet to one side when the first crate was opened. The panther jumped out snarling. I stumbled back, and before I could recover and focus, a lashing tail disappeared into the tall grass. The cat's complaints, ever more faint as she made tracks, drifted back to us for several minutes.

At this point I lost hope, assuming the other cat would be equally crabby when freed. But it wasn't so. The sister placed one trembling fore-paw out of the cage, and withdrew back inside. Several minutes passed. Tentatively, looking fearfully around, she crept out. She walked slowly down the road, pausing to look back in our direction as though for encouragement. I was able to make the picture on the left before she disappeared from sight, forever, or so I thought.

The picture on the right was made about fifteen minutes later. Most of the park personnel were prepared to leave the scene immediately after the cats' release, but seasonal ranger Stuart Cassidy walked off into the grass after the cat. In a few minutes, he returned. "She's sitting under a little pine about a hundred yards from here," he said. "Come on!"

I followed, and there she was. She was panting, and obviously nervous. She walked around a little, she sat down. She lay down. She sat up. She walked in a circle through the grass and came back to sit under the pine. Cassidy and I stood within fifteen feet of her, and she ignored us. As far as I know, we could have continued snapping away with our cameras, except we ran out of film.

Predator releases are rare. I know of only one other that has ever taken place in Everglades National Park, and it also involved a panther. The photographer who was present got no satisfactory photographs, so I count myself very lucky for having made these.

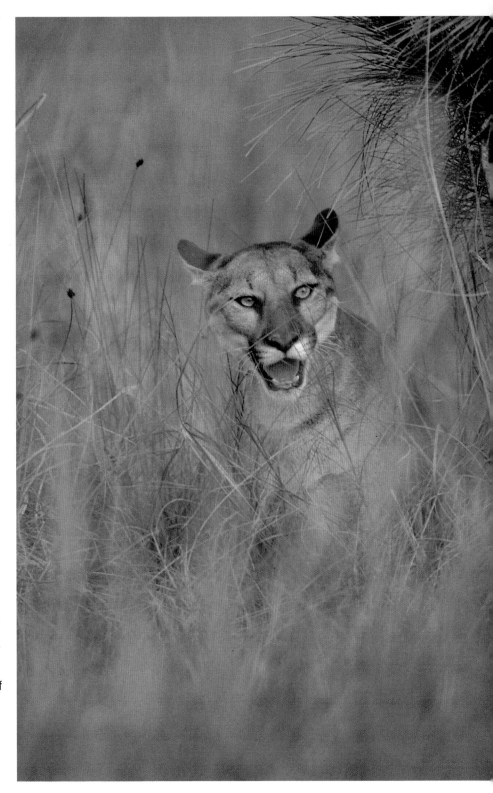

Generally, films and pictures of predator-prey encounters are made in large compounds familiar to one of the animals, usually the predator. And you can bet it is kept hungry before its prey is introduced, a practice that tends to guarantee action.

I haven't worked this way myself, but I think it is legitimate. Setting up a situation that no amount of time could produce in the field is the only way many photographs can be made. And seeing these photographs is the only way most people can be educated about animals. Even set-up shots of wildlife aren't altogether a snap, so to speak. The photographer can't control where the animals go in big compounds. For example, the significant action could take place a hundred feet away from the camera in front of a wall, instead of on the open ground where the photographer wants to see it.

Making Wild Animals into Pets. Successful nature photographers occasionally adopt wild animals as pets, photographing them as they grow up, and then either keeping them forever or donating them to zoos. By and large, zoos disapprove of this practice because they rarely need such an animal for display. It is also unfair to the animal who can't then adapt to less personal relationships with zoo keepers. In many cases, adopting wildlife is forbidden by state game laws, federal laws, and animal protection societies.

Even local animals can't usually be returned to the wild successfully. Much of the knowledge an animal needs to survive—especially a thoroughgoing aversion to people—must be learned from its parents. Once you have removed an animal from nature and it becomes imprinted on you, it is yours.

Young animals whose parents have been killed are obviously quite a different matter because of their certain demise if left alone in the wild. Still, be sure to obtain permission from the state game authority before taking in any wild animal, regardless of the circumstances. Special permits are required in most states, even for nongame species.

Camouflage Techniques for the Truly Wild

Although it's true that some of the best animal pictures are made by using captive animals on sets designed for wildlife photography, the finest nature photographers cultivate special outdoor skills and shoot their pictures in the wild. Sometimes there is no easy way to accomplish your picture goals. The most difficult problem with animal photography is not photographic—it is finding your chosen subject and approaching it closely enough to work effectively without disturbing it. You don't want your presence to drastically alter the animal's appearance and behavior; otherwise, you may not be able to photograph it. To

Looking at this picture of a bobcat, you'd have every reason to think I somehow tracked the animal to its lair and awakened it from its midday nap. In fact, its lair was a cage at Okefenokee Swamp Park, and Johnny Hickox, the park's official chief guide, was responsible for the realistic-looking palmetto-fan background and the transported forest litter on the cage floor. The bobcat was lured into an attached holding cage while John and I set up the background. Upon release into its regular cage, the bobcat sat around for a bit batting pine cones about; then it attacked our elaborate setup. I had time to make several pictures before the demolition.

I was on an important assignment when I made this picture or I wouldn't have asked permission to stage such an out-of-the-ordinary event. Johnny was paid to help me, and the park, which has a small zoo and specializes in guided trips through the swamp, is unusually cooperative in working with professional photographers. This picture represents my only such effort with large creatures, but many other nature photographers frequently do similar work.

This coyote named Snake was biologist Don Henderson's pet. During a walk we all took, she struck several natural poses against different backgrounds. I exposed this one for 1/60 sec. at *f*/5.6 on Kodachrome 64.

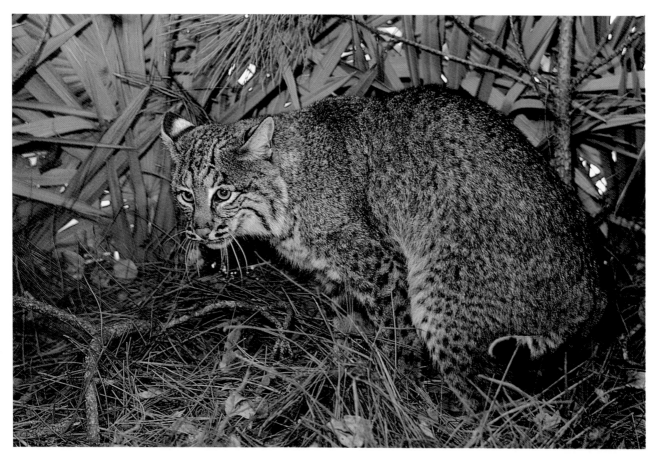

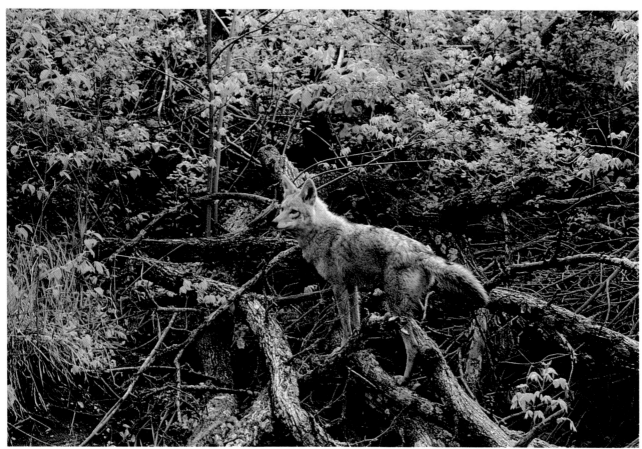

Instead of showing you photographs of the different types of camouflage material that you can see at any hunting shop, army-surplus store, or in any outdoor-supply catalog, I thought I'd show you how natural camouflage works for animals.

In the top picture, a coral snake crawls from its usual leaf-detritus habitat into a clear spot on the pine-forest floor near Okefenokee swamp. The part of the snake lying in the leaves is practically invisible. The part on the sand stands out clearly both in shape and in color. This is exactly what happens when a photographer, dressed in dappled-light camouflage clothes, steps out on a road cleared through the forest.

Next look at the picture of mule-deer—you can hardly see them. Their forms and color blend in perfectly with the winter-dead grasses on the prairie at Crescent Lake National Wildlife Refuge in western Nebraska. The deers' shaggy winter coats are shedding, and they even resemble the patterns and shades of the dead foliage.

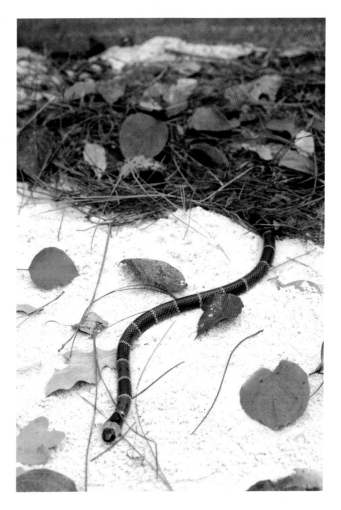

avoid this problem, successful mammal photographers pay attention to how animals see, hear, and smell, which in many ways differs greatly from our own sensory perceptions. Once you understand an animal's perspective, you can plan your approach strategy accordingly.

How Mammals See and Smell. There are some very important differences between your eyesight and the way most of your animal subjects see. Apparently, except for the higher apes, few mammals see in color. Most are color blind, or nearly so. And with a few notable exceptions, such as cheetahs, mammals don't see detail too clearly from a distance. However, they can recognize animal shapes, especially the bipedal shape of humans, from far away, and are particularly sensitive to any movement.

Mammals have a much more acute sense of smell than we do. Their acute olfactory sense can give our presence away even when we are visually concealed inside camera blinds. Consequently, the special portable blinds that are so useful for bird photography are rarely successful for animal photography.

We photographers have a lot to learn from seasoned hunters and trappers. They try to eliminate any trace of odor that might be associated with humans from their equipment, their clothes, and their persons. Tobacco is regarded as a sure giveaway. The trappers I've worked with don't smoke. They wear freshly laundered clothes whenever they go out to check traps, and they wear gloves to handle their trapping equipment. Some trappers immerse their boots in cattle or horse dung to eliminate the scent of rubber and tanned leather, odors that a smart animal would associate with people even though these scents are imperceptible to us.

Olfactory Camouflage. Although the trappers with whom I've worked haven't used camouflage scents, special scents for camouflaging human odor are available from trapping supply houses. The most effective scent is called *skunk screen*, and it is available in a two-solution form that I prefer. This way, the skunk screen remains odorless until its two solutions are mixed together. Skunk screen is a powerful scent, and very little needs to be used at one time. I suggest putting a few drops of each solution on a rag; then pin or tie this cloth to your outerwear or to your equipment. After you've finished working for the day, leave the rag behind or toss it in the garbage instead of bringing it indoors.

Musk scent is another camouflage scent particularly recommended for deer hunters and deer photographers. This scent smells like heavy musk perfume and is somewhat less offensive than skunk screen.

Camouflage Clothes. Wearing camouflage clothes is standard operating procedure for many hunters and should be for photographers, too. Camouflage clothes visually break up a human shape, thereby permitting it to blend in with natural surroundings if the light is right. Since most mammals are color blind, the mix of tones, or darknesses and lightnesses, is more important than the colors of the camouflage material itself. Birds do have color vision, so camouflage clothes for bird photography must match the colors as well as the tones of the environment. Most camouflage clothing is meant to simulate the appearance of dappled sunlight and shaded foliage.

Every conceivable type of camouflage outerwear is commercially available, including caps, gloves, coats, shirts, sweaters, pants, and masks. There is even camouflage makeup. What constitutes camouflage depends on the area and the season in which you work. Camouflage for winter snows or summer beaches—white or light sand-colored garb—won't work in such places as a leafy forest or a dark, rocky shore.

Most of the clothes manufactured and sold as camouflage are meant to be used in wooded surroundings. Different basic colors are intended for different seasons. Tan background material should be worn in early spring and autumn, and green clothing is meant for summer. Another type of camouflage to consider is the tree-bark clothing used by deer hunters in the autumn and early winter. When you are wearing clothes meant to simulate the appearance of tree bark, you'll blend in with the tree trunks around you; you could even use one as a backrest while waiting for wildlife to approach. I recommend using several camouflage techniques at the same time: for example, wearing camouflage clothes and applying camouflage scents. Animals can be spooked by either seeing a human shape or catching a human scent.

I don't always wear camouflage clothes to photograph my subjects. For example, I want moose and bison to see and clearly recognize me, at least those moose and bison inhabiting parks and refuges where they aren't hunted and have no fear of man. These enormous and dangerous animals will try to identify any suspicious object, and their curiosity may bring them close enough to me to charge if for some reason they perceive me as a threat.

Don't wear camouflage during the hunting season unless you are in parks or refuges where hunting is banned. And don't wear camouflage off-season in a region where there might be off-season hunting or poaching. If there are hunters with guns in an area, I forgo visual camouflage and don flame-orange or bright red clothing.

Avoid hill tops and places where your form would be silhouetted against the sky, as well as situations where you'd be backlit in relation to your subjects. The briefest, unintentional exposure to your subjects can ruin the potential results of hours of careful stalking or attracting animals with lures to your camera.

No matter what kind of camouflage technique you use, being completely still when you are in your subject's field of vision is essential. That is why totally enclosed blinds work so well. Animals can spot you if you so much as blink an eye. A hunter's job is much easier than yours; a hunter must hold still only until the game is within target range, an area much farther away for weapons than it is for cameras.

Camera Blinds for Beasts

The most wary and intelligent mammals, especially those that are hunted or trapped, won't knowingly approach unfamiliar structures. If they catch a human scent, they won't go near familiar structures. Therefore, as a rule, ground-level blinds are not productive for photographing mammals except in special situations. However, these exceptions, described below, are important.

Permanent Blinds. Permanent blinds and permanent structures used as blinds are more useful than portable blinds. Animals are familiar with every detail in their home range, and it can take days or months for them to become accustomed to any new addition. In areas where they aren't trapped or hunted, animals may become comfortable around a new structure within a week or two.

Naturally, permanent blinds must be located where animals habitually pass or congregate. Most animals are creatures of habit—they use the same trails day after day, they regularly return to the same area to rest or to sleep, and they go back to the same place to feed as long as food is available.

In Africa, permanent blinds have been erected at a number of watering holes where animals congregate during the dry season. The scientists who built the blinds for their studies left them in place, and they're now available for tourists to use for photography. Please note that because of the dry season, the animals have no alternative but to visit these water holes where they are under surveillance. Given a choice, most of the creatures would go to a watering place without a blind.

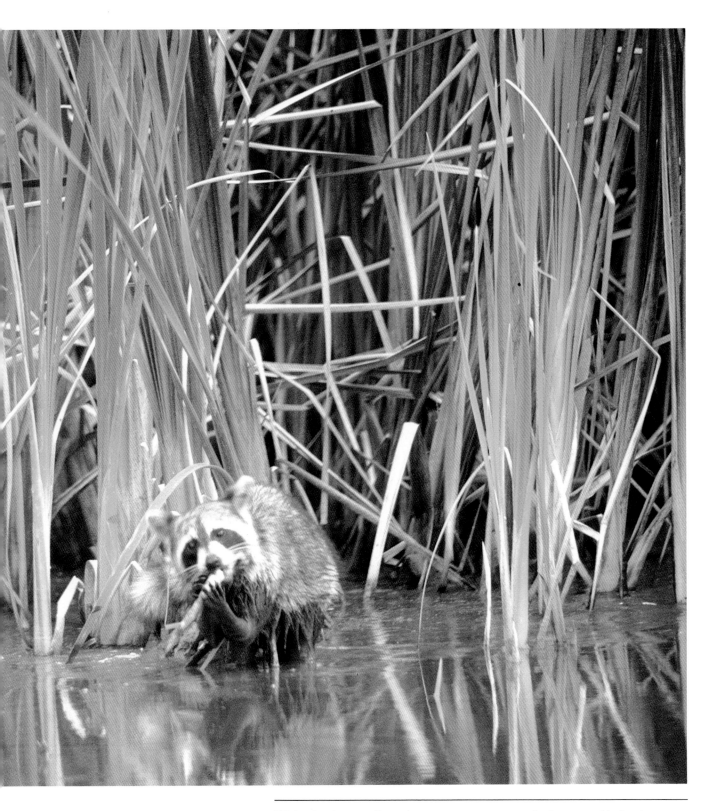

Wild animals sometimes ignore people if frequently exposed to them. These cattails were growing around the edge of an Everglades pond that is heavily visited by tourists for a few weeks every year. There were at least fifty people in plain sight of this raccoon that emerged to feed on cattails. Many of us photographed him with 300mm and 400mm lenses during the fifteen or twenty minutes he stayed in our view. The day was overcast, and my exposure was 1/60 sec. at ƒ/5.6 on Kodachrome 64.

Tree Stands. Hunters, especially deer hunters, often work from platforms, called *tree stands*, that are attached to trees at heights of eight feet or more. Deer and many other big mammals aren't accustomed to trouble coming from above them, plus the height of a tree stand tends to elevate and diffuse human scent.

Permanent or semipermanent tree stands are often erected by hunters who own big pieces of property. Tree stands can also be found in areas owned or leased by hunting clubs. Portable tree stands are available from several suppliers. Constructing a blind around such a tree stand is very simple to do using poles and camouflage cloth, available in bulk at many hunting-supply stores as well as by mail order.

As I've mentioned, shooting at a deer is in some ways simpler than taking pictures of it. A hunter doesn't have to be as close to his quarry as the photographer does, and after the hunter's first shot is fired, the animal is either dead or off and running. A photographer's first shot is hopefully only the first of many exposures of the same subject; however, the photography can continue only as long as the deer is unaware of it. Constructing a good camera blind in a tree stand may be just the extra effort that pays off in pictures.

Using Food As Bait

What do bears gathered at a garbage dump and squirrels raiding a bird feeder have in common? Both were unintentionally attracted somewhere by food. Intentional baiting is standard practice for many wildlife photographers, especially those living in the country or in places sufficiently exurban to include fields and woods occupied by raccoons, opossums, and other small animals. Animals visit feeding stations at whatever feeding times are usually preferred by their species. Deer most often feed at dawn and dusk. Squirrels, chipmunks, and rabbits feed in daytime. Predators are most easily lured in at night.

Animals can become accustomed to a food supply at any time of year if they aren't hunted or threatened. Still, some seasons are bound to be better than others. The best season for baiting animals is when natural food supplies are scarcest, usually during winter and early spring. Where there are only wet and dry seasons, the dry season is often a better time for baiting because the ponds that remain function as good baiting sites. Baiting is best practiced regularly. Sporadically placing food in different locations at best yields sporadic results.

Many mammals are most active just before and after sunrise and sunset. I found this female white-tailed deer and her fawn feeding in a meadow about fifteen minutes after sunrise, and I exposed them for 1/250 sec. at *f*/8 on Kodachrome 64, using a 500mm lens.

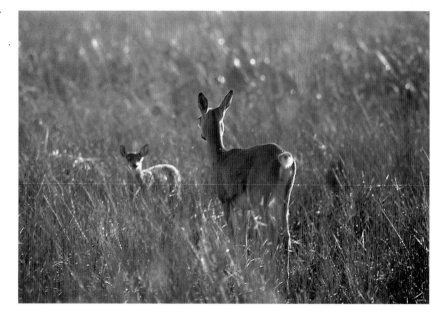

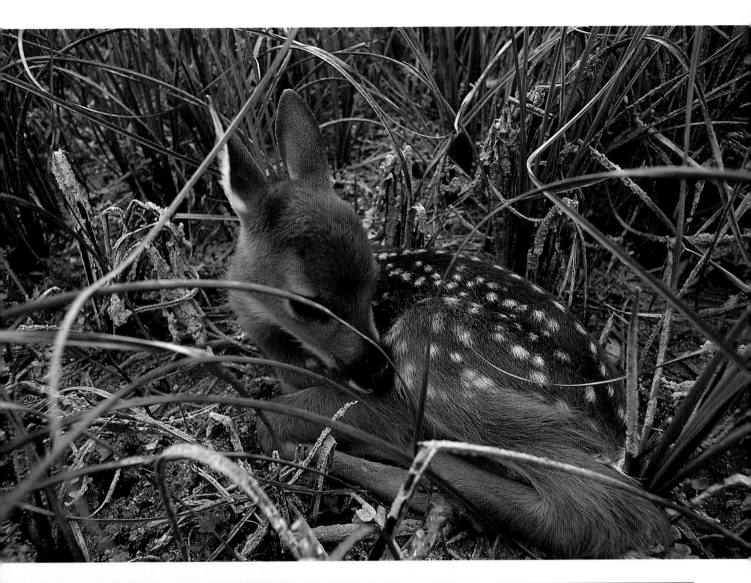

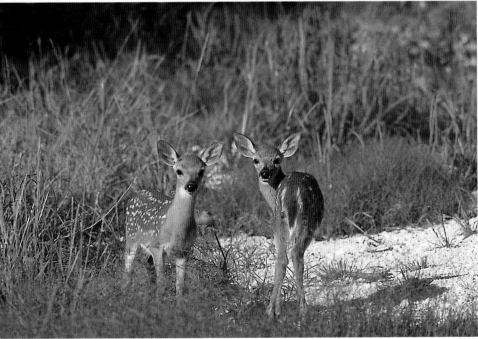

Female deer often bed down their fawns and leave them while they go off alone to feed. The fawns appear to be frozen in place; they instinctively hold still even if you approach within a few feet of them. I exposed this fawn with a 20mm lens for 1/15 sec. at *f*/16 on a dull, overcast afternoon.

Key deer, the nearly extinct race of miniature white-tailed deer found exclusively on some of Florida's lower keys, are easier to find by cruising side roads in a car than by looking for them on foot. I found these fawns about half an hour after sunrise on No Name Key. I photographed them using 70–210mm zoom lens, and my exposure was 1/250 sec. at *f*/8 on Kodachrome 64.

Where to Bait Mammals. There are several considerations involved in choosing the best place to bait your subject. One is that you want to be able to stay out of sight, even if your subject knows from your scent that you are present. If you live in the country, you may be able to use your house as a camera blind and lure such animals as raccoons, opossums, squirrels, and deer up to a window. Alternatively, you could use a shed or a barn, or construct a special permanent or semipermanent blind at another location. Be sure to take the background into account. If your yard is beautifully landscaped, you may prefer to use another, more natural-looking, site for photography.

If you decide to bait an isolated location and want to shoot photographs from your car, you should regularly visit and bait the spot with the same car. By regularly, I mean every day at the same time. Animals can tell the difference between one car and another. Using this tactic, you may discover that although the bait is being consumed, you never see any animals even if you remain in place for several hours. In such case, it is best to abandon the location unless you can erect a permanent structure there and regularly spend hours in it. In this type of situation, a camera trap (see the appendix) comes into its own.

The beauty of backyard baiting should now be evident. If you can lure your subjects close to a house, you are spared countless hours of fruitless waiting in blinds. You may want to plant some favorite wildlife and bird foods in your yard. You can work from a window in your house, erect a small blind, or leave a portable blind semipermanently located in your yard. However, blinds do offer some choices in terms of camera angle, and this advantage over using a house window can't be overestimated.

One commercial source of marshland, pond, and upland plants that are popular foodstuffs for animals and birds is Kester's Wild Game Food Nursery, P.O. Box V, Omro, Wisconsin 54963. The Kester catalog lists over one hundred plants that are attractive to wildlife and details the particular habitats in which the plants successfully grow. Planting natural foods offers an advantage over putting out food supplies on the lawn—the plants' natural growth makes a much more natural-looking background for the photographs.

State wildlife agencies are sources of possible subjects that are already, in effect, baited because in many states, various animals are fed during different parts of the year. Check to see if this is being done in your area by contacting the public information office of your state game commission or your local game warden.

Naturally, the best places to bait animals for photography are areas that ban hunting. Also, you can't expect to be allowed to bait or feed animals in public or private nature preserves where feeding the animals is prohibited. However, you could try contacting a conservation-minded farmer, rancher, or landowner who'll let you work on his property, particularly in exchange for prints of the best pictures you take.

Preparing the Right Menu. Animals' tastes vary from species to species and sometimes from season to season for the same species. I've found that peanut butter is universally popular with herbivorous and omnivorous mammals, regardless of whether you add oats or other grains. Grease is another favorite food, especially bacon grease mixed with grain. Deer are happiest eating the foods on which they naturally browse: twigs, small branches, bark, and shoots. If these preferred foods are in short supply, deer can be attracted with alfalfa or clover hay, or corn. Carnivores are best baited with aged meat hung as high as possible so that the scent will carry far and wide and lure them to the site.

If you start a feeding program for animals in the autumn and carry it into the winter, you should keep it up until the spring or at least until the heavy snows have melted away. In deep snow, deer can't travel far from their bedding area, or yard, so you'll be most successful if there are dense stands of trees near your feeding station.

Baiting Animals with Scent

Trapping-supply houses sell many kinds of olfactory lures. Here are the names and descriptions of a few:

Fox Lure No. 1: This lure is composed of fox glands and secretions and not only calls foxes to your sets but actually makes them less suspicious. This scent is intended for autumn use but is always good for attracting the red and gray fox.

Fox Lure No. 3: This lure contains an assortment of fox aphrodisiacs and is extremely valuable during January and February.

Mink Lure No. 1: Made from female mink glands and urine, this long-lasting lure has a true and natural odor that is ambrosia to far-ranging buck mink.

Wolf and Coyote No. 4: This powerful food and curiosity lure is very lasting.

The success of these olfactory lures depends on one or more of three animal instincts: hunger, sex, or territoriality. If you order olfactory lures from a trapping-supply house, use them sparingly. Most of them come in small one-ounce bottles. A few drops are all you need at one time. Instructions for using the lure should accompany it, but if you're not an experienced trapper or a research biologist who is thoroughly knowledgeable about animal habits, buy some of the small booklets sold by the trapping-supply houses that describe where to find animals and, more specifically, where to set traps for them. Substituting your olfactory lure for the trap, devise a camera blind for viewing and photographing the animal when and if it comes to the

Fox squirrels are rare but relatively tame. I lured this animal into the range of my 70–210mm zoom lens by offering it peanuts. My exposure was 1/60 sec. at ƒ/5.6 on Kodachrome 64.

Racoons are fairly easy to bait. They have little fear of people and may crawl into your garbage can looking for food or try to hibernate in your garage. Happily, I encountered this one in a forest, a more photogenic place than a driveway.

scent, or set up a camera trap. Your success in using olfactory lures to bring animals within camera range depends on more than the attractiveness of the scent. You'll still need to practice all the camouflage techniques discussed earlier in this chapter.

It is forbidden to use olfactory lures in national parks. Be sure to get permission from the local representative of the forest service or from the refuge manager in national forests or national wildlife refuges. You should also check with your state game commission and at state parks, state preserves, and private refuges to see if these areas permit baiting for photographic purposes.

Your best bet for using olfactory bait may be on private lands that don't permit hunting or trapping. Whenever I want permission to take pictures on private land, I seek out the landowner or his or her representative and ask for permission, which is usually granted. Most landowners have a genuine affection for the animals on their property and are happy to have someone take pictures of them. I don't trespass on private lands without the landowner's permission, nor should you.

Luring Animals with Sound

Animal-scent suppliers carry substantial libraries of records and tapes featuring sounds that are attractive to a variety of animals and birds. They also sell special record and tape players that are used by hunters. These players can produce a greater volume of sound than the small cassette players intended for your home and office.

The sounds that attract predators are generally the sounds of terrified or tortured prey animals, hardly music to my ears. Some of the recorded calls and the animals they are meant to attract are:

Baby Jack Rabbit: These high-pitched squeals call predators of all kinds.
Jack Rabbit: A medium-pitch distress cry calls coyotes, wolves, bobcats, foxes, and other predatory animals and birds.
Red Fox Pup: This distress cry calls foxes.
Javalina Pig: Pig squeals call javalinas, alligators, and other predators.
Squealing Woodpecker: This very effective call lures cats, raccoons, foxes, coyotes, and all birds.

Elk Bugling: This is the sound of a bull elk during rutting season.
Moose: The mating sounds of cow and bull attract all bulls within hearing.

Devices for Simulating Animal Calls. One of the main disadvantages of using records or tape recordings to attract animals is the bulk and weight of the tape player. How far you plan to travel from your vehicle to try using sound as bait is the big factor. Traveling with heavy equipment is less of a problem in wide-open spaces than in dense forests where there is no possibility of using your car to drop off your gear.

A lightweight alternative is to use the many tools available for simulating predator and game-animal calls. These devices look like whistles, and the sounds they make come from a reverberating diaphragm or reed. It takes skill and practice to use most of these tools. If you want to try them and can't find a good teacher, there are instructional records to help you.

Don't overuse your animal calls. For example, don't expect to have success with predator calls more than once a year in a given area, and by area, I mean several square miles. Once a coyote or bobcat is fooled by a tape recording or a diaphragm call simulating a distressed prey animal, he won't be fooled again in the near future.

How to Stalk

There are two ground rules for stalking wary animals: 1) Stay downwind. Be sure the wind is not blowing from you directly toward the animal. 2) Only move when the animal isn't looking your way.

If your subject lowers its head to feed, you can walk straight toward it as long as its head is down. If the animal isn't actively feeding, don't approach it directly even when it isn't looking your way. Instead, take a zigzag course to bring you in closer. Don't look directly at the animal. If the animal shows signs of nervousness, your best tactic is often to sit down for several minutes and watch your proposed subject from the corner of your eye. A direct approach is more successful with individual animals than with herds where one or more members usually serve as lookouts.

The favorite habitat of white-tailed deer is the edge between forest and meadow. The deer there often

Baby animals are often easier to photograph than adults since the babies are much less fearful of humans. I shot this young opossum at f/8 with electronic flash using a 105mm lens.

Here is the same opossum; I made this exposure at f/16 with electronic flash and a 105mm lens.

freeze in place at your approach if you don't walk directly toward them. They rely on their camouflage against the forest for protection.

Plains herbivores, such as pronghorn and bison, behave quite differently. Pronghorn have excellent eyesight, so approaching a wild herd closely enough to photograph it is difficult. Pronghorn usually flee as soon as they spot you in the distance. One solution is to work with an assistant who gets behind the herd and spooks them toward you while you lie in hiding.

Since the extinction of the plains wolf, bison have been the lords of their natural environments, and in areas where they are not hunted, they are quite fearless of man. When you approach them, make sure they know you are human. If they don't recognize your shape or human scent, they may approach you out of curiosity. If you stalk bison, use the zig-zag method, and don't wander too far from your car—you'll want to be within easy distance of it should an animal begin to charge at you. Male bison are particularly aggressive during the rutting season. Females can be dangerous too, and you should be especially careful not to come between a female and her calf.

The parks and preserves where I've photographed bison have good roads for seeing and photographing the animals from a vehicle. Of course, the animals aren't always just where I want them for photography, but it is possible to get pictures by waiting or driving along until a photogenically located bison appears, instead of by walking across the hills in search of them. In fact, I go out of my way to avoid approaching bison on foot.

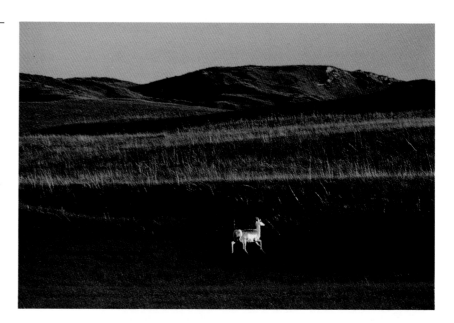

Upon rounding a hill in the Nebraska sandhills in my car I spotted this pronghorn at rest. He immediately trotted off while I shot off a few frames. My exposure of 1/500 sec. at ƒ/5.6 on Kodachrome 64 was based on the sunny ƒ/16 rule.

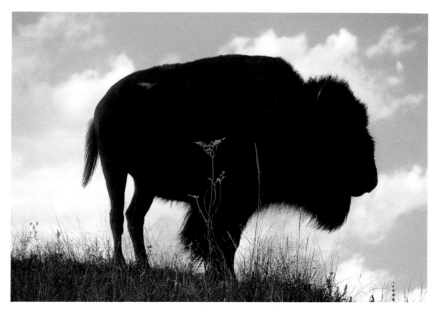

I exposed this scene for the bright sky behind this cloud-shadowed buffalo bull, shooting for 1/250 sec. at ƒ/8 on Kodachrome 64. I took the picture from a car window.

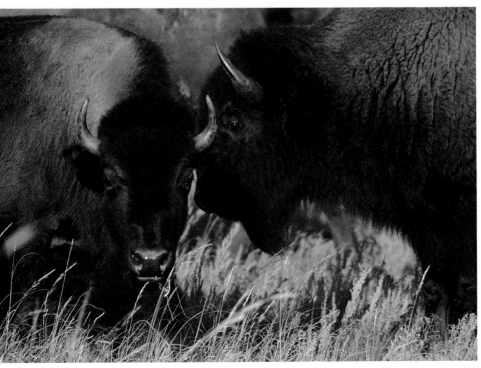

Every wildlife frame that you shoot doesn't have to be filled from edge to edge with the animal. Magazine editors also like pictures showing the animal in its environment. This buffalo is part of a herd at Fort Niobrara National Wildlife Refuge near Valentine, Nebraska. I exposed the scene with a 200mm lens for 1/125 sec. at f/8, on Kodachrome 25.

For your own safety, the best way to approach many animals is from a vehicle. If you were on foot and came as close as I did to frame these bison, they would either flee or charge at you. I made this picture from a jeep at Fort Niobrara National Wildlife Refuge near Valentine, Nebraska.

Equipment and Techniques for Stalking. You need telephoto lenses and telephoto zoom lenses when you stalk animals. The focal-length lens I most frequently use is my 300mm. It is short enough so that I can handhold it, preferably at a shutter speed of 1/250 sec. or faster. This lens and shutter speed combination adheres to the rule of thumb stating that lenses shouldn't be handheld at shutter speeds longer than the reciprocal of the focal length lens in use. For 500mm lenses you should use speeds of 1/500 sec. or less. (I generally don't recommend handholding cameras—it is always preferable to work from a tripod. Only in a real pinch should you try to handhold your camera.)

The other lens I always carry with me when I'm out for animal pictures is a 70–200mm zoom. This zoom and my 300mm lens account for 99 percent of the successful animal pictures that I've taken. Other wildlife photographers favor a 400mm focal length. I think whatever focal length you choose is a personal matter—you should work with whatever lens makes you happiest. I know several photographers who work with lenses designed to be used with or without a special teleconverter supplied by the lens manufacturer.

Shooting a Photo Essay of Prairie Dogs

Taking single pictures of any subject is different from covering it in a photo essay. Both are interesting approaches that require different types of thinking. In one sense, a photo essay is a compound entity made up of single photographs. However, these photographs must be sufficiently different from one another—in terms of the activities portrayed, lighting, camera angles, camera-to-subject distances, exposure techniques, lenses, and composition—to give the editor and art director a variety of images for making an interesting layout.

I did this photo essay on prairie dogs some years ago for *National Geographic* magazine. What you see is part of the outtake, pictures not run in the magazine. If you like, you can compare them with those that were published by going to your library, finding the August, 1979 issue, and looking over "The Hard Life of a Prairie

I often find animals to photograph while searching for another species. This weasel was hunting in a prairie-dog town when he paused for this picture. My exposure was 1/250 sec. at ƒ/8 on Kodachrome 64, using a 300mm lens.

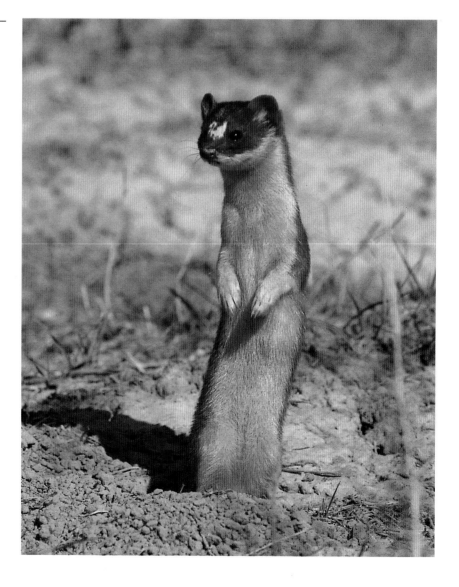

Dog" starting on page 270. I shot thousands of pictures for this story over the course of two consecutive springtimes. I want to discuss some of the photographic and nonphotographic problems and decisions that arose while executing this story so that if you're interested in doing wildlife photojournalism, you'll have some idea of what it entails.

If you propose a story to a magazine, be sure that there is indeed a story that can be photographed. Getting close enough to the animal to see and photograph it is not always possible, at least within the budget constraints of most publications. Before I could in good conscience make a definite story proposal to *National Geographic*, I knew I'd have to go to a prairie-dog site to see if I could get close enough to the animals to take good pictures.

My first step was to go to New York City's American Museum of Natural History library to research the existing literature on prairie dogs. This consisted largely of PhD dissertations that described prairie-dog behavior observed in the field. For my purposes I

decided to concentrate on two species: the endangered Utah prairie dog living in the mountain valleys of southwest Utah, and the black-tailed prairie-dog that inhabits the Great Plains. Regardless of their species, all prairie-dog offspring emerge from their burrows on practically the same day in spring, which meant it would take me two years to provide thorough coverage of both the species I wanted to photograph. I discovered, through contacts with editors at *National Geographic* magazine and by networking with museum and university mammalogists, that research was going on at a Utah prairie-dog colony. My experience with field biologists has generally been excellent. Most field researchers need quality photographs of their subjects and sometimes of themselves working, so the chances of getting permission to work with them in the field are reasonably good. I then arranged to meet the researcher in Panguitch, Utah and to visit the colony with him.

Seeing the prairie-dog town, I realized I'd be able to get close enough to the animals to photograph their

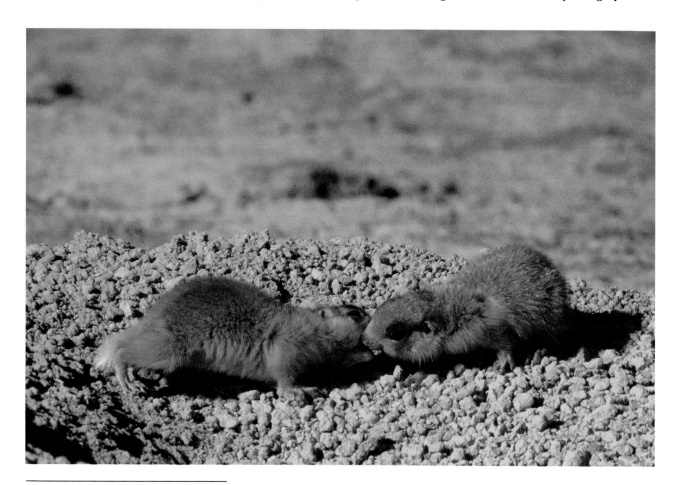

"Kissing" is a frequent activity between all prairie-dog generations. These are Utah prairie dogs.

behavior from my car. There were several dirt tracks crossing the colony, and by driving along them, I could photograph the animals living in the adjacent burrows. After spending a few days in Utah, I returned to New York and wrote a story proposal for *National Geographic* that included information on the prairie dog's social behavior and taxonomy, why I could cover the subject photographing two of the five total species and which two were best, where the best places to shoot were, what their seasonal behavior is like, why this story would have to be shot over two years, and why an article on prairie dogs was timely as well as interesting. After getting the assignment, I made arrangements to meet with the Utah researcher on the exact day that the young came up out of the burrows, the time when the social behavior of the animals was most evident.

The photographs I took throughout the assignment were straightforward documentary pictures of grooming, feeding, nursing, pups playing, and mock fighting.

However, they weren't as easy to get as you might think from seeing the results. None of these activities went on constantly, and I often couldn't photograph what I observed. Frequently, the action took place too far from the camera and was over before I captured it because I was focused on a different group of prairie dogs. Sometimes the pictures didn't clearly show the relevant activity because one animal was behind another or the angle of the camera was wrong. For example, several days labor might bring me close enough to take only one good sequence of prairie dogs playing, grooming, or fighting. In fact, during the entire assignment I shot only one good sequence about burrow building, one good sequence of pups playing, and a couple of good shots of them nursing. Although prairie-dog behavior is easy to observe, it isn't that easy to shoot—that is why most prairie-dog pictures are essentially the same picture of an animal sitting on its haunches at the entrance to its burrow.

In my opinion, this is one of the only truly amazing shots I got during the entire prairie-dog assignment, and I only saw this behavior happen once. The picture shows cooperative burrow building. The black-tailed dog you see is hammering soil with his nose onto the cone-shaped exterior of a burrow, while the presence of his fellow worker inside the burrow is evidenced by the mud that is flying through the air. I made this shot (and all the others not attributed to a different focal length) with a 300mm lens. The exposure was 1/500 sec. at ƒ/5.6 on Kodachrome 64.

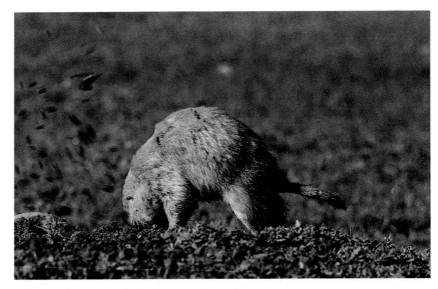

I photographed this adult Utah prairie dog carrying nesting material into its burrow by using a 300mm lens. My exposure was 1/250 at ƒ/8 on Kodachrome 64.

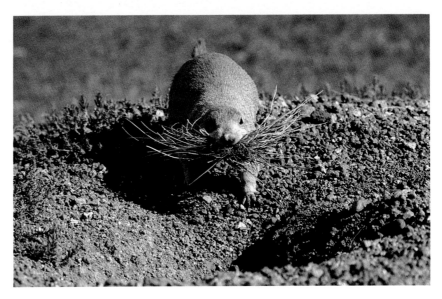

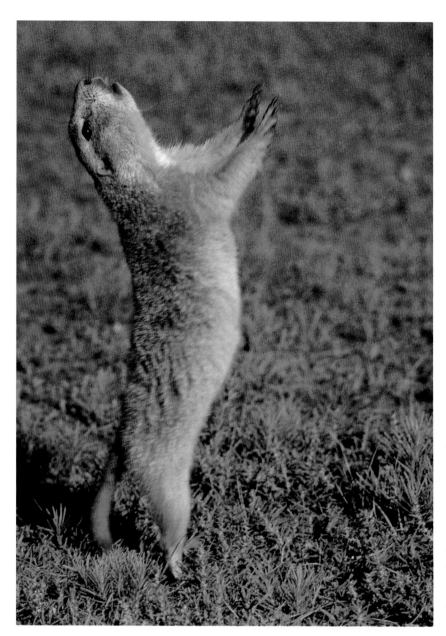

Prairie dogs emit several distinct and significant calls. When near their burrows, they vigorously throw themselves up and backward during their most often uttered vocalization, a call, shown in both pictures, that seems to say, "This is my home, and I am at it." The top picture shows an adult black-tailed prairie dog, the bottom an adult Utah prairie dog (note the different posture of the arms). The young give voice to this call as soon as they emerge from their burrows.

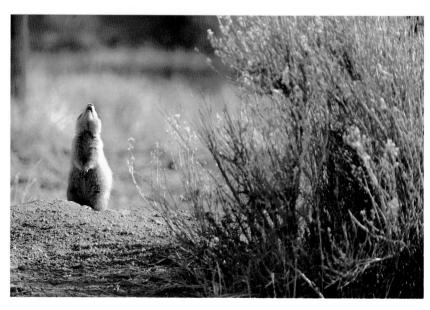

I shot many sequences of young prairie-dog pups nursing, doing mock battle with each other, and perching on their mothers' backs. Mutual grooming between adults and between adults and their offspring is another common prairie-dog activity. You can see it going on all around you at prairie-dog towns on lands where prairie dogs are protected, but getting close enough to photograph it is rare.

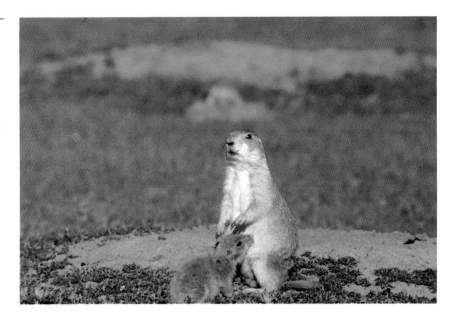

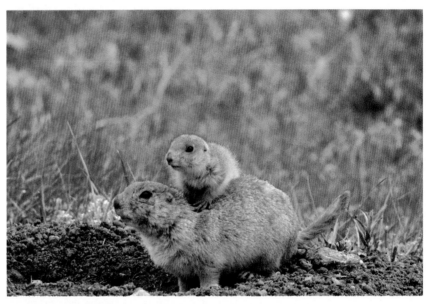

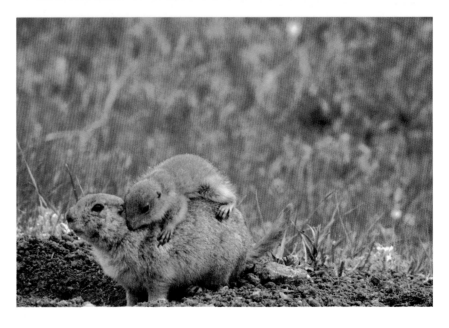

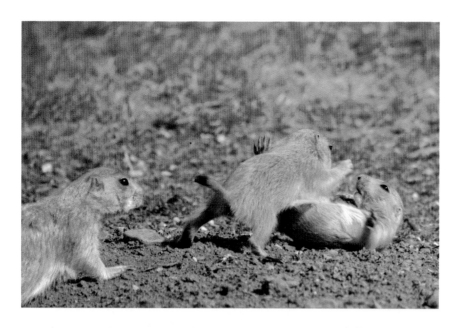

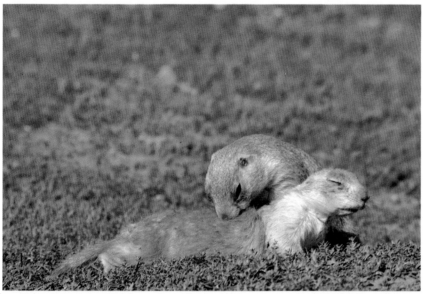

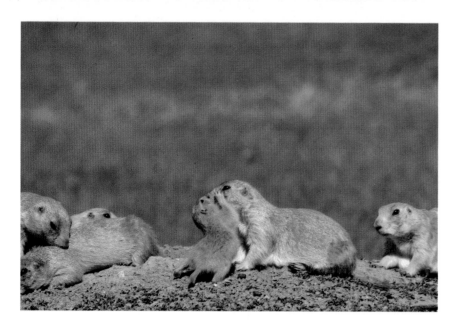

I made aerial as well as ground-level shots for my prairie-dog story. Here, members of the Utah State Game Commission are shown capturing prairie dogs for release in another location. When I shoot aerial photographs I always use the highest shutter speed possible—1/1000 sec. on my camera—to reduce image blur resulting from the plane's vibration. I made this picture with a 105mm lens set at $f/4$ on Kodachrome 64.

Including a picture that compares your animal subject with an object of known size is a good idea. The tiny size of this baby black-tailed prairie dog is revealed in comparison with a researcher's boots. I exposed the picture with a 55mm lens for 1/60 sec. at $f/16$ on Kodachrome 64.

In the top picture a biologist is painting distinctive strips on a young black-tailed prairie dog to identify it during behavior studies. The three black-tailed siblings below were given unique stripes for study at their home burrow. I used a 55mm macro lens to expose both pictures at 1/125 sec. at ƒ/11 on Kodachrome 64.

Shooting my story required more than straight wildlife photography; for instance, I also had to photograph the various researchers at work. In fact, I did a little picture story on each of them, documenting their own particular activities with prairie dogs. This assignment also involved driving thousands of miles around the plains making arangements with several different researchers and trying to show the other animals that make use of prairie-dog burrows, among them burrowing owls, toads, rattle snakes, weasels, and rabbits. But in the end, I think all my effort was worth it.

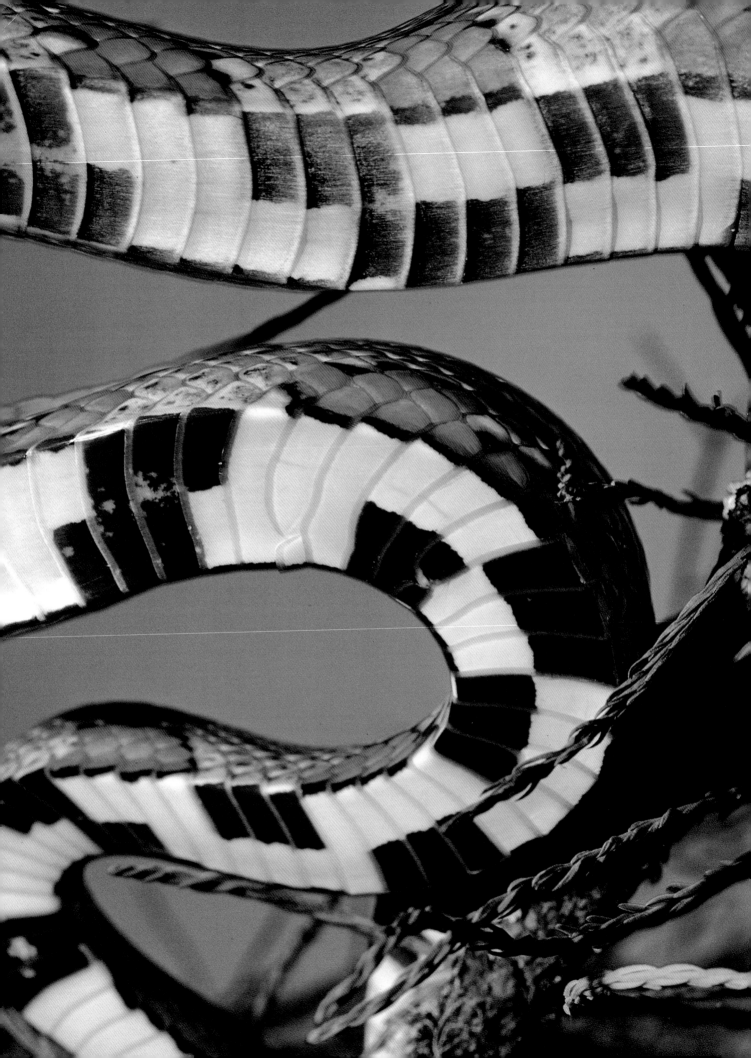

Chapter Six

AMPHIBIANS AND REPTILES

Most people have a natural affection for such warm-blooded animals as mammals and birds, but few have equal regard for amphibians and reptiles, two of the three classes of cold-blooded vertebrates. If you're not already a reptile-and-amphibian, or *herptile*, enthusiast, learning something about "herp" behavior and their ecological roles may convert you. For example, I became much more interested in *saurians*—crocodiles and alligators—when I learned about their complex social behavior. Female saurians help their young hatch and guard them for about three years until the offspring can defend themselves. Snakes increased greatly in my estimation when I became aware of the invaluable economic role they play in keeping areas free of disease-ridden rodents that devour and despoil crops. As for frogs and toads, I became a fan when I found out that they feed on insects that bite humans.

Distinguishing Reptiles from Amphibians

Those of you who are naturalists and biologists may be able to readily distinguish between reptiles and amphibians. It's important for anyone who plans to photograph them to understand the distinction, because the care and handling of amphibians and reptiles differs in some respects. Their most important similarity is that both are cold-blooded and control their body temperatures by moving to warmer or cooler environments. Most herps are comfortable living in temperatures between 70°–83°F.

Here are some of the differences between amphibians and reptiles: Reptiles have claws and dry skin mounted with scales, shields, or plates. They lay watertight eggs on dry land, and their offspring when hatched look like small versions of the adults. Snakes, lizards, turtles, and alligators are all reptiles. Amphibians are clawless and have moist, glandular skins. After they hatch from eggs that are almost always laid in fresh water, most amphibians pass through a larval aquatic phase that looks very different from the adult. Frogs, toads, and salamanders are all amphibians.

The herptiles that are most often confused for one another are: salamanders for lizards, salamanders for snakes, and some specialized lizards for salamanders. In their adult form, many salamanders have lizardlike shapes; others are legless and resemble slippery snakes. Because it is important to identify your subjects, a field guide to herptiles is invaluable.

Amphibians should be kept damp, or wet and cool; reptiles should be kept dry and cool. Apart from this important difference, many of the tools and techniques for capturing, storing, and caring for amphibians and reptiles are the same.

I seized upon a not-often-seen aspect of the corn snake, a tree climber, by placing it in a small cypress tree. Then I sat on the ground and photographed up at the snake to show its spectacular underside.

Collecting Herptiles for Photography

My photographic approach to most herps differs significantly from the methods I use for mammals and birds. I often collect the smaller herps—frogs, toads, salamanders, snakes, lizards, and fresh-water turtles—in order to photograph them later. There are several reasons for this technique. One is that although dusk and nighttime are the best times to find many herps, I would rather photograph them by available daylight than by flash at night. Another reason is that herps are often found in unphotogenic places. Camouflage is an important herp survival mechanism. Often I can hardly see my subject against its natural background. A third reason is that when you come in close enough to effectively photograph herps in their natural habitats, most become agitated and try to escape. However, if they are confined, handled, and fed for several days, many become tame and easy to pose.

Why Assistants are Necessary. Many of the small herps you see pictured in this chapter were first captured and then released for photography in more photogenic surroundings. I employed help in catching these animals, and later, in taking pictures of them. Unlike other photographic fieldwork where having an assistant is often an asset but not usually necessary (I've made most of my pictures of mammals and birds unaided), photographing herps requires assistance. Most of the photographs you see in this chapter couldn't have been made without help. The photographer must be free to take a picture as soon as the herp is released or posed. Prefocusing a tripod-mounted camera and then using a cable release with one hand while posing the subject with the other is no substitute for working with an assistant who handles the subject.

Catching Herps. Bare hands are all you often need to capture herptiles. Many herps—frogs, toads, salamanders, lizards, and some nonpoisonous snakes—can be grabbed by the midsection. Others, especially those that hold still until you are virtually upon them, can be gently immobilized with your hand by pressing them against the surface on which they rest. However, tools can also be helpful, especially the snake sticks available from Carolina Biological Supply Company, Burlington, North Carolina 27215. On one end of a snake stick there is a set of pincers, and one of them is hinged. Operated from the other end, the pincer can gently close over a reptile and immobilize it. Many herpetologists and photographers make their own snake sticks by attaching an angle iron to a pole. Different-sized snake sticks are meant for use with different-sized snakes. Carolina Biological Supply also has a huge assortment of nets in various shapes and sizes for catching herps, but you can buy nets from local hardware, sports, and pet stores, too.

I found this native green tree frog resting on an exotic bromeliad in an Everglades friend's backyard. I used a 105mm macro lens to expose the scene for 1/60 sec. at *f*/8 on Kodachrome 64.

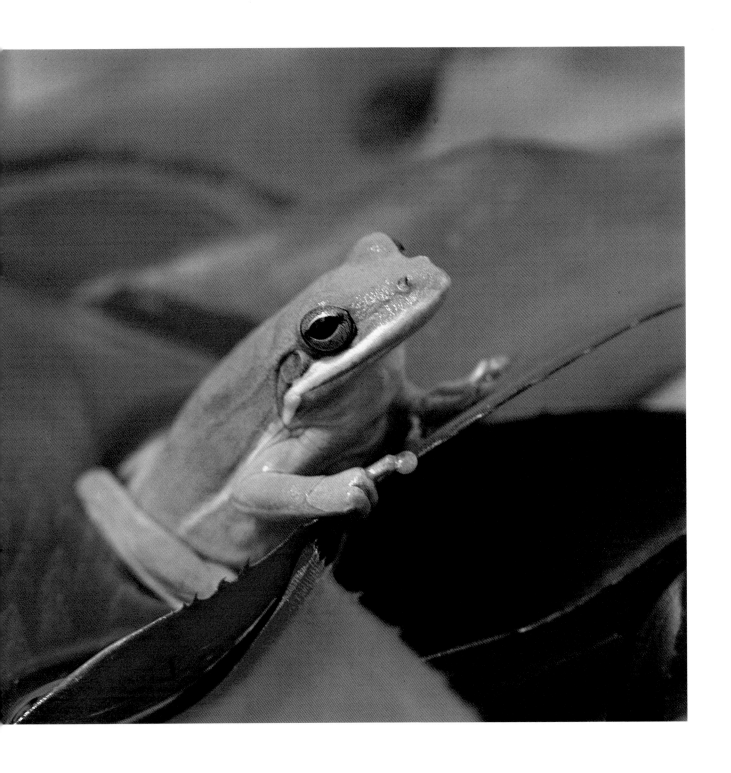

The most widely used container for holding herps just after they've been captured is the snake sack, a canvas bag about the size of a pillowcase with tightly sewn seams. These sacks are self-knotted instead of being secured with twine or a wire tie. Several sacks can be stuck under your belt if you are on a collecting expedition, leaving your hands free. Some herpetologists prefer to use heavy-duty, clear-plastic bags because their contents can be identified at a glance.

Always put different species of amphibians and reptiles in different sacks. Sacks containing amphibians should be kept wet, and sacks containing reptiles should usually be kept dry, but if you're working in very hot weather, you may want to include some wet paper toweling or leaves with your reptiles; the evaporating water will help keep them cool.

Glass jars with perforated lids are better semipermanent containers than sacks, especially for amphibians. I always carry some empty jars in my car trunk, with foam packing material between them to prevent breakage. Wide-mouth gallon jars are particularly useful. I get mine from a restaurant that purchases mayonnaise and mustard in them and is happy to save empties for me. I wash and rinse the jars and lids thoroughly, before and after using them. I punch breathing holes in the jar lids from the inside out to protect the captives from possible cuts and abrasions.

I usually photograph amphibians and reptiles within a day or two of capturing them and always release them wherever I find them, except for the ones I pick up on roads. I let these go at least a hundred yards from any roadway.

I photographed the two pig frogs early one morning on what became a very hot day. Early morning is the best time to work outdoors with any herp because morning is usually the coolest time of day, a time when herps are least active. The lily pads where I put the pig frogs lend scale to the photograph, just as the cabbage-palm trunk does to the barking tree frog.

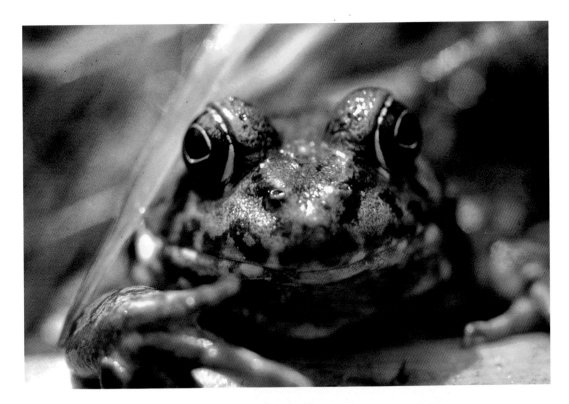

These pictures of a leopard frog and a cricket frog were made on a permanent set created for herptile photography. Ross Allen, the herpetologist helping me, posed the leopard frog in the top picture several times before the animal held still and let me close in on it with my camera. The illumination was natural light from an overcast sky. I used a large aperture and focused on the frog's eyes, and the resulting limited depth of field doesn't detract from the picture. I wanted the fastest possible shutter speed to minimize the effect of any camera movement because I was handholding the camera.

I photographed the tiny, almost transparent, cricket frog in the bottom picture on the same set, but here I used electronic flash, one unit held about two feet away to the left of the subject. Because the flash was quite powerful, I used an aperture of $f/22$ for correct exposure.

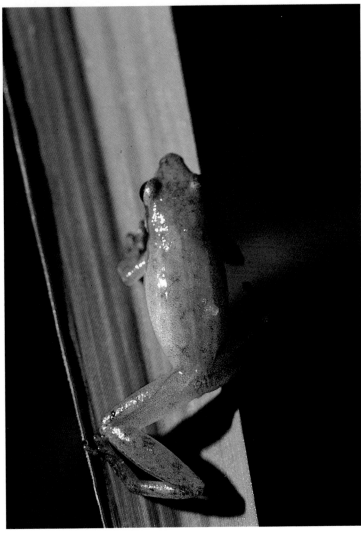

Housing Your Herps

You must be very careful not to leave any herps caged, boxed, or bagged in direct sunlight or in a locked car parked in the sun. In the winter most houses in temperate zones are too cool for herps. With insufficient warmth they will probably stop eating and may even try to hibernate. It this would be a problem for your herps, you should heat their quarters. Be careful to keep amphibian quarters humid. If necessary, enclose sponges with the amphibians and keep the sponges wet. If you don't, the animals may die of dehydration.

Don't permit hibernation! While the ambient temperature in your house may be too cold to keep herps moving and eating, it isn't cold enough to make hibernation practical. Without extreme cold a herp's metabolism will continue at too fast a pace, and it will burn up its own body tissue and die of starvation. To warm aquatic herps I use an aquarium heater set at 75°–85°F. I put electric heating pads or electric blankets under herp cages to keep terrestrial herps active throughout the winter months. Special heaters for animal cages are sold at pet stores.

There are wonderful cages, or environments, available commercially as long-term housing for herps and for other animals. Carolina Biological Supply Company carries an assortment, but the most generally useful containers are aquaria that you fix up to suit the occupants. When you capture an animal, its surroundings reveal much about what it requires in the way of housing and climate. A field guide can tell you even more. A swamp amphibian may require a terrarium floored with several inches of black dirt atop charcoal and planted with tropical vegetation. This terrarium should contain a large water dish in which the animal can sit if it wishes. On the other hand, if your guest is a desert snake, you may want to scatter clean, dry sand in the aquarium and put in a substantial water dish. Always include a hiding place—a piece of bark or wood, or a flat stone propped up on smaller stones—for the animal.

As for frogs, toads, and salamanders, the terraria or aquaria you use should have tight-fitting lids made of screen or glass. Salamanders are unlikely to jump out of containers, but they will crawl out if given a chance. Like other herps, salamanders need to have a hiding place, and a terrestrial salamander in a terrarium should have a large water dish.

Reptiles can drink and immerse themselves in water that comes directly from the tap. But tap water for amphibians should be aged—let it stand overnight. Amphibians' skins are moist and permeable, and the chlorine added by many communities to make water safe to drink will harm amphibians. Letting their water sit overnight permits the chlorine to evaporate.

I captured this cricket frog and held it overnight. The next day I posed it and photographed it on these colorful leaves.

My herpetologist assistant, Rhea Warren, posed this barking tree frog on a cabbage-palm trunk similar to the one on which he had found the frog the preceding night. The frog stayed where Rhea placed it, and I was able to make several different pictures from various distances.

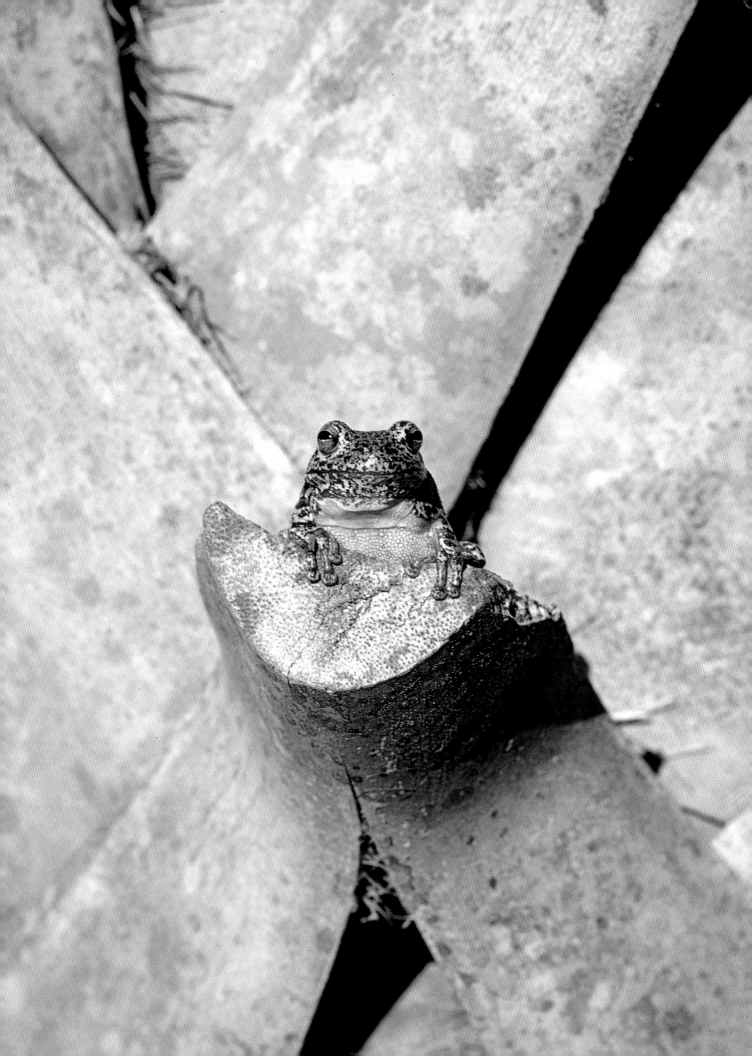

Working with Frogs and Toads

The best season for finding frogs and toads is spring-time. The best places to search are the ponds and sections of streams that frogs and toads favor for breeding and spawning. Some of the ponds in which amphibians lay their eggs are really large puddles and are therefore fish free, which offers protection to the eggs. Frogs and toads will travel miles to a preferred pond, bypassing other ponds along the way. During the breeding season, frogs and toads call loud and clear, and different species give voice to different calls. Most herpetologists are knowledgeable about the calls and can locate a specific type of frog or toad by its voice.

Warming temperatures and rainfall trigger amphibian breeding. In good habitat areas the first warm spring rain brings out frogs and toads in droves. For example, the time of year this usually takes place in New York is late March to early April. The males usually reach the preferred breeding territory first and do the calling, and the females come to their calls. When the females arrive, the males leap on top of them and grip them from behind. This breeding position is known as *amplexis*. Toads remain in amplexis for as long as two weeks. Frogs rarely, if ever, remain in amplexis for more than a day. Frog and toad eggs are externally fertilized as they are laid.

After the breeding season, frogs stay active in moist, humid habitats or live close by streams or ponds. Toads are able to occupy much drier environments, and some disperse to habitats far away from surface water. There is no reason why you can't capture and photograph frogs and toads at any time of year that they are active. I recommend their spring breeding season only because the greatest concentrations of frog and toads in any one place occur then.

Most frogs and toads call at night, and that is when they are easiest to catch. A specimen that is unapproachable during the daytime will let you come right up to it after dark. Working with a colleague is a great help when stalking frogs and toads. It isn't difficult to determine the direction from which a call is coming. You and your colleagues should separate and approach the subject from different directions, stopping frequently to point a flashlight toward the source of the call. When you both meet, the frog or toad should be very near; however, it still may take a lot of work to find it because it may be hidden behind leaves or under grasses. If you think that a particular frog or toad is rare, a thorough search for it may be worthwhile, but if it is common to the area, it may take less time to locate another member of the same species.

The only frog and toad photographs that must be made on location are pictures of the males calling because captive males won't usually call. You can get within a foot or two of calling male frogs and toads. Go slowly and have your camera preset for the magnification you want; in other words, have the lens prefocused for your shooting distance. A certain amount of stumbling is hard to avoid if you're chasing about in a swamp after dark, and you risk ruining your camera equipment doing it. For this reason alone it makes sense to confine most of your nighttime fieldwork solely to collecting specimens, leaving your camera and flash units in a dry place.

A picture of a captive specimen can be set up on a landscaped stage or in an aquarium. You can also pose a subject outdoors in more photogenic surroundings than where you found it. Some nature photographers only work indoors with herps, so they collect local foliage, earth, and rocks along with their animals to make their backgrounds look more authentic. I prefer working outdoors in a natural setting. You can keep frogs and toads for several days in glass jars, but be sure to include damp paper towels, leaves, or foliage with them. If you have an aquatic frog, you should include some of its pond water in the jar.

Providing Food for Captive Animals. If you intend to keep a frog for more than a few days, you should be prepared to feed it, and of course you should also give it larger quarters than a jar. Most frogs and toads are insect eaters. In the summer you can easily feed them by catching and collecting insects from screened windows at night when the insects try to fly to indoor lights. City pet shops often stock crickets, mealworms, and other live insects to feed frogs and toads.

Photographing Frogs and Toads. Look carefully at the eight frog and toad pictures in this chapter without reading the captions. Besides the picture illustrating amplexis, only one other was made unposed. I stalked the subject for several minutes until I was close enough to frame the picture. Can you guess which one? Two of the other pictures were completely controlled; I took them on an outdoor set landscaped strictly for photography. Two were made at locations chosen for their natural photogenic appeal. Their subjects could have been found exactly where you see them. The last picture can't be faulted photographically, but there is something so wrong with it I doubt it will ever be published outside of this book. Its amphibian subject is juxtaposed with most unlikely surroundings.

The set-up subjects were held for only two nights. I kept them contained in large-mouthed glass jars along with a little of the water in which they were found. Some photographers recommend chilling amphibians and reptiles in the refrigerator, but I don't believe it's a good idea. Herps are pneumonia-prone in captivity, and I am sure that artificial chilling isn't good for them.

96

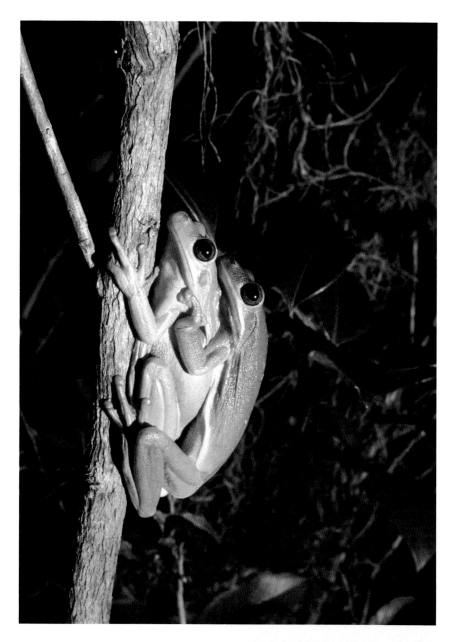

These two frogs are engaged in amplexis, the mating embrace of a frog or toad during which eggs are shed into water and fertilized.

This picture of a tiny toad posed on a lily pad is the blooper as far as staging a subject in a likely environment is concerned. The toad's next leap would land it in the water, not its natural dry-land habitat.

Seeking out Salamanders

North and Central America are home to more species of salamanders than all the rest of the world. True, the largest known salamander is not American; it is Japanese and five feet long. Still, our salamanders come in extraordinary shapes and sizes, many looking more like imaginary creatures from outer space than natives of Mother Earth. If salamanders are so unusual looking and so plentiful, why do Americans rarely see them? The answer is because most are aquatic, and all are nocturnal.

As with frogs and toads, the best time for a salamander search is at night during or after a spring rain. That is when terrestrial salamanders go on the march, looking for mates and laying their eggs in the water. Unlike frogs and toads, salamanders don't have mating calls, and in other respects, they have different life styles.

Most salamanders have an aquatic larval form and develop into terrestrial adults. Some terrestrial adults return to the water after one, two, or three years on land and redevelop gills for underwater oxygen absorption before mating. Some salamanders never completely metamorphose in the first place and grow instead into big larvae that reproduce. Some salamanders live underground, lack external limbs, and look like large earthworms.

Photographing Domestic Salamanders. Salamanders will become tame if hand-fed, and posing them presents no special problem. For illumination I prefer either electronic flash or soft daylight. Salamanders in their terrestrial form make ideal terrarium inhabitants. In their aquatic form you should house them in aquaria.

I feed earthworms to terrestrial salamanders. To draw a salamander's attention, I dangle a worm in front of it; then the salamander grabs the worm and swallows it. I've also fed lean ground steak to salamanders. I make a small ball of the ground meat and impale it on a toothpick. Moving the toothpick seems to interest the salamander the same way live prey would.

Searching for Snakes

When I first started to specialize in nature photography, I had an idealized and inaccurate view of the methods used by naturalists to find reptiles and other animals. To capture serpents I thought the experts went directly to the deepest, darkest center of the swamp to collect water moccasins and other water snakes; and to gather rattlers and other snakes that frequent dry areas, I imagined hunters traveling to the highest, wildest cliffs and pulling specimens from their dens.

This picture was made on the same stage set I used to photograph the frogs. The salamander shown is a burrowing, legless variety, and I couldn't devise any way of showing its natural surroundings. Instead, I aimed the lens straight down at it and framed the leaf to give some indication of scale. The illumination I used was sunlight.

A yellow rat snake that I planned to photograph started shedding when confined in a snake box. When Ross Allen and I noticed it, we rushed forth with the snake box and the camera in our respective hands looking for a photogenic location to record this behavior. The dead stump fit the bill, and I was able to take several pictures of the shedding process.

Compared to these expectations, my snake hunts have been anticlimactic. My most productive searches involve slowly cruising country roads at dusk and in the early evening. Roads retain the heat of the day, and reptiles crawl to them for warmth. Another good hunting ground is in and around culverts.

In snake country you can lure your subjects to you by propping a pile of boards or almost any low, solid object about an inch above the ground. Most snakes like to hide under things, and they seek cover and shade. When I lived for many months in a trailer in the Everglades, I regularly checked for snakes beneath a discarded skid left in the communal trailer yard. More often than not, I was rewarded with a new subject. I typically found species common to the region: rat snakes, several types of water snake, and pigmy rattlesnakes. I used a snake stick to raise the skid, protecting my hands from possible bites.

One of the reasons warm roads are particularly happy hunting grounds for snakes is that I can easily spot reptiles crawling on them, not just because roads enjoy an unusually high snake population. In snake-filled areas there are lots of snakes in the grass, in the trees, and in the mud, fields, and hills; however, snakes aren't easy to find because much of their protection from predators depends on their camouflage.

Catching Snakes. Catching snakes usually involves a little more effort than the smooth, swift, one-handed grab I recommend using for other herps. The standard snake-catching techniques calls more for fancy footwork than for deft manipulation. When I find a non-poisonous snake that I want to photograph crawling on the ground, I pin it down gently but firmly with one foot, keeping my heel on the ground and my forefoot levered down on the snake. I pin the snake as close as possible to its head. Then I bend over and seize the snake right behind the head. There is always a possibility that I'll be bitten. Having a snake stick three or four feet long helps a lot. With it I can pin the head to the ground after I've pinned the snake down with my foot. According to a popular rule of thumb, New World snakes can strike a distance of no more than one-third their own length. So the minimum-sized snake stick you want should be longer than one-third the length of any snake you try to handle.

This bull snake had been captured on the Nebraska prairie several days before this picture was made. Obviously ready for a good meal, the snake moved in on the curlew eggs as soon as it was released, and I was able to make a rare picture. By the way, this was not an active curlew nest. The nest had been deserted by the parent birds at least a week before I set up this picture.

Some snakes specialize in one kind of food or another. The hog-nosed snake shown on the left specializes in toads. These snakes have but one tooth, and they use it to puncture toads that puff up when threatened. Other herptiles also feed on toads, as shown in the picture of the toad being attacked by a garter snake.

I photographed the hog-nosed snake in the top picture engaging in its threat display where and when I found it; in fact, the display was in response to me. The garter snake was attacking the toad in the yard of a house in the Everglades, and it was the noise of the action that alerted me to it.

I put this yellow rat snake on a pine bough to illustrate the realistic situations in which I've found other yellow-rat snakes. They are expert tree climbers and often feed on eggs and birds.

I don't recommend using a forked stick largely because it is unlikely you'll have exactly the right-sized fork for the reptiles you find. If the fork is too long, the serpent will slip through it. If the fork is too short, you'll injure the snake or perhaps break its neck.

Finding a knowledgeable colleague is especially important when you're working with snakes. If you are not an expert in catching and handling snakes (and there is no reason why you must be a snake expert to take good pictures of snakes), make an effort to find an associate who is. If there is a nature center near you, ask for their recommendations. Also, check with a local high-school biology teacher. If you still haven't found an assistant, continue searching until you find one.

All Snake Bites are Serious. Bites from even non-poisonous snakes can cause much discomfort, even serious illness. The wounds often become infected because a snake's teeth and mouth harbor many different bacteria. As for poisonous snake bites, I have several expert friends who are missing a finger from snake bite and one friend with a sorely crippled hand from a bite received forty years ago. I never try to catch poisonous snakes. I leave that to the experts. If you feel confident of your expertise, go ahead and catch as many poisonous snakes as you wish, but please, never without a knowledgeable companion. Remember, my snake-bitten friends are snake experts. One was bitten by a "dead" diamondback rattlesnake that had been run over by a car hours before it came back to life. The biting reflex in many snakes is very strong. I've heard reports that I can't personally verify of decapitated snakes biting hours after they were beheaded. If you live or are traveling in poisonous-snake country, memorize the obvious characteristics of the local poisonous serpents before starting to work in the field. Poisonous snake bites should be immediately treated at the nearest hospital.

Housing and Feeding Snakes. If you fix up an aquarium as a snake habitat, you must make a very tight-fitting, secure, wood-and-screen cover for it. How you landscape it, if at all, depends on the reptile and its habits. Don't put several inches of dirt over charcoal the way you would in a terrarium housing amphibians. Snakes usually burrow out of sight, so it is better to leave the aquarium bare if you want to see your serpent. Don't forget to include a good-sized water dish; many snakes, even those from dry regions, like to soak themselves thoroughly.

Poisonous snakes should be kept in snake boxes, and the boxes should be clearly labeled "POISONOUS SNAKES". The snake boxes I've worked with were all homemade with solid wood on five sides. The sixth side should be partly made of screen and hinged so that it can be lifted to remove the snake.

In the wild, I've seen a few snakes, probably suffering from extreme hunger, ingest creatures that were long dead. Wild snakes usually eat only live prey, and live food should always be provided for captive serpents. Rodents are their most common food. Use your snake's size to determine the ideal size of its rodent prey, and feed your snake accordingly, from newborn mice for baby snakes to adult rabbits for large constrictors. In the wild, of course, snakes eat birds, eggs, frogs, and fish, in addition to rodents and small mammals. The type of food that you should offer a captive snake is indicated in field guides and in guides (available from pet shops) about the care and feeding of snakes. The veterinary staff and keepers at your local zoo are also good sources of information.

Posing and Photographing Snakes. The excitement of being pursued and captured usually thoroughly agitates snakes. However, if they're held for a couple of hours or overnight in a snake sack, they calm down and can be fairly easily posed. The snakes I've photographed have paused for a few seconds when first released, giving me a chance to expose some film before they moved away. When they start to move, I continue to shoot and can sometimes get enough pictures without needing to repose them.

As you did with the frog pictures, look at the snake pictures in this chapter without reading the captions. How many do you think were taken when I found the subjects? How many were posed or removed to different environments from where I found them? The answers are almost more surprising than with the frog pictures. Two of the snakes were photographed without being touched or moved in any way. Four were moved to more photogenic, natural locations and were released in better light than that in which they were caught.

I've watched herpetologists persuade small, non-poisonous snakes to pose for me by placing the snakes where I wanted them and cupping both hands over them as a kind of shelter. So covered, the snakes have evidently felt secure because they've stayed coiled where they were placed after the hands were removed. Putting a bucket or a towel over a snake will stop it from moving and induce it to coil. I suggest using a snake stick to flip the cloth out of the way or use tongs to remove it. Develop safe habits for all your snake handling; then you're less likely to be careless with a poisonous subject.

Capturing Lizards

Lizards are generally the hardest reptiles to catch. Swift moving, they usually flee before you are close enough to grab them with your bare hands. Always grasp a lizard around the middle of its body, never by the tail. Many lizards have detachable tails, which confuses their predators when they are attacked. When you or a predator grasp such a lizard by its tail, the tail breaks off and the rest of the lizard runs away.

Using a noose to catch lizards is worth trying, but don't expect immediate or 100-percent success. Make your noose out of fishline strung on a fishing pole or even plain string dangling from a long stick. If you can, loop the noose around the lizard's neck, and then move the noose gently upward. Jerking the pole too forcefully can break the reptile's neck.

Another technique for catching lizards is to use a net on a long pole or handle. A butterfly net is fine. Sidle as close to the lizard as possible, moving very slowly until the net is in position. Then snap the net down over the lizard as fast as you can.

These pictures of a cottonmouth moccasin displaying his cotton mouth on top and of the shy brown water snake beneath it were both made on my herptile photography set that I later used to photograph lizards and turtles. I was astonished by my subjects' responses in both pictures—astonished and delighted.

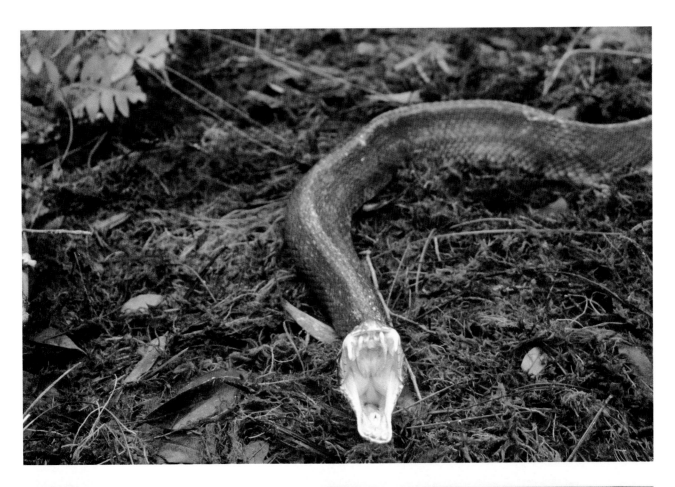

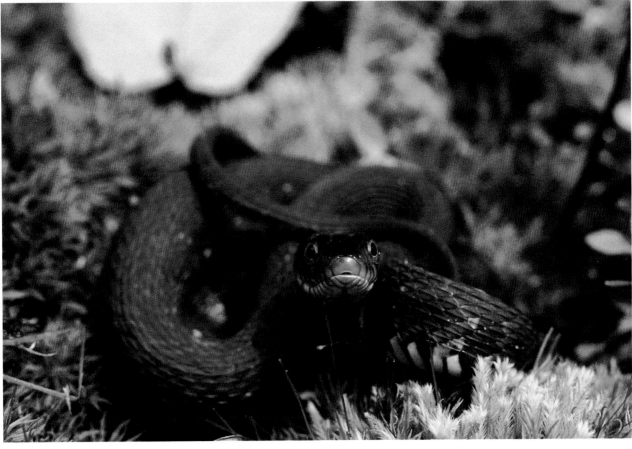

Some lizards, such as geckos, are nocturnal; some, such as green anoles, are diurnal. Nocturnal lizards are most easily caught during the day, and diurnal lizards are most easily caught at night. The green anoles living in the humid south don't have dens; because of their chameleon ability, they are usually safe sleeping in the open. You can find green anoles by examining bushes at night with a flashlight or a headlamp.

Food and Housing for Lizards. In the wild lizards usually eat insects. You should provide live food for any lizards you keep. Although a water dish must be included in any habitat you fix up for lizards, most lizards won't drink from standing water. Sprinkle or spray water on the inside of the aquarium glass, and your lizard will lick off the drops. Don't house lizards of substantially different sizes in the same aquarium, or you may end up with only one large lizard. This generally holds true for other herps as well.

Photographing Lizards. Like most other herps, lizards become tamer if exposed to human beings, especially if they associate humans with food and if the humans move slowly and carefully. If you've landscaped a terrarium for your lizards, you can photograph from there. If you want to release them in an outdoor setting, it is best to work in the early morning before the heat of the day. You can often make good pictures of wild lizards by slowly stalking them as they sun. Use a long lens such as a 200mm or 300mm and, if necessary, an extension tube to focus closer than normal.

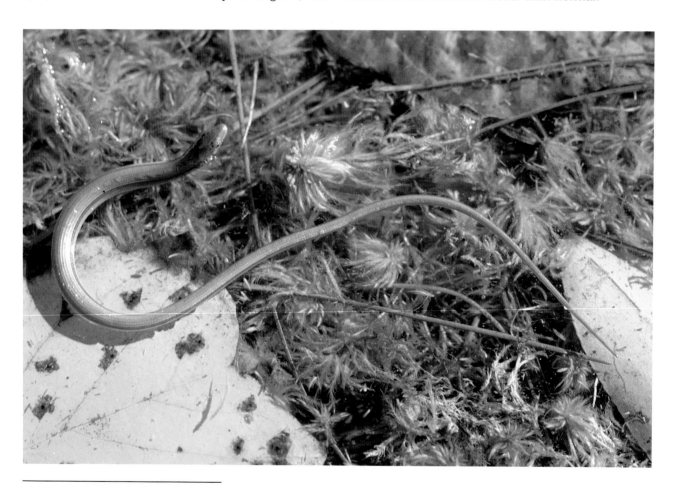

I found this legless glass lizard several days before I made this picture on my herptile photography set. Glass lizards are burrowers, and rarely are they as clearly seen in nature as the one in this picture although its surroundings are authentic. The glass lizards I've photographed have been very easy to handle and stayed where they were put long enough for plenty of picture-taking.

Although I photographed this green anole in the early morning, I had found and caught it the preceding night. I used flash for illumination and was able to make several photographs of it before it moved from its branch.

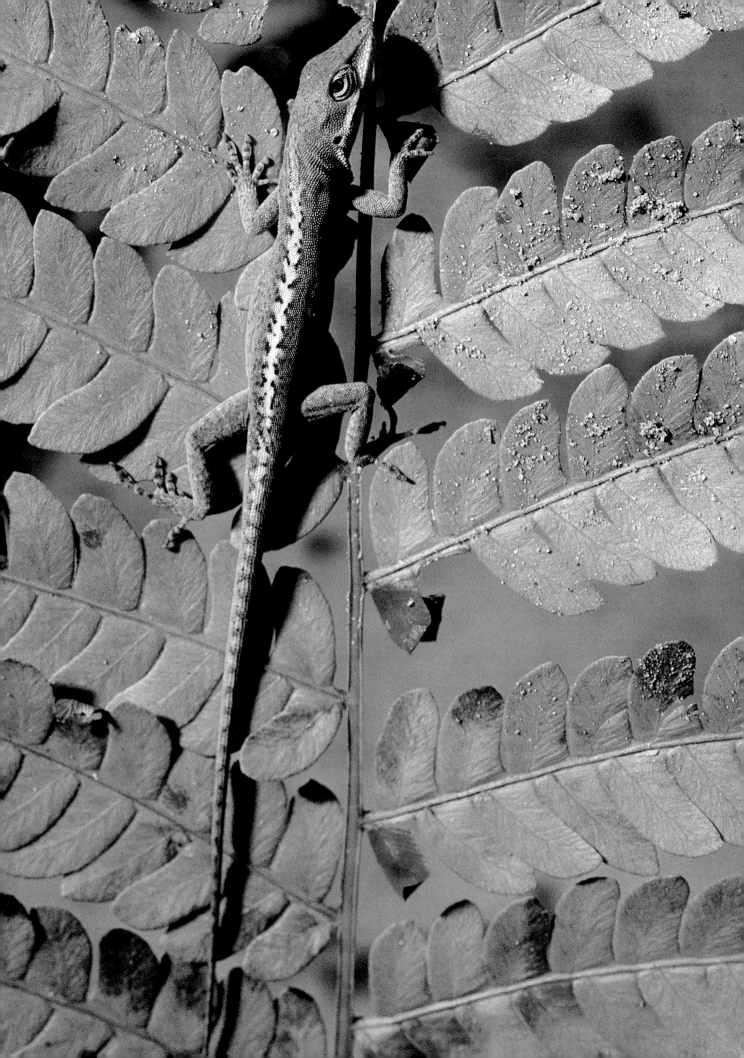

Finding Tortoises and Turtles

Green and other giant sea turtles once nested in great numbers on the beaches along the Gulf of Mexico and the Atlantic coast as far north as the Carolinas. The record weight for an Atlantic Green turtle is 845 pounds. Individual adults usually range from 200–300 pounds.

The robbing of turtle nests by such accomplished predators as the raccoon has contributed greatly to the sea turtles' demise, as has human hunting for the turtle's succulent flesh. Coastal development adversely impacts sea turtle populations even more than predation. Hunting giant sea turtles and disturbing their nest sites is now outlawed in the United States because of the turtles' endangered status.

I find smaller species of freshwater turtles crawling across roads on their way to nesting and laying eggs in springtime and early summer. In drought-stricken regions I've even come across such thoroughly aquatic varieties as snapping and softshell turtles walking overland in search of deep ponds or permanent streams.

When adult aquatic and semi-aquatic turtles are in the water, they are very hard to approach. You can rarely get close enough to them to take pictures even if you have a long lens. To capture adult turtles by hand is impossible. Baby turtles are much easier. I have successfully used a dip net to catch babies swimming near pond edges, and I've caught several by hand as they sunned on rocks and vegetation. Tortoises and terrestrial turtles are even less difficult—you can just pick them up. A snapping turtle's substantial tail provides a good carrying handle. Hold it so that the *plastron*, or bottom shell, is facing your leg, or else you may be bitten. Don't capture turtles on their way to nest. Release any you do catch where they were caught, just as you would any other herp.

You can carry most turtles in a snake sack or plastic sack, and most can be kept temporarily in cardboard boxes until you are ready to photograph them. However, I don't suggest using either a sack or a cardboard box for snapping turtles or turtles that bite. Once, a baby snapper that I had confined to a cardboard box chewed his way out of it. If the cardboard box had been in my car trunk, I would have had quite a problem. Turtles usually manage to lodge themselves in inaccessible car parts from which they must be rescued, so I would rather not have them loose in my car.

Housing Turtles. Suit the accommodations you provide to the turtle's needs. Before box turtles were protected by law, I kept four of them at home for many months. Because these tortoiselike turtles are terrestrial in the wild, I didn't try to contain them at all. They walked all over my apartment, spring, summer, and autumn. During the winter, I put them in big cardboard boxes on top of an electric blanket, and I hung an electric light low over them. I took these measures to prevent them from attempting hibernation. The turtles stayed active and eating all winter.

I've also have several baby aquatic turtles. I tried housing them in different containers and finally settled on a 20-gallon aquarium. In the wild these turtles would be swimming and feeding underwater, and resting and sunning on shore. I arranged a piece of slate on top of several tall water glasses, which permitted the turtles to rest as well as swim in the nearly 12-inch deep aquarium. The turtles thrived and grew. When I was finished photographing them, I released the turtles in the same place where I found them.

Taming Turtles. The turtles I've kept have become very tame, adults and young alike. My taming technique consists largely of hand-feeding. All the turtles I've tamed have taken food from my finger or hand; however, I don't do this with large turtles, snappers, or softshells.

I've had more experience caring for and observing captive turtles than any other animal. A turtle's preferred food varies with its species and its age, and evidently turtles have personal taste preferences, too.

These young Atlantic green turtles were hatched in captivity at an experimental turtle farm located in the Florida Keys. I took this picture from a dock overlooking the huge penned area in Florida Bay where the young were being reared. All the other pictures I took were quite conventional, showing one or two turtles swimming through turtle grass at or near the water's surface. This picture was taken looking straight down from the dock. This strong composition lasted only a split second, and I was able to shoot only one frame before it vanished. I used a 105mm lens for an exposure of 1/125 sec. at *f*/5.6 on medium-speed film.

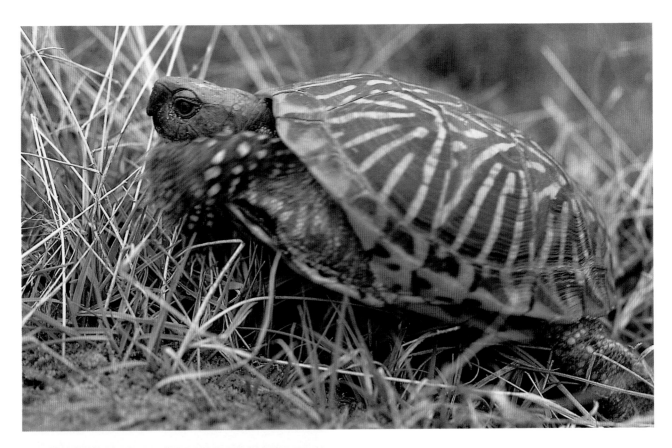

This box turtle's behavior was typical of turtle behavior in the field. I tried to photograph him when I first found him, but he was intractably determined to escape. So I packed him up in a cardboard shoe box that I left on the floor of my car. I kept all the car windows open for the rest of the day, and I brought the turtle into my air-conditioned motel room that night and left him there. Several days later, I met someone who was able to assist me in photographing the turtle.

We took the turtle back to where I had found him. I lay down on the ground, prefocused the camera, and framed the area you see in the picture. My assistant released the turtle just outside the area framed to the right. When the turtle was released, he steamed across the frame to the left because that was his only unobstructed path. My helper was behind him, tall vegetation was to his right, and I was on his left.

The camera angle I used was important. The camera was on the ground, below the subject's eye level. From experience, I knew turtles travel faster than generally believed; so I chose an exposure of 1/250 sec. to stop his motion on the film. Notice, however, his blurred foot.

For example, some of my water turtles liked canned dog food better than chopped steak fortified with bone meal and baby vitamins. One baby turtle loved greens. When she was about the diameter of a fifty-cent piece, she would chomp her way through a whole leaf of romaine lettuce in a few hours. The three other baby water turtles in that aquarium wouldn't touch vegetables. There are booklets, available from pet shops, that describe turtles' care and feeding in detail.

Photographing Turtles. I've made most of my turtle pictures while doing regional coverage of wild areas and other wild animals, instead of during a turtle project *per se.* On a typical day shooting regional coverage, I may photograph several birds and a lot of plants, making overviews of the landscape and designing pictures of smaller areas. In addition, I may portray several turtles and other herps wherever I find them. I travel into the field prepared to collect herps, and I may keep them for a day or more until I can find someone to help me photograph them. An assistant can herd a subject in your direction while you keep relatively still, concentrating only on focusing the camera and on minor changes in framing.

There are many creatures, including turtles, that I like to photograph with a camera angle that gives me a low vantage point. Such an angle exaggerates the animals' size and importance. If you employ ground-level vantage points, I have a suggestion for you. Buy a present for your neck: a 90-degree accessory finder for your SLR. Otherwise, you'll need stretching exercises to develop a 90-degree neck. Keep in mind, though, that while a low angle is often effective, it is not the only, nor necessarily the best, vantage point for all turtle photography.

North America's Crocodilians

Alligators and crocodiles are the two species of crocodilians, the largest reptiles in North and South America. They were once abundant over a much more extensive area than they are today. Always more numerous, alligators originally occupied the great southern-river swamps and lowlands of the Atlantic and Gulf coastal plains from central Texas to North Carolina. They were found in lakes, ponds, marshes, swamps, and water courses sometimes hundreds of miles inland from the sea. Associated mostly with fresh water, alligators were also active in brackish estuaries, except at the lower tip of Florida. There a healthy population of American crocodiles inhabited the keys, the brackish mangrove islands, and the swamps of the lower extremities of the mainland. Evidently natural enemies, the crocodiles kept the alligators from extending as far into the estuaries and bays as they might have otherwise gone.

Today, the American crocodile seems to be on the increase, since it is now protected by law from the hide hunters that nearly extirpated it. The crocodiles' comeback has largely been in the saltwater keys of Everglades National Park. Alligators (or 'gators as they're called locally) are also supposedly more numerous now, but I suspect that much of their so-called overpopulation actually results from the alligators' habitat continually being destroyed by developers; this in turn has increased people-'gator confrontations.

Finding the Most Photogenic Populations. The best places to view and photograph alligators and crocodiles are protected, patrolled areas, such as parks and refuges. My own experience photographing crocodilians has been in south and central Florida and in the Okefenokee swamp in Georgia. In south Florida the best locations are Anihinga Trail and the Shark Valley Loop Road off the Tamiami Trail, both in Everglades National Park.

Spotting a crocodile from a distance is a rare event, so I wouldn't make firm plans to photograph them. It's possible you may come across one or more of them if you're boating in Florida Bay and exploring the mangrove islands. If you come across a big crocodilian in

This scene belies the alligator's fierce reputation because it shows one with an animal on which it sometimes preys. I took this picture from a tower at the end of Shark Valley Loop Road in the Everglades in April, a time when the big borrow pits are congested with fish, feeding birds, and alligators, all of which have gathered together because the surrounding Everglades has dried up.

Discovering such a scene in the unprotected wild of Florida's interior is most unlikely. By the time you poled a boat or waded through the swamp, then climbed a tree for the elevation necessary to show the scene, your subjects would be long gone. But at the Shark Look Observation Tower, the animals and birds are accustomed to human traffic. Also, the tower is located some feet back from the edge of the borrow pit that harbors the animals. The tower itself is big enough to dwarf the people climbing it, which makes the human contact less distracting to the animals than it would normally be.

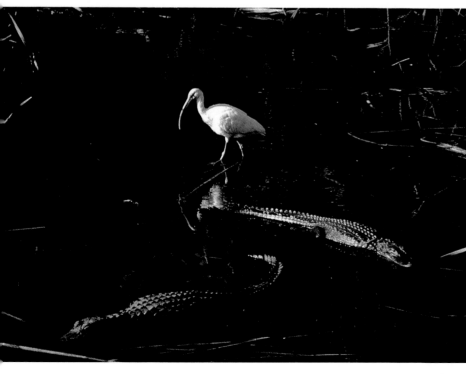

Although turtles are food for alligators, you sometimes find them together in pacific poses such as this one, captured by my 300mm lens on an Okefenokee shore. My exposure was 1/250 sec. at ƒ/8 on Ektachrome 400.

this area, it is probably a crocodile unless you are on Big Pine Key or one of the other large keys. Be very careful around any big crocodilian, but be especially so with crocodiles. They are more aggressive than alligators. Both animals should be approached with caution if there is any possibility of their having nests in the vicinity. Crocodile and alligator females protect their nests vigorously and are very dangerous when motivated.

A Season for 'Gators. In South Florida the dry season is the alligators' social season because it coincides with springtime and mating. The annual drought-like condition leaves water standing in canals, borrow pits (the trenches left behind after dirt has been "borrowed" to elevate some kind of project, such as a road), and alligator holes, as opposed to normally being spread out in a sheet over the entire Everglades and Big Cypress swamp.

Alligators are much easier to spot during the dry season than during the rest of the year when the land is flooded. In dry years great groups of 'gators congregate in certain locations. Whenever you see a photograph of such a gathering, you can be sure that the subjects were free-ranging alligators harboring at a deep body of water during a dry year, or else the picture was taken at one of the many alligator farms scattered across the South.

Calling Crocodilians. My technique for working with alligators and crocodiles is completely different from my tactics with smaller, more manageable herps. I don't catch crocodilians. I don't try to tame them. I don't feed them. I photograph them just as they are,

wherever they are. The only special technique I use is to call them.

In chapter 5, I discussed using acoustic calls to attract mammals. Recorded calls and calls made with one of the devices mentioned earlier can be used to attract alligators, too. I don't use either of these methods to call alligators because I learned how to do it without props from some real masters: the herpetologist Ross Allen and various game wardens from the Florida Fresh Water Fish and Game Commission.

I don't pretend to have any approximation of the vocal repertory that Allen and the game wardens possess for calling alligators. Allen can give voice to many calls and has elicited different types of 'gator behavior. I can make only one call: an approximation of the sound a baby alligator makes when in distress and summoning its mother.

I wish I could bind in this book a little record or tape of the call because once you hear it a few times, you'd find it quite easy to make. I can best describe how to make it by telling you to say "ugh, ugh" in the back of your throat with your mouth shut. The "ugh" should be somewhat nasal and high pitched. I've had a great success with my calling and have summoned alligators from perhaps a quarter of a mile away in Okefenokee. All adult 'gators answer this call, not just a threatened infant's mother.

Photographing Crocodilians. When they are so minded, alligators can move faster than race horses for short distances. I always use a shutter speed of at least 1/250 sec. for alligators in motion, and when I am using long, 200–400mm focal-length lenses, I try to use 1/500 sec.

I photographed this alligator, seen in repose amidst the reflections of a dawn sky, with a 105mm lens. My exposure was 1/250 sec. at *f*/8 on Kodachrome 64.

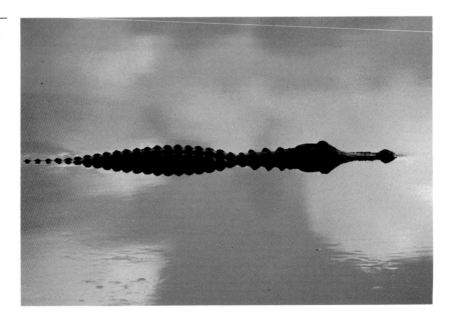

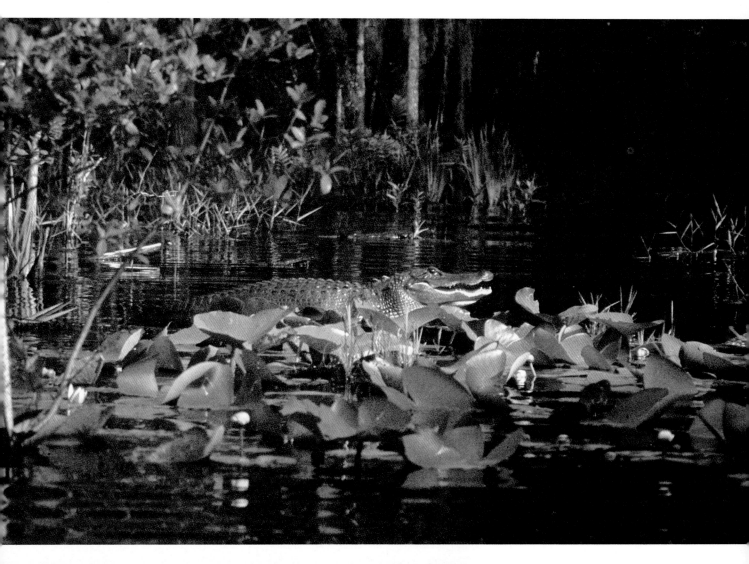

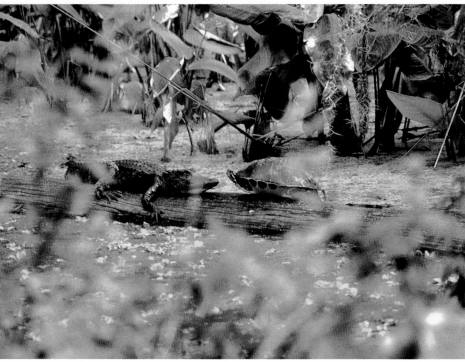

This Okefenokee alligator "held it" for just an instant. I was lucky to make one good shot even though I was using a motorized camera. My exposure, made with a 300mm lens, was 1/60 sec. at ƒ/8 on Kodachrome 64.

I took this picture from another man-made structure: the long boardwalk at Audubon's Corkscrew Swamp Sanctuary near Naples, Florida. It was midsummer, a time when the boardwalk is little visited by people. I've always made much better pictures from this walk when human traffic was at a minimum. I owe many of my successful photographs made on this trail and others in natural areas to my slow and silent stalk. Tramping feet and shrill voices frighten wild animals and thus should be left behind with the transistor radio and pop cans.

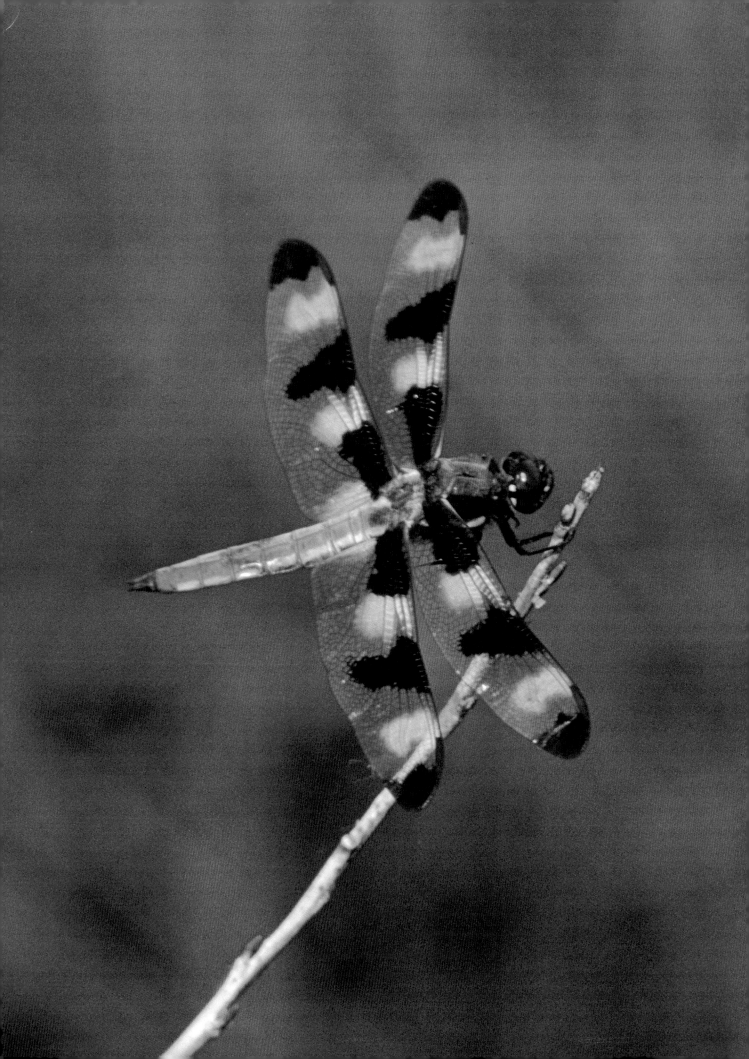

Chapter Seven

INSECTS

Approximately one million species of insects have been identified. They are found almost everywhere on the planet; a few species even live in the ocean and on its surface. Some insects, including butterflies and moths, go through three different stages before reaching adulthood. They emerge from their eggs, as caterpillars, feed on nearby plants, and molt numerous times before affixing themselves to a plant and spinning a cocoon around themselves for protection. Then their bodies undergo a complete metamorphosis. After weeks, months, or sometimes an entire winter, the adults emerge to fly off, feed, mate, and lay eggs on the caterpillars' favorite food plant.

Other insects, including grasshoppers and katydids, have an incomplete metamorphosis. The nymphs that emerge from their eggs resemble tiny adults. They feed and molt many times before reaching their final adult size and form.

Insect life cycles are fascinating. Any reading you do on the subject of insect behavior will pay off when you are in the field with your camera. For example, knowing what an insect eats tells you where to look for it. At least half the extant insects eat one or more types of green plants at some point in their life cycles. Many insects, such as the praying mantis, eat other insects, and still others survive on dung or dead animals.

In addition to taking flight, insects have a variety of offensive and defensive survival tactics. Some insects are armed—bees, wasps, hornets, and ants to mention a few. Many rely on camouflage for protection, at least during part of their lives. This is true of many caterpillars, most moths, and some butterflies. Insects that are conspicuously marked usually sting, taste bad, are outright poisonous, or resemble a more numerous species that repulses predators after the first bite. And then there are the mimics, insects that look like part of the natural flora by imitating twigs, sticks, thorns, leaves, and bark. The problem with photographing these creatures isn't getting close enough, it is being able to see them in the first place.

How to Stalk Insects Outdoors

To find some of the larger, sun-loving insects, I often examine a field of flowers or a patch of reeds next to a pond by searching them through binoculars from a distance. Before I begin to stalk my subjects, I determine whether one kind of flower seems more attractive to butterflies than the others, or I decide which particular twig or reed is a dragonfly's favorite perch. Then I put the appropriate closeup devices for my chosen subjects on my camera, knowing in advance the approximate camera-to-subject distance I'll use and the image size I'll obtain with the equipment that I select.

A slow, smooth approach without stops, starts, and gestures is the best way not to alarm insects. Many insects have excellent eyesight and a healthy distaste for being closely approached. Insects can flee at amaz-

A dragonfly always prefers one twig above all others and will return to it regularly. I used a 300mm lens with a short extension tube to expose this specimen for 1/250 sec. at $f/8$ on Kodachrome 64.

The best time of day to shoot arachnids, insects, and many other small invertebrates is at dawn. The cooler temperatures slow these animals down, making it much easier to approach them without scaring them off. I exposed this picture with a 55mm macro lens for 1/250 sec. at ƒ/8 on Kodachrome 64.

This katydid was laying eggs while I took ten pictures of her deep in a cypress swamp on a dark day. I used a 105mm lens with extension tube and exposed this shot for 1/60 sec. at ƒ/5.6 on Kodachrome 64.

I was sitting in a ditch photographing wild flowers when this butterfly landed on a flower about eight feet away from me. I was able to crawl about four feet from it and photograph it with a 105mm lens before it flew away. My exposure was 1/60 sec. at ƒ/5.6 on Kodachrome 25.

ing speeds either by flying or by running across the ground or along a plant stem. Be especially careful not to cast a shadow on winged insects. Wearing a camouflage-cloth coat or poncho and positioning yourself to take advantage of such natural cover as bushes are good strategies for insect photography. Most important is having the right equipment to permit an adequate working distance from your subject.

The best time to photograph insects is shortly after dawn. The night's cooler temperatures slow insects down and make them more approachable. Spiders are not insects, they are arachnids, but the techniques for photographing them are the same. Spider webs look wonderful just after sunrise when they are still wet with dew. They can also be effectively photographed in bright sun against a background in dark shade, or they can be illuminated with an electronic flash that underexposes the background.

Spiders are ubiquitous in swamps and meadow lands. You can find dozens of spider subjects in a short time if you examine the foliage and flowers there. I made this picture with a 55mm macro lens, exposing it for 1/60 sec. at f/5.6 on Kodachrome 64.

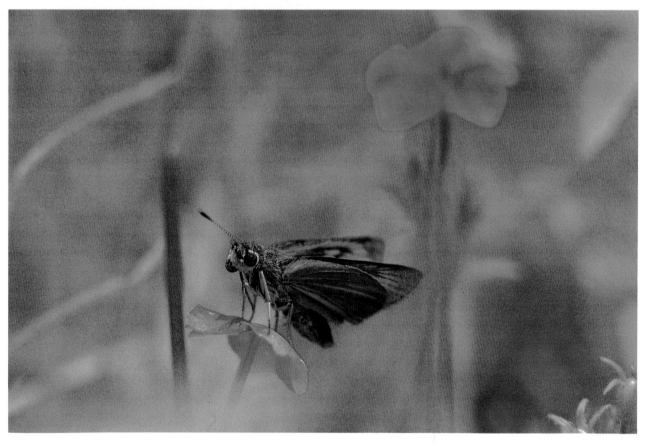

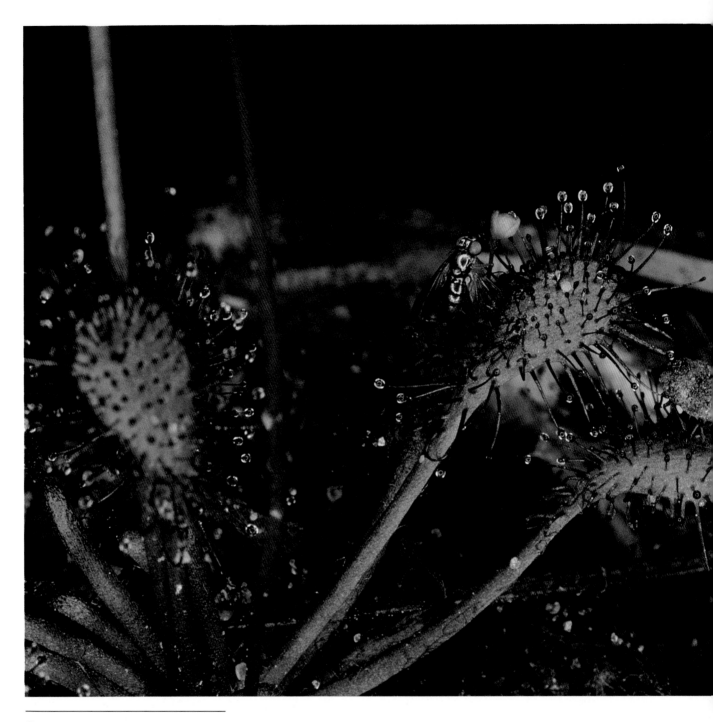

Carnivorous plants prey on insects.
Here a fly is stuck on a sundew's
treacherous petals.

Baiting Bugs with Food

Overripe fruit is a good bait for bugs. You can put the fruit wherever you think you'll take the best pictures. Trees that have been trimmed or were damaged by a storm will attract insects that feed on the sap weeping from their wounds. If you have a garden, plant the flowers that insects like. Insect-pollinated flowers are usually the most fragrant and colorful. Butterflies, moths, and bees are plant pollinators. Field guides to insects usually include information on their favorite food plants.

One common way to attract night-flying moths is called sugaring. First, you have to prepare a special concoction that moths find irresistible. The recipe calls for boiling a pound of molasses with two pounds of brown sugar, ½ pint of beer, and a shot of rum. Then you paint or smear this mixture on fence posts or tree trunks. Quiet, humid, overcast nights are the best times to photograph moths with electronic flash as they come flocking to the bait. You can also collect moths and photograph them the next day. During the day, moths usually stay where you put them and are very easy to photograph. Don't overdo sugaring, or you may inadvertently decimate the local moth population. Moths that get stuck in the mixture are easy pickings for birds the next morning.

I found this large scorpion in Cataract Canyon, formed by the Colorado River. Note the shallow depth of field at such a close focusing distance; this was a problem despite the small f/22 aperture I used. I exposed the scene with a 105mm macro lens for 1/30 sec. on Kodachrome 64.

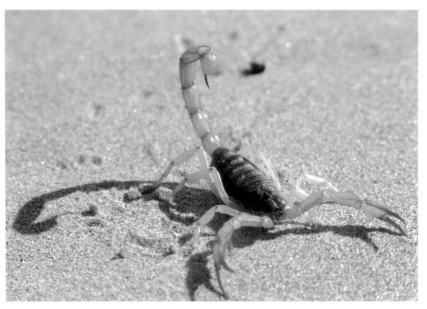

Collecting and Housing Insects

As you know, interior and exterior lights on a summer night attract insects. If you leave lights on inside your house, you can collect bugs from the outside of your window screens. Special mercury-vapor lamps that emit ultraviolet rays are used by entomologists for the same purpose.

Don't trap or confine more insects than you can photograph. Place individual specimens in glass jars with perforated lids. You can also cover jars with mesh or mosquito netting and secure it with tight rubber bands.

When you use glass jars to temporarily house such insects as caterpillars and butterflies, include some of the plant from which the caterpillars were collected. Putting the food-plant stems in a container of water inside the insect cage keeps the plants fresh and edible longer. If you don't have ready access to an insect's food plant, it is irresponsible to take the insect home. Like other creatures, insects should always be returned to the place where you found them when you've finished photographing them.

If you keep caterpillars for a while, change their food plant daily and find larger quarters for them. Special insect cages and a variety of different nets for catching insects are available from biological supply houses such as Wards Natural Science Establishment, P.O. Box 92912, Rochester, New York 14692, or Carolina Biological Supply Company. As an alternative to these cages, you can use the gallon-sized glass jars that I described in the last chapter.

Photographing Insects in the Studio

You have probably seen flawless pictures of butterflies and moths emerging from cocoons and have wondered at the pictures' perfection. Well, they were undoubtedly taken indoors under controlled conditions and illuminated with artificial light involving multilight electronic-flash setups. Professional and amateur entomologists collect plants that host insect eggs and caterpillars. Then the entomologist/photographer houses and feeds the subject as long as necessary to photograph as many phases of the insect's life cycle as possible. The photographer may not know what species the insect is until the winged adult appears. If you can catch an insect emerging from the cocoon, you'll have plenty of time to photograph the adult before it flies away. It takes an hour or so for an insect's wings to spread and set after it emerges.

Here's a picture of an entomologist setting up lights as bait to attract flying insects for collection at night. I used daylight film to make this shot. Despite the film's color balance, the very blue color of the picture indicates that the color temperature of these light sources is much bluer than sunlight. My exposure was 1/30 sec. at f/3.5 on Ektachrome 400.

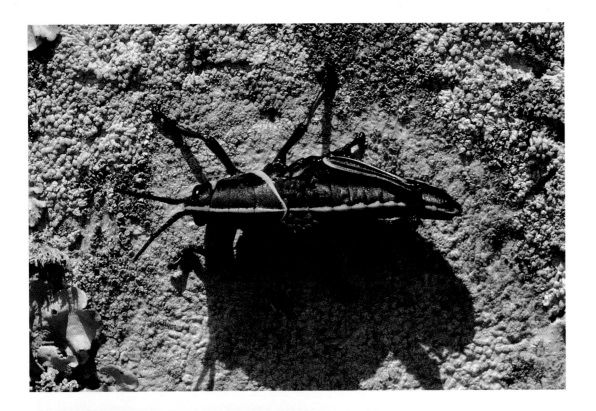

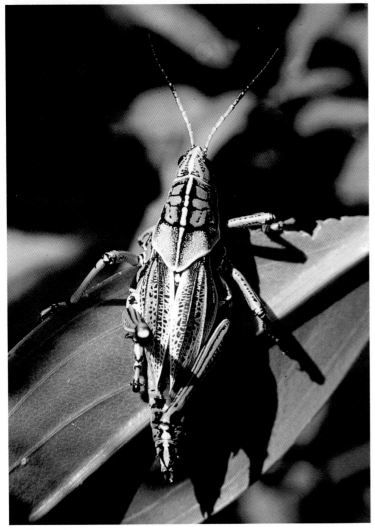

This juvenile big-lubber grasshopper is infested with red mites. This species can be approached within a few inches and still won't flee. I photographed this specimen with a 105mm lens and an extension tube, using an exposure of 1/125 sec. at ƒ/11 on Kodachrome 64.

In summer, adult big-lubber grasshoppers are abundant in the Everglades. I exposed this specimen with a 55mm macro lens for 1/250 sec. at ƒ/8 on Kodachrome 64.

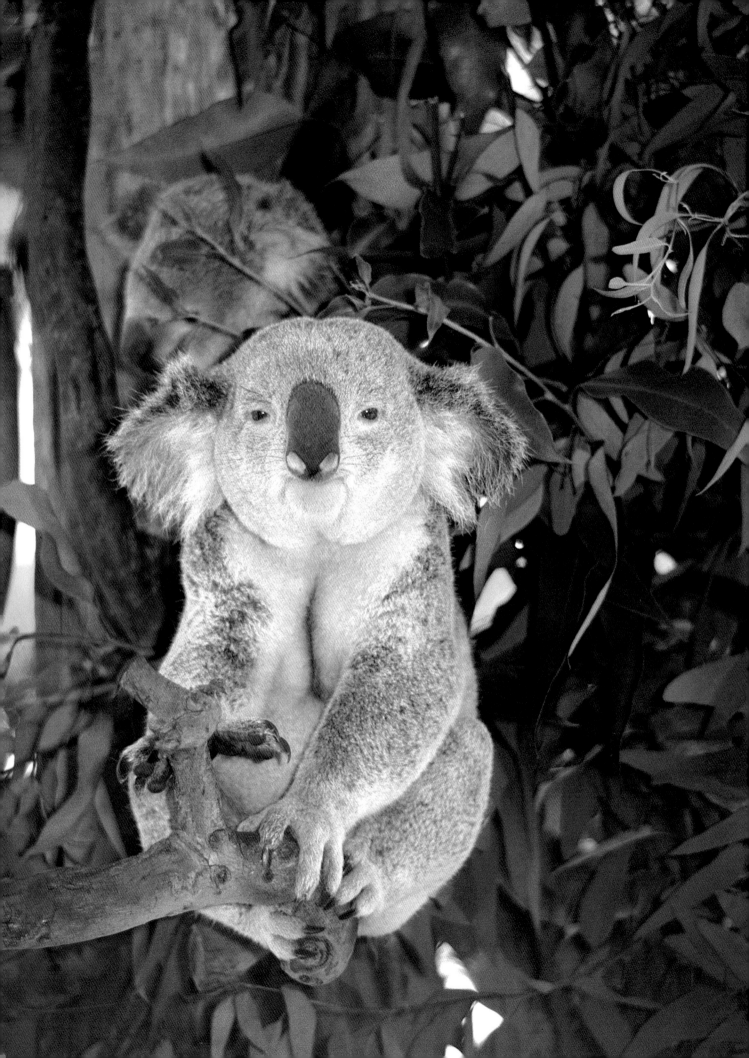

Chapter Eight

AT THE ZOO

Zoos present us with an incredible range of picture-taking opportunities. Even old-fashioned cages occupied by individual animals can be sources of good portraits, and natural-habitat enclosures housing several animals allow you to photograph animal behavior. You would have to spend a lifetime in the field to find the number of animals you can photograph in just half a day at most large metropolitan zoos.

Your local zoo, whether big and famous or a modest display specializing in local species, can be your standard hunting ground for wildlife photography. As I've discussed in previous chapters, finding your subjects in the field is ninety-nine percent of the battle. Obviously, that problem disappears at the zoo. Although captive animals may not behave exactly the way they do in the wild, their behavior isn't entirely different either. Many of your zoo pictures will be portraits, but many will also show some significant aspects of animal behavior. Don't overlook the signs labeling the various species. These signs often explain something important about their behavior. Be sure to copy the information from or take a picture of the sign, so you can later identify the subjects in your pictures.

Eliminating the Visual Barriers

There is only one important special technique that you must have to make great zoo pictures, and it is quite simple: When photographing caged animals, wait un-til your subject is at the back of the cage and use a telephoto lens set at a wide aperture. This technique should put any foreground barriers in front of the lens completely out of focus, allowing you to make bars, fences with small mesh openings, and scratches on glass enclosures disappear. Again, part of the trick is to catch the subject when it is far away from the barrier and to hold the camera as close to it as possible when shooting. For example, ideally you'll be able to put the lens right up to a wire fence and center it in one of the holes. (If you can't get next to a fence, try to shade the wire through which you're taking pictures.) The reason this technique works is because when an object is sufficiently out of focus, its image is spread throughout the entire picture area and thus isn't visible in the negative or transparency.

With SLR cameras you can see on your groundglass viewing screen how different camera positions affect the elimination of bars or other caging. Using the depth-of-field preview, you can also observe the effect different apertures have on the barrier. Under some circumstances you can stop down several f-stops from the maximum aperture. To photograph smaller animals in smaller cages you'll frequently be able to work with your standard focal-length lens as well as with telephoto lenses; however, wide-angle lenses will probably show the caging material, even when they're used at maximum apertures.

This koala bear was part of an outdoor bar-free exhibit at the San Diego Zoo. The bear was in deep shade under a eucalyptus tree; to illuminate it I used fill flash at $\frac{1}{15}$ sec. at an aperture selected by the camera.

Analyzing Ambient Light

The most important factors for success—the actual size of the holes in the barriers, and whether you can approach closely enough to put your lens right up against the cage and center the lens in an opening— also influence the accuracy of your exposure-meter readings, including those made through the lens (TTL). White or light-colored caging is more difficult to eliminate than caging that is black or dark colored. If the caging material is white or light colored, your meter's reading may be higher than necessary for proper exposure of your subject. If the cage is black or dark colored, the reading will probably be accurate.

The range of different kinds of lighting you may encounter at a zoo is unequaled, no matter what your photographic specialty. First, you have every variety of daylight: bright sun, sidelight, backlight, open shade, and various degrees of overcast. Indoor displays may be evenly illuminated by tungsten or fluorescent light or lit with floods or spot lights that make one or more areas in the enclosure significantly brighter than others. Indoor illumination often comes through a skylight.

While the built-in TTL meter in your SLR is invaluable, don't follow it slavishly at the zoo. Analyze the lighting in every cage and enclosure. Is the light contrasty or flat? How about the light on the subject's face compared to the rest of the composition? Although the light source might be a skylight across the entire cage top, the lighting contrast in the cage could still be great. Your subject's face and eyes might be in dark shade even though your overall impression is of even, diffused light in the cage. In such cases you should bracket your exposures.

Spend several sunny days noting how the light falls on different outdoor exhibits. Then you can plan to work at a specific exhibit when you know the light is best. In the long run, foreplanning will save you a lot of time. You should also note the feeding times for different animals. Try to be on hand before, during and after potential camera subjects are fed. Frequently, animals are more active around feeding time, which may be the best time for pictures.

Using Flash at the Zoo

The room for exposure error is even greater if you are using flash. Cage bars or mesh may block a substantial part of the flash illumination from reaching your subject. As the light bounces back from the subject to the camera, it has to pass through the barrier again, so another significant portion of the flash will be absorbed.

I cropped my subjects' bodies, legs, and heads to create an unusual composition of the flamingo congregation at the San Diego Zoo. I used a 70–210mm zoom to make an exposure of 1/250 sec. at ƒ/8 on Kodachrome 64.

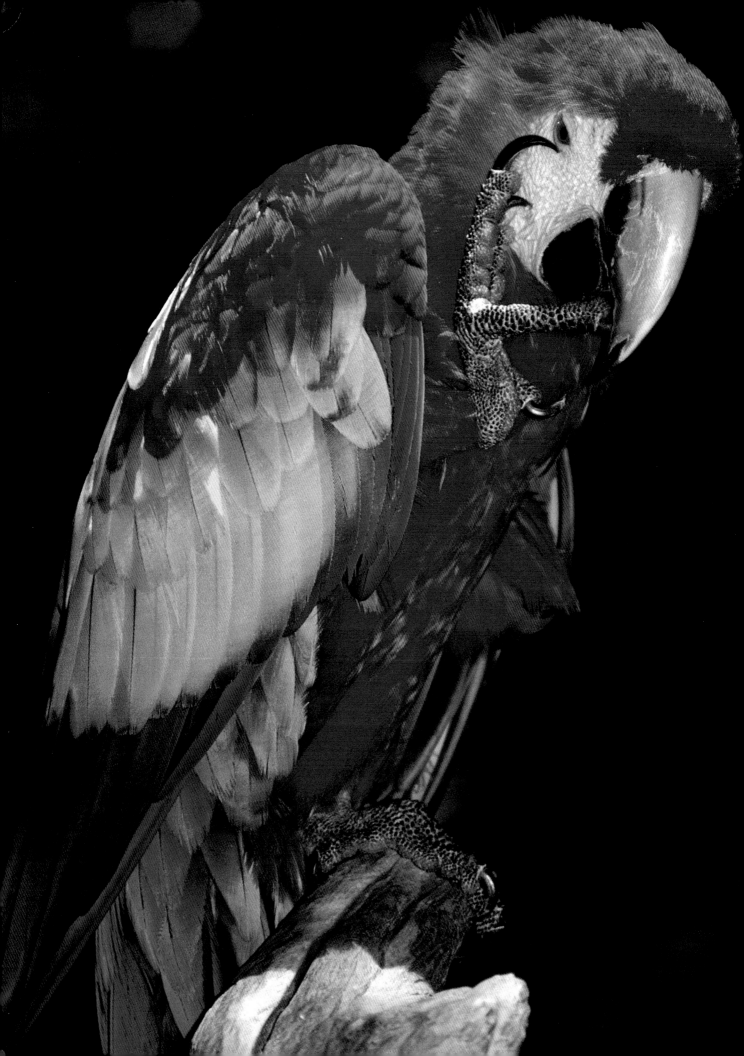

How much should you compensate? There is no certain answer. Too many factors are involved. For example, if the mesh is fairly open, say about 2"-square, and you can come right up to the cage and center your camera lens and flash unit in openings, you may not have to compensate at all because none of the flash will be absorbed by the caging. On the other hand, if the mesh is small and you can't come right up to the cage, several times more exposure may be needed.

The suggested guide number or *f*-stop on your electronic flash unit is typically correct only when the unit is used in enclosures with light-colored walls and when the area of illumination is about the size of an average living room. If you are using a flash head close to your subject and photographing a very small, light-walled cage, the recommended guide number or *f*-stop may lead to overexposure. If you are taking pictures of a large, dark-walled cage, the indicated exposure may not be sufficient. Most animals don't notice electronic flash, but they are startled by the much longer duration of flash bulbs going off. Therefore, I recommend using electronic flash at the zoo.

Controlling Reflections from Glass Barriers. Unless you can put your camera's lens right up against a glass barrier, you'll have to examine the glass carefully for any reflections that your camera might record. Spotting reflections requires conscious attention; ordinarily, we look right through them. One of the most common reflections in a glass barrier results from working in front of a lighted glass wall. Another comes from you and your camera, so you should wear black or dark clothes when photographing glass cages. You should also put black masking tape on shiny camera parts and on your tripod.

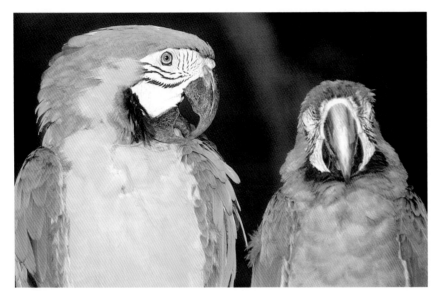

I photographed these parrots at Parrot Jungle, a tourist attraction in Miami, Florida. The dark, junglelike plant growth made electronic flash necessary. I used one flash on-camera, and I calculated the different exposures using the guide-number method.

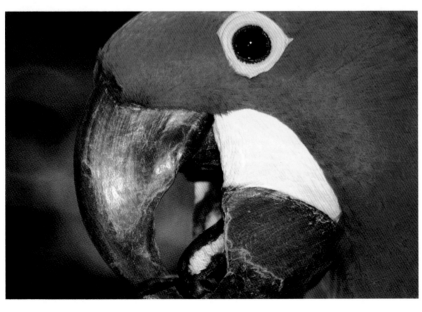

Your electronic-flash unit is guaranteed to cause trouble if you aim your camera and flash directly at the glass. The flash head should always be at a 45-degree angle to the glass and should be closer to the glass than your camera.

Shooting Exposure Tests

Before beginning any extensive work at your zoo, shoot exposure tests of all the lighting situations you may want to photograph. Make specific notes about these pictures, including the exposure recommended by your meter's reading and your impression of the scene's contrast. If you have a spotmeter, measure the darkest, lightest, and most important parts of the subject and record your findings. Note the lens that you use and the camera-to-subject distance. If you are shooting through bars or wire, record the camera-to-fence distance and the fence-to-subject distance. When shooting exposure tests with available light on black-and-white and color-print film, bracket in full *f*-stop from two stops over to two stops under the exposure recommended by your meter. With color transparency film, bracket in half stops.

Bracketing for electronic-flash tests should be at least as extensive as for available-light tests. During exposure tests for flash, you should also note the flash-to-subject, or flash-to-cage and cage-to-subject, distances. Ideally, you should be able to remove the flash head from the camera's hot shoe and position the flash wherever you want by attaching it to an extension cord. To support an off-camera flash head, use a light stand, have a companion hold the flash, or hold it at arm's length from the camera. If you employ an off-camera flash in your exposure tests, note the flash position with the rest of the information you are detailing.

Examine your test rolls after processing, and make clear notes of the exposures that worked best in different situations. Don't try to rely on your memory—take these final notes with you on subsequent trips to the zoo. With your exposure tests out of the way and your results in hand, you're free to shoot any situation in depth.

Focusing Your Interests through Self-Assignments

Thinking up self-assigned projects will help you make the most of your zoo resources. For example, record the growth and progress of a baby animal and its relationship with its mother from week to week or month to month. Photograph the interrelationship of a family of animals or such social groups as a pride of lions, a pack of wolves, or a herd of zebra. As you keep returning to the same subjects, you'll find that your pictures are improving because your vision is becoming more acute as the project continues.

Even if you aren't working on a project, you may want to simplify your life by photographing only one subject in one lighting situation each time you go to the zoo. This cuts down on the equipment and materials you need to carry with you. For example, if your zoo has a lot of outdoor natural-habitat exhibits, concentrate on them for a day. Another day, concentrate on the birds. On a third, work extensively in the monkey house.

Don't expect the animals to behave significantly or spectacularly the minute you arrive at their enclosure, but bear in mind the hours, weeks, or months you would have to spend in the field to find and photograph these animals in the wild. At the zoo you may have to play a waiting game, too. It could easily take days to make a picture you like of a particular animal, but those days represent a small fraction of the time it takes to do wildlife photography in the field.

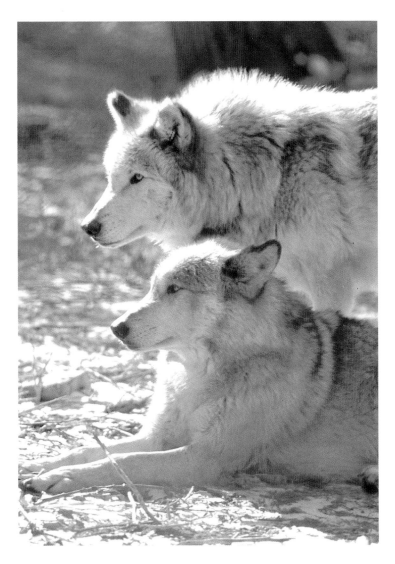

I took these pictures of a pack of wolves at Chicago's Brookfield Zoo to illustrate one of the most significant and detailed wolf-behavior studies ever made. I was on assignment from *Natural History* magazine. Although I was briefed by the scientists doing the three-year study at the zoo and had read the planned magazine article before taking the pictures, I didn't have any privileged access to these wolves. I took almost all of the photographs from the front of their large enclosure, standing exactly where the public stood to see them.

Even though my three-day trip was timed to coincide with the period when the wolves were most active and their social practices most evident, my job wasn't easy. It was the last week in February and very cold and windy in Chicago. Despite being warmly dressed, I got very cold. The scientists had an indoor vantage point in a nearby building, but it wasn't good for photography.

The photography itself was not particularly difficult. The first day was overcast, but the sun was out the last two days, backlighting the animals. Although I prefer using slow- or medium-speed films, I needed high-speed film for this assignment. I knew in advance I would mostly work with long lenses—200mm, 300mm, and 400mm focal lengths. I had a tripod with me, but I hardly used it. The action was too brief and fast.

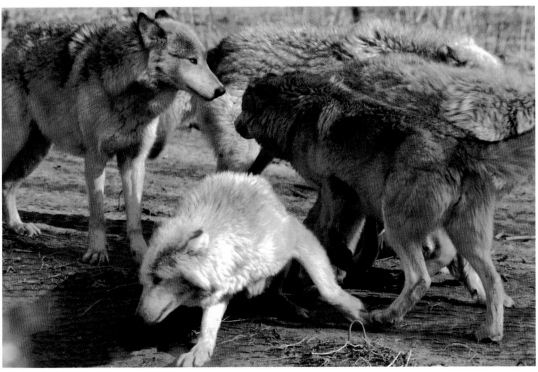

APPENDIX

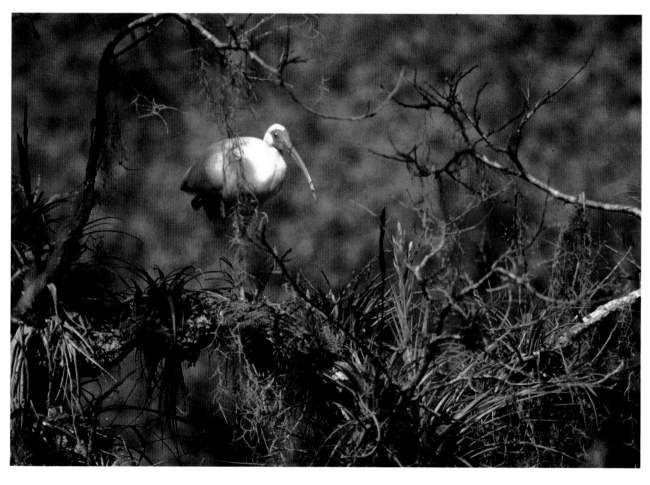

CLOSEUP PHOTOGRAPHY

Photographing insects and other small creatures usually involves closeup photography, which requires special equipment or techniques. You'll probably need some closeup optics and accessories, and unless your camera and flash equipment are completely automatic, you'll have to learn how to calculate and provide the extra exposure that closeups require.

Ways to Extend Your Lenses for Closeups

Lenses focus closer as they are extended farther away from the film. Macro lenses, which were discussed on page 16, are no exception—they simply incorporate longer-than-normal helical focusing mounts. These permit focusing distances that are either equal to or are half the focal lengths of the lenses. The major selling point for using macro lenses is their convenience—they permit continuous focusing without any additional accessories.

When working with such animate subjects as insects and other tiny animals, you need a greater working distance than with rocks, flowers, or other inanimate subjects. Although my 55mm macro lens gets quite a workout photographing wildlife, I usually use my 105mm macro lens for insect pictures because it lets me back away from these easily frightened subjects. A 200mm macro or a regular lens modified with extension is also excellent for insect closeups. You can make a regular lens focus just as closely by putting extension tubes or bellows between your lens and camera.

Extension Tubes. A less expensive way to do closeup work is to extend your regular lenses with extension tubes. They are rigid tubes of fixed length and are usually sold in sets of three. Various lengths are available from most camera manufacturers and also from such independent manufacturers as Spiratone. You'll probably want to buy automatic tubes to couple with the auto-diaphragm mechanism of your lenses.

Bellows. Bellows can give you continuously variable extension because they move lenses in and out of focus on a rack. The main disadvantage to using bellows is that they are more fragile and considerably bigger than extension tubes. Many bellows lack auto-diaphragm mechanisms. Those that do incorporate them are fitted with a double-cable release that works well in the studio but isn't so convenient in the field. Not having an autodiaphragm device is more of a problem when you're working closeup instead of at normal focusing distances. As you extend a lens, the image on the viewing screen becomes very dark, which makes a wide-open lens necessary for viewing and focusing.

Teleconverters. These optical devices are typically used to increase a lens's focal length, but they are also handy for closeup work. Placed between the lens and camera body or between an extension tube and the camera body, a teleconverter magnifies an image by the teleconverter's conversion factor. For example, if you insert a 2X teleconverter between a fully extended macro lens that renders a life-size image and a camera body, you'll create a 2X image on film. It is important to note that teleconverters decrease a lens' effective speed by the same factor that they increase its focal length or magnify the image. A 2X teleconverter transforms an F2.8 lens to an F5.6 and F5.6 lens into an F11. However, this light loss is no different from what you encounter when you use any kind of extension for magnification.

How Much Extension Is Needed?

To make a life-size picture, or a picture in which the image on film is the same size as the subject, you need to extend your lens by an amount equal to the lens' focal length. If you're using a 50mm lens, you need 50mm of extension for a life-size image. If you're using a 100mm lens, you need 100mm of extension, and so forth. Some of this extension—actually, a considerable amount of it with macro lenses—comes from the lens' own helicoid focusing mount. Most 50mm or 55mm macros are designed to focus to one-half life-size. To obtain a life-size image, you must add the life-size tube that comes with the lens. For 50mm lenses this tube is 25mm long; for 55mm lenses the tube is usually 27.5mm.

A simple formula tells you how much extension is required to achieve the magnification you want:

$$\text{magnification} = \frac{\text{extension}}{\text{focal length}}$$

Another way to express this is:

$$\text{extension} = \text{magnification} \times \text{focal length}$$

Therefore, the amount of extension you need to achieve a given magnification increases with your focal length. For example:

extension = 1 × 50 for a life-size image made with a 50mm lens

extension = ½ × 50 = 25 for a one-half life-size image made with a 50mm lens

extension = 1 × 100 for a life-size image with a 100mm lens

You might now logically ask why you shouldn't take all your closeups with a 20mm lens, which would allow you to make greater-than-life-size images with a mere 25mm tube. The answer is that magnification is only one of several important considerations in doing closeup work.

Working Distance. An especially important factor when photographing animals, working distance is the space between your lens and your subject. Don't forget that insects and other tiny subjects can see you—imagine the threat you and your camera seem to pose from their point of view! The farther you can stay from them, the better your chances of success. I suggest you experiment using extension with 200mm, 300mm, or even 400mm lenses for shots of butterflies and other winged insects.

Camera-to-subject distance is very important in other respects, too. The greater your working distance is, the less background you'll include in a given framing at a specific focal length. The longer the focal length, the narrower your field of view will be. In other words, you can get simpler backgrounds by moving back from your subject and using longer lenses.

Achieving Sharp Focus. Unfortunately, there is no way around the law that depth of field decreases as magnification increases. You'll never get the foreground-to-background sharpness in closeup work that you're accustomed to seeing in normal photography. Depth of field in closeup work is very shallow, so you must focus very carefully. If your focus is off as little as a millimeter, you can ruin a picture.

The apparent sharpness in a closeup depends on several things: careful selective focusing on a very small area, and/or very careful alignment of the camera's film plane with the subject plane meriting sharp focus. Be prepared to spend a lot of time maneuvering your tripod until the film plane is parallel to the subject. It is easier to do this with a relatively long lens than with a very short one.

Determining Exposures in Ambient Light

With closeup work through-the-lens (TTL) exposure meters are very helpful. If your subject is middle-toned overall—for example, a green grasshopper on green grass—your meter will recommend the right exposure. If your subject is not middle-toned, focus on it first and then aim your camera at a middle-toned part of the scene or at a grey card for the right exposure information. Do not, I repeat, *do not* refocus the camera when re-aiming it for an exposure reading. Every change in extension, including the changes that occur while focusing, changes the amount of light reaching the film and thus changes the correct exposure.

If you don't have TTL metering and if you are shooting at magnifications greater than about 1:6 or 1:4 (one-sixth to one-quarter life-size), you'll have to calculate the exposure factors involved. Image brightness is significantly less when a lens is fully extended than when it is focused at infinity. At a magnification of 1:1, or life-size, image brightness drops four times, or by two *f*-stops. Obviously, you must compensate for this light fall-off, and if you don't have a built-in meter, then you must do your own calculations. The simplest way to calculate the necessary exposure increase is to start with the magnification.

The following chart shows the exposure increases needed at different magnifications. In the chart, magnification is expressed two ways: as a power, and as a ratio. For example, one-half life size is .5X or 1:2. Next to the different magnifications, on the chart are the exposure adjustments needed for each one. The exposure adjustment is also expressed two ways: by the exposure-compensation factor

(ECF), and by the number of extra *f*-stops you would have to open the aperture to achieve the necessary exposure increase. For example, at 3X (3:1, or three times life-size), the ECF is 16; opening up four additional *f*-stops (for example, from *f*/11 to *f*/2.8) increases the exposure by a factor of 16.

EXPOSURE INCREASES FOR LIGHT LOST TO EXTENSION

Magnification by power	by ratio	ECF	Extra f-stops
.25X	1:4	1.4	½
.3X	1:3	1.7	⅔
.4X	2:5	2	1
.5X	1:2	2.3	1⅓
.7X	2:3	3	1⅔
1X	1:1	4	2
1.5X	1.5:1	6.3	2⅔
2X	2:1	9	3⅓
3X	3:1	16	4
4X	4:1	25	4⅔

This chart has a number of uses. For instance, you could take a shutter speed you would use for a noncloseup picture at a given aperture and multiply that shutter speed by an ECF listed above to get the correct exposure for a closeup shot under the same lighting conditions. You could also divide a film's exposure index by an ECF and reset the ISO dial on your camera according to your result. Your camera's exposure readings would then be correct for a closeup shot at that magnification. You could increase the aperture as indicated by the ECF, keeping in mind that a one-stop increase admits twice as much light, a two-stop increase admits four times as much light, and so forth (thus, an ECF of 1.4 indicates a one-half stop increase, an ECF of 2 indicates a one-stop increase, and so on).

Electronic Flash for Closeups

Using flash for closeups of inanimate subjects is occasionally desirable for its dramatic visual effect, but using flash for closeups of tiny animals is often necessary to stop motion. You need a tiny, weak flash for tiny subjects. The flash should be close to the subject so that you can use an aperture between *f*/11 and *f*/16 even if your flash

has a guide number of 25–40 with Kodachrome 25. Most cigarette-pack–sized flash units are just right. The flash must have provision for off-camera use by means of a sync cord because you can't mount your flash in the camera's hot shoe when working closeup. The extended lens will prevent light from the flash from reaching the subject.

For closeup work the flash must be held in fixed relation to the camera by means of a bracket. I am familiar with only a couple of good brackets. One is George Lepp's two-flash bracket. It is available from Lepp & Associates (see page 48 for the mail-order address). The other is John Shaw's butterfly bracket. Directions for building the bracket are in Shaw's book, *Closeups in Nature* (Amphoto, 1987), an excellent guide to closeup photography, and a variation on this bracket is manufactured by Michael Kirk, RR 4, Box 158A, Angola, IN 46703. The Kirk bracket is attached to a 25mm extension tube that you supply; the Shaw bracket screws into the tripod socket. Both seat the flash several inches above the lens. The bracket contains a slot so you can extend the flash as you extend the lens. Extending the flash with the lens is more than the key to insuring that light hits the subject instead of hitting the lens—extending both together solves your exposure problems, too. If you extend the flash unit exactly as much as you extend the lens, you can use the same *f*-number for all your magnifications, thereby circumventing the need for tedious calculations.

Several devices that affix the flash to the front of the lens are available, but they are not particularly satisfactory. They always keep the light at the same angle, something you will certainly want to change with different subjects. Also, the angle these devices provide is too close to the lens axis, resulting in light that is too flat for many subjects.

Adding extension reduces the amount of light that reaches the film plane. If you can move the flash closer to your subject according to the length of the extension, you can cancel out the light loss and use the same exposure for different magnifications. To do this, position the flash above a definite point on the lens. The front of the lens will do just fine. This technique works with magnifications one-sixth life-size and smaller and requires that you alter the exposure for subjects darker and lighter than middle-toned just as you do at normal shooting distances. White or light-colored subjects, or such white or light-colored backgrounds as white sand or snow, are particular problems. To photograph them with flash closeup, close down your aperture by three-quarters to one full stop. For dark subjects, open up by one-half to one full stop.

Determining Flash Exposure. There are two ways to determine the right exposure for closeups made with flash. One is to use a flash meter; the other is to run a test.

To run a test, use the same kind of film you will be shooting for your closeup pictures; I recommend a film no faster than ISO 64. You don't have to use a specific magnification; anything between about 1/6X and 3X will do. Mount your flash on the bracket in the position you plan to use: several inches off the lens axis, above it or beside it, and toward the front of the lens. Shoot a series of test frames ranging from $f/5.6$ to $f/22$ in half stops (i.e., $f/5.6$, $f/6.3$, $f/8$, $f/9.6$, $f/11$, and so on). When you examine the film after processing, decide which exposure looks best and use that f-number as your base exposure for your future work.

CAMERA TRAPS

A camera trap is any device rigged to take pictures of animals when you're not present at a site or need to resort to remote controls. There are three main reasons to use camera traps. The first is to photograph animals that are difficult or inconvenient to approach. A camera trap is is one alternative to spending long hours in a blind using super-telephoto lenses; even better, camera traps sometimes succeed where you'd otherwise get no pictures at all because the subject is so shy. Another reason to use a camera trap is to record nocturnal activity. A third reason is to record movement that is too fast for human reflexes to pinpoint, such as insects and birds in flight, and frog and chameleon tongues in action.

Two Types of Triggers

Basically there are two types of camera traps: electrical and mechanical. In an electrical trap the animal closes a switch that electrically fires the camera's shutter release. Electrical traps usually require cameras that have power winders or motor drives. In a mechanical trap the animal trips a mechanism that physically presses the camera's shutter release. There is also a hybrid device that is essentially an electrical trap, except that the circuit doesn't directly fire the camera's shutter. Instead, the circuit activates a solenoid—an electric conductor—that mechanically fires the camera's shutter release.

Electrical Triggers. All electrical shutter releases work the same way. They are switches that close a circuit, thereby firing the camera. To use these electrical triggers you need an electrical shutter-release socket on your camera and a motor drive or a power winder. Different cameras have different types of sockets, but more and more cameras are being manufactured with provision for electrical shutter release. Without a winder or a motor drive you'll be limited to taking single shots.

If your camera takes a standard electrical shutter-release fitting, you are in luck; you can pick up the appropriate wires and plugs at a local electrical-supply shop and inexpensively make your own electrical circuit. If your camera has special electrical release fittings, you'll have to cannibalize the manufacturer's electrical-release cable. Cut off the firing button and splice in the switch to your camera trap.

Mechanical Triggers. The advantages of electrical triggers are so dramatic that I strongly recommend you use them if at all possible. However, if your camera equipment is incompatible with electrical triggers, you may want to try the mousetrap trigger used for many years by nature photographer Russ Kinne. Basically, a mousetrap trigger is a trip wire attached to a modified mousetrap that pushes a cable release when it is triggered.

You have to modify the mousetrap because the spring travels too far with too great a force to be useful in firing the cable release. First remove the straight wire that holds down the mousetrap's spring. Attach the wire to the other end of the trap, then bend it so that it supports the spring at a point about halfway through its normal arc of travel. Remove the bait hook, and in its place mount the end of the cable release. Solder or glue a flat piece of metal across the spring, so that it pushes the cable release down as the spring descends. Finally, insert a flathead screw into a small wooden block and attach the block to the trap so that the screw head faces upward. Adjust the screw so that it protrudes just far enough to halt the spring when the spring has fully depressed the cable release.

When you have finished, the spring should travel only a short distance before it depresses the cable release. When the spring has pushed the cable release as far as necessary to trip the shutter, the screw head should halt the spring. Use the mousetrap with a trip wire (see below for details). Make a loop at the end of the trip wire, and put the loop around the bent wire that supports the spring. This way, if the animal doesn't break the trip wire, the loop will pull clear after firing the mousetrap.

Firing Methods

There are three classic methods for firing a camera trap's shutter release: the trip wire, the treadle, and the photoelectric beam. Standard bait can be attached to trip wires and treadles to lure animals into the camera traps. The trip-wire thread can be tied directly to the bait, or the bait can be placed on a treadle in which the switch is wired to go off when weight is removed from the treadle.

Trip Wires. Stretch a very fine black nylon thread across a game trail, the front of a den, or any place animals are likely to pass. The thread must be placed at a height appropriate for the animal you want to photograph. For deer put the thread about 3–3½ feet above the ground. For such smaller mammals as raccoons, skunks, and beavers, the thread should be about 6 inches above the ground.

Make sure that the thread runs freely. The exact details of how to do this vary with the specifics of the setup. Bent coat hangers pushed into the ground, or wire loops attached to tree trunks or branches are good guides for permitting the thread to run freely to the firing mechanism. If you use a microswitch with an arm on it, the trip wire can be tied directly to the arm. You can also make a simple switch from paper clips and thumb tacks.

When you use trip wires to fire a shutter release, you are probably going to get only one shot. To avoid injury to the animal as well as damage to the camera, the thread is supposed to break after the switch closes, so don't use a thread with great tensile strength.

Treadles. There are any number of ways to make a treadle. I've used pressure mats similar to those that open supermarket doors and set off burglar alarm systems. I've also used a treadle made from a microswitch and a hunter's steel trap with the jaws removed. You can build a simple treadle with two pieces of wood, a hinge, a spring, and a microswitch or mercury switch. The microswitch has to be squeezed to close the circuit, and the mercury switch must be tilted.

A treadle should be placed in a shallow depression the same size and should be enclosed in a plastic bag to keep out the dirt, leaves, and water that can cause malfunction. Lightly cover the treadle with natural materials, and landscape the disturbed area to look like its surroundings.

Photoelectric Camera Traps. Probably the most effective trigger mechanism is an infrared light beam or a visible light beam. Light-beam shutter trippers enjoy several advantages over trip wires and treadles. The light beam is invisible, or nearly so. Certainly there is nothing for the animal to feel or touch.

A photoelectric camera trap can be used for repeat shots as an animal moves in and out of the beam or as several animals visit the site. Moreover, this is the only practical arrangement for taking pictures of birds or insects in flight.

The disadvantages are that photoelectric traps are fairly complex to make at home, and commercial units are often hard to find. There doesn't seem to be enough demand to make their manufacture for photographic use economical. Most homemade units are modified burglar-alarm circuits. These units tend to be temperamental and require such ancillary equipment as light stands, batteries, and wires. Setting up such a unit is complicated and must be done carefully.

However, most really remarkable camera-trap pictures are made with light-beam trippers. As far as nature photography is concerned, Stephen Dalton's famous camera-trap pictures are in a class by themselves. His sophisticated sensor system of light-beam trippers works in indoor and outdoor controlled setups. He uses custom-designed, custom-made, short-duration electronic-flash equipment combined with a high-speed electronic shutter mounted in front of his lenses (this shutter-method reduces the firing delay after the light beam has been interrupted).

Can you hope to emulate Dalton's results with the camera-trap setups described in this chapter? I'm afraid not. The cost of Dalton's equipment, which was made with the help of electronics engineers, was tens of thousands of dollars. The only circumstances in which you can expect comparable results is when you can use open flash— in other words, in very low light levels when you leave the shutter open and fire the flash with a light-beam tripper. If you are using a light-beam tripper at a site where you can observe the photography action, having a kill switch to shut off the light-beam tripper is a big advantage, permitting you to prevent film wastage on undesirable species or on obviously bad shots.

Electronic components are being upgraded so quickly that circuit diagrams are usually out of date before the books in which they appear are published. Still, you may want to look at the circuit diagrams in Harold Edgerton's book, *Electronic Flash-Strobe* (MIT Press, 1979). Also, many electronics-project books have plans for light-beam burglar-alarm circuits that could be modified for camera traps. The best way to get a light-beam tripper is to have a friend who is an electronics hobbiest build you one by modifying a battery-powered burglar alarm.

Delay Times

The delay between the firing signal and the opening of the shutter is a complicated factor when using trip devices with fast-moving subjects such as flying birds. Delay times are not usually a problem with terrestrial mammals. On a typical SLR camera the delay is about 1/10 sec. to 1/20 sec., which covers the time it takes for the mirror to go up, the lens to stop down, and the focal-plane shutter to open. These fractions of a second may seem short, but a flying bird may cover a foot and a half in that time. If the lens is framing and focusing an area traversed by the light beam itself, the bird will be out of the frame by the time the camera fires.

The exact framing and focusing you need varies from species to species and must be determined by trial and error. Set up your camera and flash equipment in a dark room, and run a test by quickly waving your hand through the light-beam tripper. The flash will freeze your hand at the moment of the shutter release. The distance your hand has moved out of the light beam indicates the general distance you may expect a flying bird to cover during the delay. Use this distance as a starting point when setting up your light-beam tripper and camera.

If your camera can accept a Polaroid back, it will be a tremendous help in accurately framing and focusing your subjects since you won't have to wait for the film to be processed. You can also use 35mm Polaroid film, but you might have to waste much of the roll.

If you can lock up the mirror of your SLR, you can reduce the delay time to between 1/50 sec. and 1/100 sec. while still using the camera's focal-plane shutter. By using a special electronic shutter in front of the lens with the camera's focal-plane shutter held open, or by using a camera such as an electronic Hasselblad that has a be-

tween-the-lens shutter, you can reduce it to approximately 1/500 sec.

Stopping Motion with Flash

For camera-trap use with fast-moving subjects such as flying birds and insects, you need a very short flash duration to avoid blurring. There are three ways to do this. You can use high-voltage flash units, such as the special industrial strobe units currently manufactured, or you may be able to pick up second-hand units that were widely used by professional photographers in the fifties. These are not ideal for field use because they are heavy and tend to short out in wet weather. They can deliver powerful, even lethal, shocks. Another way to create short-duration flash with sufficient power is to use a number of small, manual, battery-operated, shirt-pocket flashes connected to slave sensors so they will fire simultaneously. These units have relatively short durations, 1/2000 sec. to 1/3000 sec., but they may not be adequate to freeze the action you want.

The best method is to use regular amateur autoflash units with power-ratio controls. These units allow you to set the power output at full power, half power, or less. At full power they have durations of around 1/400 sec., but at one-sixteenth power they have durations of around 1/10,000 sec. It is possible with some of them to get down to one-sixty-fourth power, which lasts for about 1/40,000 sec. (The autoflash instruction booklet usually lists the unit's flash durations.)

The problem with these units at these short durations is that they don't provide much light, so you'll need to gang a number of them together for all but extreme closeups. If you use slave sensors to trigger the units, you may discover that at very short flash durations there is a significant delay between the times the first unit and the other units fire. If this seems to be a problem, try using multiple flash cords.

Buying a number of autoflash units is not cheap, but it is a practical way to get short duration and high power in the field. An alternative is a custom-designed, custom-built unit that would

cost must more. If price is not an object, you should look into the Presto unit imported by Dr. John Cooke, P.O. Box 2217, Berkeley, CA 94702, telephone (415) 849-3327. The Presto has a flash duration of 1/40,000 sec. at all power outputs. It is waterproof, can operate from a twelve-volt car battery, and recycles in under five seconds.

Batteries for Flash Units. For field use you need low-drain flash units, high-capacity batteries, or both. The best flash units for camera traps require accessory high-voltage battery packs. These batteries don't run down as fast as conventional ones. I once had camera traps set up for over a month, and they operated smoothly with the same 510-volt batteries throughout this period. Another advantage to high-voltage batteries is that the flash units don't buzz or whine when they are ready to fire or when charging. Also, they take only a second or two to recycle.

Some Successful Working Methods

Surprisingly, suburban and exurban locations are excellent for camera traps. The animals there are used to people and are not often hunted; therefore, they are much less likely to be spooked by your equipment. When dealing with shy animals, you may have to resort to the visual and olfactory camouflage techniques, outlined throughout this book, that are used by trappers.

Covering or masking the shiny parts of your equipment is a good idea no matter where you are working. For protection against wet weather, I enclose my camera, flash units, and external battery packs in plastic bags, carefully taping the plastic to keep the equipment dry even in heavy rain. I protect the camera lens—the only part of my equipment not covered by plastic—with a skylight filter and lens hood.

I don't often use camera traps, and if they can be avoided, neither does anyone I know. My reluctance is probably due to my initial frustrating experience with them. I was on an assignment to photograph an endangered species. My subject was red wolves, a species distinct from both gray wolves and

coyotes, that once ranged through Florida, Louisiana, Oklahoma, and Texas, and on down into Mexico.

The shooting location was the coastal plain of east Texas. There were definitely wild canines in this largely uninhabited region, but their heritage was in question. Originally, red wolves bred true, mating with their own kind in preference to the coyotes with whom they shared their range. The personality, appearance, and behavior of the two species were different. Red wolves traveled in packs and were relatively easy to shoot and trap. However, when the packs were wiped out, the survivors mated with coyotes. Later, feral dogs complicated the gene pool. By the time I was given the assignment, red wolves were feared to be extinct. In an effort to save the species, biologists were analyzing blood samples of trapped animals. Amazingly, they could sort out the genetic proportions of coyote, feral dogs, and red wolves in an individual. If no pure red wolves were captured, the biologists hoped to recreate the animals by selective breeding!

I flew to Houston, rented a car, and drove to Liberty, Texas to meet the expert trapper and wildlife researcher Glynn Riley. Over coffee Riley asked if I had brought a treadle or a device we could set up for a wolf to trigger a camera and take its own picture.

Such specialized equipment was not part of my usual pack; in fact, until then I had never needed to set up a camera trap. I immediately called my picture editor for advice. We were in luck. The technical department at the magazine had a treadle on hand that they had designed and built for another assignment; they would send it to me.

The pictures we were hoping to take would happen at night, requiring us not only to connect the camera to the triggering device but also to set up electronic-flash units on the soggy, mosquito-infested plain. If we were fortunate, we'd get just one picture; after the animal's trauma with the camera and flash, we'd never have another chance. Everything had to be perfect the first time. If we didn't like our first results, we couldn't change the camera position, the working distance, the ex-

posure, the angle, or the flash distance for another go-around.

Fortunately, the magazine's technical director became so interested in our project, he decided to bring the treadle and lights to me and to help me set up. With a post-hole digger we sank two posts. On one we clamped the motorized camera and an electronic-flash unit. On the other we mounted a flash unit and a slave to fire it the instant the first flash went off. The treadle the magazine had supplied was somewhat larger than what Riley had in mind. It was one of the huge doormats that open airport and supermarket doors when you step on them. He was skeptical of the treadle working, not only because of its size but also because of the materials from which it was made. Even if Riley could hide it visually, he knew he couldn't hide its odor. Creatures as fearful of man as these wild dogs would probably not approach it until the last vestiges of its rubber and plastic smells wore away, and that might be long after we had given up trying to photograph them.

We wired the treadle to the camera's motor, and Riley landscaped and hid it. He baited the setup with feces and urine collected from caged animals, and we left the site. When after a few days we had no results, Riley and I devised a second triggering device with the help of a mud engineer from a nearby oil company. We used a steel trap's trigger and a microswitch so impervious to water that oil companies put them at the bottoms of oil wells to count pump strokes. I put this treadle, along with a second motorized camera and more flash units, at another promising location where big canine tracks had been seen—about fifty miles away from the first camera trap—a short hop by Texas standards.

My daily, predawn-to-late-afternoon routine was to check our setups to see if any film had been exposed. Although I was based in the town closest to Anhuac National Wildlife Refuge, the location of my first camera and treadle, I was still about seventy-five miles away from it. To reach the second camera, I had to backtrack substantially from the first. All in all, checking both traps involved a two-hundred-and-fifty-mile round trip.

Checking the setups required more than simply looking to see if any film had been exposed since the previous day. The Texas Gulf Coast is humid and rainy, and it supports a substantial rodent population. Riley and the refuge staff were concerned about our arrangement because mice seemingly love to chew up wire left outdoors.

I had completely wrapped the cameras and flash units in heavy-duty plastic and plastic bags that I had carefully taped in place. To check the cameras I had to remove the tape and the bags to see the frame counters. If I found that no film had been exposed, I stepped on the treadle, listening for the motor and watching to see if both flash units fired. If they did, I retaped the plastic over the camera unit after noting the frame number. If they didn't fire, I had to check the appropriate batteries, plugs, and wiring to find the trouble and fix it. It doesn't sound like much, but it really was quite time consuming, especially considering the effort of hiking a half mile from the car to the camera trap.

This routine continued for about ten days. Meanwhile, I tagged around with Riley. I took pictures of researchers shipping animals off to a special laboratory and animal compound in Wisconsin, pictures of the animals being fed in big cages near Anhuac Refuge headquarters, and pictures of Riley giving a tranquilized animal a bath to rid it of fleas, lice, and ticks.

Our time was growing short. The wolves' mating season was over, and the time for denning was near. Accompanied by newborn young, the animals would be even more wary and more difficult to bait, trap, or photograph.

Then, the second camera trap showed half a roll had been exposed! I rewound the film, reloaded the camera, clamped it back on its post, replaced the sheltering plastic wrap, charged to my car, sped fifty miles to the nearest telephone, and called my picture editor. "We've got eighteen frames exposed," I said. "That's great," he said. "How soon can you get it here?" "Houston's a hundred and fifty miles from here," I said. "I'll call you from the airport and let you know when the plane is leaving."

I got back into the car and onto the road. One hundred fifty miles and more than two hours later, I ran into the air-freight office at Houston International Airport and asked when the next plane to New York would depart. "We've got one going nonstop in twenty minutes," the air-freight clerk replied. "Can I get a package on it?" "Just about," he said. I put the single precious roll in a big, preaddressed box, completed the paperwork, and trailed the air-freight man out to the runway to be sure my package was put on the plane.

I phoned my picture editor again, and told him the flight would arrive at 5:20 P.M. "Great," he said. "Just great. I'll keep the color crew late, send a messenger to the airport, and we can process it tonight, I'll stay to look at it."

I stopped at a phone booth the next morning between checking the first and second camera setups. Yes, the film was exposed, and there were animal pictures on it. Several were of toads. There was an otter and muskrat. None, however, were of my quarry, the elusive red wolf.

A few days later, when the original trigger setup showed an entire film roll exposed, I was more cautious. Instead of making a flying trip to the airport to fly the film to the magazine, I took it to a custom processor in a nearby town.

The whole roll of pictures were of boys in scout uniforms jumping up and down and mugging at the camera. I continued working on this project for another two weeks, but those were the only two rolls exposed with our automatic cameras.

Although the red wolf fiasco represented a lot of work and expense, it was not very lengthy as animal quests go. It lasted for about six weeks, but for ten days or so, while waiting for the technical editor and the treadle to arrive, I had made photographs elsewhere. If I had come prepared to set up an automatic camera, or if I could have returned earlier the next season, it is entirely possible we would have captured our pictures.

WORKING AT NIGHT

Although it is true that many species are active day and night, others are entirely nocturnal. There are many picture opportunities available to those photographers who make the effort to work after dark.

If I am planning a shooting session at night, I try to take it easy during part of the day. Depending on what hours I plan to work, beforehand I'll schedule several hours of rest or sleep. If I want to start in the evening and work into the night, I sleep during most of the afternoon until about an hour before sunset. For a shooting session after midnight I try to catch some sleep as soon as the sun goes down, and I set my alarm clock for the appropriate hour.

Finding Wildlife Subjects in the Dark

Most nocturnal creatures have an abundance of rods, or photoreceptors sensitive to faint light, and very few color-perceiving cones in their retinas, which makes them essentially color blind. If you put a red gel over the flashlight you use for spotting animals and focusing your camera, many animals won't see the light. Those that do can only perceive it dimly and are likely to go about their business undisturbed. Varmint hunters and field biologists know this and capitalize on it.

Hunting and trapping supply houses sell special high-intensity spotlights and headlamps that often feature focusing beams. I suggest you buy this

equipment if you plan to do any night work. Some flashlights and headlamps don't come with red filters, but they are easy to construct. Simply cut a red theatrical gel to fit over the lamp, using the glass that covers the lamp as a pattern. I find headlamps preferable to flashlights, especially when I'm working alone. Headlamps operate with battery packs that attach to your belt, leaving your hands free to operate the camera.

Headlamps and most flashlights are only useful at fairly short distances. John Netherton, who has worked extensively with red filters on headlamps and flashlights, says that with practice you can use them to focus the camera on subjects up to about twenty-five feet away. Most flashlights and headlamps used without a gel are effective for about one hundred feet. The exact distance you'll be able to focus depends, of course, on the strength of the light and the brightness of the focusing screen in the camera.

To search for subjects at greater distances, you can use a powerful spotlight mounted on a car and powered by the car battery when you are near roads or where four-wheel drive is possible. Many available spotlights plug into a car's cigarette lighter, and some come with a red filter. Such spotting is illegal for hunting and is forbidden for other purposes in some states. Check with a representative of your state game commission for information about your local laws.

Using a red gel over a light works with mammals and some birds. However, a white light is sometimes desirable because it can hold the attention of many animal subjects and seems to virtually mesmerize them, making a close approach possible. This is always true of such animals as toads and frogs, but it also frequently works with deer, raccoons, and other mammals.

Look for Eye Shine. What photographers usually look for as they scan the night with headlamps, flashlights, or powerful spotlights is eyeshine. You may not immediately be able to see the creature itself, but as you approach it, the light reflected from its eyes becomes visible long before you are close enough to photograph it with flash.

To locate an animal by its eyeshine, hold the lamp as close as possible to your own eyes, so that the beam of illumination parallels your line of sight. Then you can focus the camera on the eye shine. If the animal is not looking your way, you'll have to focus on its body, and in that case you need to place the focusing light several feet to the side of the camera for more contrast. In such situations an assistant is invaluable.

Techniques for Night Photography

The best electronic flash arrangement to use for night work is a TTL automatic flash unit on-camera or attached to the

camera by a bracket and the appropriate cords. Use the most powerful flash unit you can afford that works with your camera. There are teleflash lenses available for many flash units, lenses that concentrate a flash's light beam, thereby greatly reducing the light falloff with distance. Lepp & Associates (see page 48 for their address) markets several special teleflash rigs.

If you can't determine the flash-to-subject distance ahead of time, automatic flash is by far the simplest method for night picture taking. Nevertheless, you can work perfectly satisfactorily with manual flash. If you don't have automatic flash equipment, run tests on the specific manual flash, film, camera, and lens combinations you plan to use. Note the correct apertures at different distances to establish an accurate guide number, or use a flash meter to find this guide number. Flash pictures made outdoors usually need at least one stop more exposure than the unit's published guide number indicates because there are few reflective surfaces in outdoor environments.

The most useful focal lengths for stalking wild animals and birds are moderate-to-long telephotos from 135mm to 400mm at the longest. Many of my night pictures of animals and birds were taken with a 300mm lens. The lens you use should focus fairly close—for example, a 300mm lens should focus at least to twelve feet—because you may be able to get closer

to some animals at night than you can during the day. For ease in focusing and to make pictures in low light you should naturally use the fastest lenses you can afford:

Fill the Frame. If you are using a dedicated flash unit or an automatic flash with a camera that determines exposure by reading the light reflected from the film plane, try to fill the frame with your subject, or photograph your subjects against backgrounds that are close behind them. Using distant backgrounds or the sky behind a subject that takes up little of the frame results in significant overexposure of the main subject. You can compensate for this overexposure with the exposure-control lever incorporated in many camera bodies. For moderate-sized subjects, set the lever to one stop underexposure; for small-sized subjects, set the lever to two stops underexposure.

Multiple Flash Setups. If you are working on a game trail and are using olfactory lures or food as bait, or if you are taking pictures at a nest or den, you'll know where to expect the animal to appear, and you can indulge in more complex lighting setups such as multiple flash. For example, to backlight the subject and visually separate the animal from the background, place a slave-fired unit above and behind the animal's predetermined location. (Use slave triggers, not wires, to fire off-camera flash in multiple setups outdoors.)

Or you can use an additional flash unit off to the side at about forty-five degrees, to fill in some shadows and emphasize the subject's shape. If you have had a lot of flash lighting experience, you'll know what to expect from such lighting arrangements. If you don't, you can test your lighting setup with an object of similar size and color standing in for the animal.

If your flash units use AA batteries, you may want to adapt them to external batteries because the little AA batteries may not last all night. There are several advantages in using external batteries. For instance, if you can adapt your units to high-voltage batteries, your units won't buzz and beep all night. If you use low-voltage batteries, I recommend that you buy gel cells which are rechargeable. Some commercial gel-cell battery units are adaptable for different flash units and are available at camera stores. Gel cells are very popular with wedding photographers who typically make many flash exposures in a short time.

There are some other power alternatives. You could use D cells with a little adapter. Although D cells are not ideal, they last longer than AA batteries. Or you could use a sealed motorcycle battery, a smaller version of a car battery that can be recharged. Also, there are units that use rechargeable nickel-cadmium batteries, such as the Norman unit, but rechargeable units are expensive.

PRESENTING YOUR PHOTOGRAPHY

I begin organizing my pictures as soon as I start taking them. I number my film cassettes when I remove them from my cameras, and I send the cassettes in for processing in the order that they were shot. After the film has been processed, I number the slide boxes the same way. If I mail my film in for processing, I arrange the mailers in numerical sequence to match the shooting sequence marked on the individual film cassettes. If I bring the film to a camera store or a custom processor, I also keep the cassettes in numerical order.

Editing Your Transparencies

I edit my film in order, too. After numbering the slide boxes, I line them up in order. My first step is to put an entire roll on a lightbox viewer, orienting my verticals and horizontals so that up is up and down is down. When they are all on the viewer right side up, I examine them with a magnifier.

I only discard those slides that are grossly under- or overexposed and those that are unacceptable because of camera or subject movement. I am not always certain which is the very best of similar pictures, especially shortly after I have taken them. My detachment from them and my critical faculties improve with time. Several years later I can go through all the yellow boxes in a take and safely throw out uninteresting and unsaleable material.

I pick up the remaining slides from my first edit according to the sequence of the frame numbers on the individual mounts and draw a thick stripe down the mount edges with a felt-tipped marker. The stripe's purpose is to mark the bottom of the mounts; they will be uppermost when I project the pictures either in trays or in my Carousel projector's stack loader. The stripe makes it easy to avoid the irritating problem of accidentally projecting slides upside down or sideways. A slide that isn't oriented correctly shows up at a glance.

Next I go through the take using a stack loader and my projector, sometimes projecting one roll several times. I pull out some of the best pictures at this point and mark them with the number on the box, so I can easily go back to the right box for variations on an image. If I made pictures with more than one camera, as is usually the case, there will be pictures of the same subject on different rolls. These are usually easy to find since their box numbers are usually close together.

If a roll contains a lot of similar images of the same subject I usually put it back on the light box and use a magnifier to make a selection rather than selecting the best at the time of projection. I find it much easier to make such decisions with all the variations lined up together than by projecting the individual images.

I always go through an entire shoot in the way I've just described, regardless of whether it is a single roll of film from an afternoon hike or is composed of hundreds of rolls taken on assignment over a period of months. What happens next depends on whether the pictures were taken on an assignment or were taken for my files. If the pictures were made on a magazine assignment, I deliver the select pictures in plastic sheets holding twenty slides apiece. If I made the pictures for myself, I also put the selects in plastic sheets because that is how I store my select slides.

Developing a Filing System for Your Slides

There must be nearly as many filing systems as there are photographers who have work to file. As far as I can tell, no single system is best. What works for me may not work for you, and vice versa. You should consider a number of factors before you devise a photographic filing system: the quantity of material you expect the file to ultimately hold; who is going to use the file; the nature of your retrieval needs; and how your memory works regarding pictures you have taken and filed.

If the pictures that will be in your file—or in any unit of your file—number in the hundreds, you won't need as rigid a set of categories as for a file containing thousands or tens of thousands of pictures. For example, I can quickly scan twenty file sheets containing four hundred pictures for an image I want or make a general selection of, for instance, fifty pictures for a submission from such a unit; however, I can't easily do the same work with two hundred file sheets holding four thousand slides.

If you are the only person using the file, to some extent you may find it easier to operate on memory instead of setting up all the different categories necessary for someone else to use the file. The extent to which you caption

your pictures may also be affected by who uses the file. If you are the only user, a subject category such as "Everglades, Birds" may be sufficient, with the different species loosely grouped together on the file sheets but not in separate categories. If someone else is using the file, and the person doesn't know much about birds, you'll need categories that describe different species as well as "Everglades, Birds." Thus you would have separate file folders for "Everglades, Birds," "Anhinga; Everglades, Birds," "Eagle; Everglades, Birds," and so forth.

When you set up a filing system, keep in mind what the general purpose of your photography is and how you ultimately plan to use specific pictures. In my case, most of the picture requests I receive are for location coverage of such places as the Everglades, Okefenokee, and the Southwest. Consequently, the most efficient filing system for me is broad categories according to location with such subunits within each category as alligators, birds, flowers, grasses, and trees.

If your photographic scope is similar to mine a file set up in the same way will probably be most effective for you, regardless of whether you submit pictures for publication or organize slide shows to show to local organizations. On the other hand, if most of your professional assignments or the slide shows that you organize as an amateur involve specific groups of animals or plants, you may find that your broad categories should be "Birds," "Mammals," and "Plants," with subunits organized either by common or scientific names. Many nature photographers file their pictures in this way.

Should You Cross-index? Do you need a complicated numbering system and a cross-index with file cards listing all the pictures in your file and their specific locations? The advantage to this is the ability to instantly find any image you want, but setting up and servicing such a system is very time consuming. I don't use a numerical system or cross-indexing myself, and neither do several other nature photographers I know.

If you mainly shoot pictures for slide shows and project the same show for different groups of people, the best place to store your select slides is probably in the same slide trays you use for projection. Putting together a good slide show is a lot of work even if the show simply consists of individual images and your own spoken narration. Breaking up such carefully planned sequences causes a lot of extra, unnecessary work if you plan to show the same pictures and give the same talk to more than one group.

Choosing a Storage System

There are various ways to store slides. Your local camera store probably stocks several different kinds of slide files. You may choose to use slide pages as I do. You can even leave your slides in the boxes that the film processor provides if you caption the outside of the box and the contents fairly thoroughly.

I usually use a two-part system. As I mentioned, I put my very best pictures in slide pages that I organize according to the general location: either a specific state, a region in the state, or a region consisting of several states, such as the Southwest. I keep the yellow boxes intact except for the most select slides that I've removed. I store the boxes in numerical sequence in a large cardboard box or box top. By marking my select slides with the number of the box that they originally came from, I can easily get back to their closest counterparts in composition and in subject matter.

Having Prints Made from Transparencies

Hanging prints in your own home is one of the most obvious ways to enjoy your nature pictures. If you are not an expert printer, you can have enlargements made by a custom lab. There are several different types of color prints, most of which are made on Kodak's Ektacolor paper. Known as Type-C prints, these can be made directly from a color negative or from an internegative produced from a slide. This process can produce excellent quality prints. The quality and permanence of Type-C prints have consistently improved since the material was introduced. Their color holds up for years if the prints are hung in normal room lighting and are kept out of direct sun. But eventually, after a decade or so, Type-C prints do have to be replaced.

You can order Kodak Type-C prints through camera stores and many drug stores. If your prints' quality proves unsatisfactory, Kodak will make them at no extra charge. Custom labs are considerably more expensive than Kodak but should deliver superior quality prints. There are excellent custom labs in most major cities. If you don't live near one, you can still patronize a lab by mail order.

The most permanent color prints are made on Ilford Cibachrome, a direct positive material. Cibachrome prints are made directly from transparencies and have high inherent contrast. Transparencies with a full-contrast range may print too contrasty for your taste. Low-contrast originals, on the other hand, may look better in the Cibachrome prints than they do as originals. Most custom labs offer Cibachrome prints as well as Type-C's and dye-transfer prints.

The process for making dye-transfer prints is complicated and expensive, especially if you want only one print of a picture. However, dye-transfer prints are the best quality color prints. This process offers the greatest control over contrast and color saturation. I have had 4×6 ft. dye-transfer prints made from several 35mm transparencies. These prints look sharp even when viewed from a distance of a few inches. Dye-transfer prints run a close second to Cibachrome prints in terms of permanence.

If cost is one of your major considerations, I suggest you get either Type-C prints or Cibachrome prints, depending on the contrast of the original picture. If cost is no object, have dye-transfer prints made and try to visit a custom lab so that you can work directly with the printer and obtain the finest results.

Producing a Slide Show

There are many factors to consider simultaneously when organizing transparencies to show to an editor or a larger audience. I always organize my slides so that similar subjects and pictures of the same subject are shown in sequence. For example, when I show Everglades pictures, first I project landscapes, then nature closeups, and then

animals, keeping the same species or closely related species together.

Another consideration is how the vertical and horizontal pictures are mixed throughout the presentation. I try to project shows that contain as few changes from format to format as possible. If I have similar vertical and horizontal versions of the same subject, I prefer to project the horizontals. Color is another factor. I try to organize the slides so that similar colors are shown together and lead into one another.

I also take into account the special interests of the audience. For example, if I am showing pictures to a group of photographers or to an editor of a photographic magazine, I group the pictures by camera technique, lighting, and other pertinent picture-taking points. The way the pictures in this book are organized exemplifies such editing. If my audience is a conservation club or is composed of editors at a conservation magazine, I organize the pictures by subject matter.

Using a Script. I've had a lot of experience showing slides, and normally I don't use a script for my narration. I think about what I want to say as I organize the slides for projection, and then I recall my thoughts when I project the pictures. Occasionally, I make a few notes to which I refer during the slide show.

I didn't always work this way—I had stage fright the first few times I delivered talks with slides. My nervousness was always evident well in advance of a performance. With plenty of warning I wrote out my entire talk, and then read it verbatim while I projected the slides. Sometimes I had someone else project them. If you anticipate being nervous, too, I suggest you also write out what you want to say in detail.

Taping the narration for a slide show is simple, plus it allows you to show pictures without necessarily being present yourself. In addition to supplying the tape, you need to provide whoever operates the projector with a clearly marked copy of the script showing slide changes; otherwise she won't know when to change the slides on the screen.

Describing how to plan and execute multiprojector audiovisual presentations is beyond the scope of this book.

Hardware for complex audiovisual presentations is available from a number of manufacturers. The least expensive unit I know is made by Spiratone, and your camera dealer may either stock different models or be able to order one for you if you are interested.

Going Pro as a Wildlife Photographer

A detailed discussion of how to sell your wildlife pictures could fill at least another book, and I'm afraid I've run out of room. The best I can do is to recommend several publications to you, all of which are important source material if you want to work professionally. One is Henrietta Brackman's book *The Perfect Portfolio* (Amphoto, 1984). Second and third are the American Society of Magazine Photographers' *Stock Photography Handbook* and *Professional Business Practices in Photography*. The ASMP is located at 205 Lexington Ave., New York, N.Y. 10016. Finally, there is *The Guilfoyle Report*, a quarterly marketing-oriented newsletter for nature photographers, published by AG Editions, 142 Bank St., New York, N.Y. 10014.

INDEX